Renaissance Art
A Beginner's Guide

D1353877

ONEWORLD BEGINNER'S GUIDES combine an original, inventive, and engaging approach with expert analysis on subjects ranging from art and history to religion and politics, and everything in between. Innovative and affordable, books in the series are perfect for anyone curious about the way the world works and the big ideas of our time.

Renaissance Art
A Beginner's Guide

Tom Nichols

ONEWORLD
OXFORD

A Oneworld Paperback Original

Published by Oneworld Publications 2010

Copyright © Tom Nichols 2010

The moral right of Tom Nichols to be identified as the Author
of this work has been asserted by him in accordance with
the Copyright, Designs and Patents Act 1988

ISBN 978–1–85168–724–4

Typeset by Jayvee, Trivandrum, India
Cover design by
Printed and bound in Great Britain by Bell and Bain Ltd., Glasgow

Oneworld Publications
UK: 185 Banbury Road, Oxford, OX2 7AR, England
USA: 38 Greene Street, 4th Floor, New York, NY 10013, USA
www.oneworld-publications.com

Mixed Sources
Product group from well-managed
forests and other controlled sources
www.fsc.org Cert no. TT-COC-002769
© 1996 Forest Stewardship Council

To my parents

Contents

Preface and acknowledgements

This Beginner's Guide draws primarily on my experience as a teacher of Renaissance art at the University of Aberdeen in Scotland. Few of my students have studied much art history when they arrive at the University (it is little taught in British schools), let alone the Renaissance. But a good number of them have already experienced something of the excitement of Renaissance art on their visits to galleries and exhibitions or on foreign holidays. Readers of this introductory book may be in a similar position. They have visited Italy, perhaps, spending time in major artistic centres such as Florence, Rome, or Venice. They may have come away with vivid impressions of the Renaissance works they have seen. Or again, they may not have yet had the chance to see such famous works 'in the flesh', but are keen to get to grips with this key period in art history before making their pilgrimage. Other readers may already have a well developed interest in art, but know more about works from more recent periods, such as Impressionism or contemporary art. Some may have only just decided that art is of any interest to them at all.

This book has been written with this wide mixture of possible readers in mind. It aims to provide a new and accessible introduction to a famous and much written-about period of art, which still possesses a certain aura of quality and value (monetary as well as artistic!). I have tried to keep things relatively simple and have provided a short glossary of 'specialist' terms, which are indicated in the text by italics. A full list of all the works

discussed, with their dates and present locations, is also included, as is a map of the cities and towns from which my examples come, and a list of books for further reading about these particular works. A basic bibliography of the key works on the Renaissance is also included so that the interested reader can gain a fuller understanding of the topic. My book is based on the close discussion or 'reading' of a small number of examples of Renaissance art (all of which are illustrated). Through close attention to these key examples, the reader will build a rich understanding of the central characteristics of a Renaissance work, and of the surrounding conditions that led to its creation.

Certain of the decisions that I have made in preparing this book need to be noted here, without making too many apologies. They have primarily been dictated by considerations of space: that is, by the need to make this a book of manageable size and scope, while also maintaining an interesting level of detail in the discussion. Renaissance architecture is not covered; and my examples date from the period roughly between 1400 and 1565. As far as architecture is concerned, this seems to me to be a vast subject in its own right, worthy of a whole other study, though it is certainly one closely related to the progress of the other arts in the Renaissance. As for the dates, arguments will long continue about when, exactly, the Renaissance started and ended, with many preferring dates of 1300–1600. But in my view its most salient features, and its best examples, only really appear in the period I cover.

Though I have been careful to give a sense of the wide geographical scope of Renaissance art, certain countries, such as France and Spain, are discussed only in passing, or in relation to works imported to them. But while these countries may have produced Renaissance works, these were, in my view, largely dependent on the more powerful examples from elsewhere discussed in the book. I must confess that my choices also reflect personal preferences. But my hope is that the decisions I have

made have not weakened the account, allowing it something of the texture and fibre that grow out of real enthusiasm. I would like to thank my family, friends, and colleagues for their help and understanding during the course of the project.

Illustrations

Plates

Figures

Introduction

'Renaissance art': a familiar-sounding phrase. But what was the Renaissance and how do we identify its presence in art? Which works of art most clearly express its values? Where and when did it emerge, and how did it develop over the course of time? This introductory book has been written with these fundamental questions in mind. Each chapter focuses on major examples of Renaissance art from the fifteenth and sixteenth centuries and is arranged in a broadly chronological fashion. The discussion follows the progress of art in different parts of Europe, targeting those places (typically towns and cities) where a distinctively 'Renaissance' approach was most developed. The chosen examples illustrate the wide variety of subjects, image types, and media that artists depicted and used, and also reveal the sheer visual range of works that can be described as 'Renaissance'. Each example is carefully set into its historical and artistic context, but at the same time the close focus on specific works will help to build a wider picture of the Renaissance as a whole.

Renaissance art has always held a strong attraction for those curious about European culture. Though the word itself was not used before the mid-nineteenth century (it was first coined by the French historian Jules Michelet in 1855) many people living in the fifteenth and sixteenth centuries already had a strong sense that they were witnessing an almost miraculous artistic 'rebirth'. This is the story told by the Italian writer and artist Giorgio Vasari (1511–74), for example, in his *Lives of the Artists* published in Florence in 1550 and 1568. Vasari believed that art had been reborn in Italy and that it had, by his day, reached perfection. His idea of a 'rebirth' was based on the perception that visual art

had already scaled similar heights some 1500 years earlier in the buildings, sculptures, and paintings of classical Greece and Rome. The story of art, so far as he was concerned, was about the rebirth of the classical principles of this earlier time, though he also thought that sixteenth-century art of the Renaissance had surpassed that of the ancients.

Vasari was an Italian from the region of Tuscany, an area where echoes of the antique past are very apparent. His account of Renaissance art was made partial and biased by his lack of understanding or knowledge about other parts of Italy and Europe and the artists who worked in these places. The *Lives of the Artists* is dominated by artists from Vasari's own region, among whom Michelangelo Buonarroti (c. 1475–1563) was deemed the most perfect of all. Few would disagree about Michelangelo's quality, and both he and many other Tuscan artists will feature much in this book (see chapters 2, 3, and 6). But it has nonetheless become very clear that Vasari's pro-Tuscan view doesn't really give a fair or accurate account of the Renaissance. This book will show that the Renaissance appeared in a number of urban centres across Europe around the same time (although it took on rather different appearances and qualities as it did so), and that it was not exclusively based on the 'rebirth' of classical artistic values.

Vasari's other great idea, that Renaissance art forms the gold standard of cultural achievement, has continued to be widely accepted and no attempt to undermine his evaluation will be made in this book. But we do need to question some of the wider claims that have been made for the significance of Renaissance art in later periods, especially the nineteenth century. In his *Civilization of the Renaissance in Italy* (1860) the influential Swiss historian Jacob Burckhardt (1818–97) developed Vasari's original idea of the Renaissance to argue that this was the period when the life of modern human beings effectively began. According to him, the Renaissance was the time

when Europeans broke free from the social and religious fetters of the earlier medieval centuries (the 'dark ages', as they were tellingly known) and became fully aware of themselves as modern individuals. Following Vasari, Burckhardt insisted that Italy and classicism were the two main players in the Renaissance, and that the unrivalled art of towering geniuses such as Donatello (1386/7–1466), Leonardo da Vinci (1452–1519), Michelangelo, and Raphael (1483–1520) reflects this brave new world of personal endeavour and cultural achievement.

Burckhardt and his many followers laid particular stress not only on Italy and the classical revival, but also on the many types of secular art that emerged in the Renaissance. According to this view, art was now freed from the shackles of the monastic and superstitious dark ages, boldly and freely confronting the real world. Evidence of this could be found in the creation of light-hearted and erotic classical mythologies, and in the penetrating portraits that laid new emphasis on the sitter's unique personality. And the success of such works was achieved through the Renaissance artists' development of a brand new naturalistic style in their works, based on the models of classical Greece and Rome.

There is something comforting about the vision of the Renaissance as a period of enlightenment and rationalistic progress, and this view still has its advocates today. But Burckhardt's view inevitably owed much to his own time: it was a product of the progressive and secularising nineteenth century, and simply ignored surviving evidence from the Renaissance period itself that suggested a much less straightforward cultural situation. The Burckhardtian view ignored the inconvenient fact that traditional Christian subjects (such as the 'Virgin and Child' or the 'Crucifixion') were the most frequently depicted subjects in the Renaissance period. And it paid precious little attention to art outside Italy, largely accepting Vasari's biased view that the

Renaissance began and ended in that country. Like Vasari, Burckhardt saw the close imitation of nature as a key feature of Renaissance art. But in the early phase of the Renaissance, the most lifelike works were produced not in Tuscany but in Flanders (roughly equivalent to modern-day Belgium). It is with these Flemish artists, whose style owed little to classical Greece or Rome, that this book begins.

Map of western Europe showing the major cities
and towns mentioned in the text

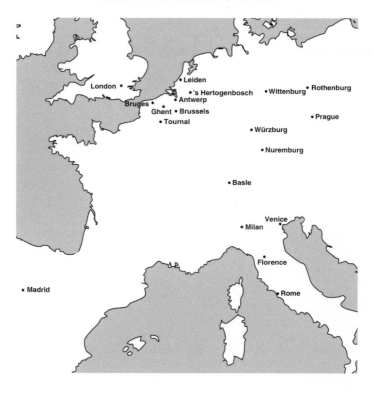

1

Realism and religion: early Renaissance art in Flanders

There are good reasons for beginning a discussion of the Renaissance with the art of Flanders. After all, it was here in the lowlands of north-west Europe that one of the main features of Renaissance art first became established: the close imitation of nature. From around the second decade of the fifteenth century onwards, Flemish paintings began to look very lifelike, featuring believable figures in settings that refer directly to the realities of life at the time. Such a move marked a clear turn away from the more otherworldly appearances typical of the Gothic style that had dominated throughout Europe in the preceding centuries (see box on p. 2).

If extraordinary lifelikeness was a central feature of much Renaissance art, so too was experimentation with artistic media and techniques. The Flemish artists discussed in this chapter used oil paint: this was particularly well suited to giving an effect of reality, and was soon to become *the* favoured Renaissance medium among painters. At the same time, a work such as the *Arnolfini portrait* (plate 1) by Jan van Eyck (before 1395–1441) is a secular painting: it is an early example of the non-religious art that gained a new foothold in the course of the Renaissance. It also provides an opportunity to consider another key Renaissance theme: the rising social status and fame of the artist.

GOTHIC STYLE

The Gothic style in art was predominant across much of medieval Europe from the mid-twelfth century onwards. In church architecture, it was characterised by strong verticals, the use of pointed arches, and elaborate decorative elements (e.g. *tracery* and *finials*). The term is also commonly used to describe paintings and sculptures in which a decorative approach is dominant over the imitation of nature. Gothic works do not attempt to give a consistent illusion of space and feature elongated, sinuous, and flattened forms. Surfaces are ornately worked and richly coloured, often using gold leaf. From the fourteenth century onwards the essential unreality of the Gothic style intensified further in exquisite works by artists such as Jehan Pucelle (c. 1300–c. 1350) and the Limburg brothers (c. 1390–1416), whose tiny miniature paintings on *manuscripts* possess a delicate refinement that reflects the elite culture of the Franco-Flemish courts. The word 'Gothic' was initially used as a term of abuse by Italian Renaissance artists who associated it with the 'barbaric' north European tribe of the Goths who had destroyed the Roman Empire and its classical art. But, as we shall see, the Gothic did not simply die out with the coming of the Renaissance. The two styles often overlapped and were not so opposed as it appears.

But if all this suggests a sharp break from the medieval past, Flemish realism was also underpinned by religious symbolism that linked it to older sacred values. The Renaissance did not, as is sometimes assumed, involve a simple move away from the religiosity of the middle ages, and Christianity remained a dominant force throughout the period. Examination of large-scale *altarpieces* by van Eyck's followers Rogier van der Weyden (1399/1400–64) and Hugo van der Goes (d. 1482) will show that art continued to form the focus of public prayer in Flemish churches or chapels, as it had for many centuries all across Europe.

The superb realism of these works was clearly intended to intensify rather than disrupt on-going Christian devotions. Despite their familiar subject-matter, drawing on well-known figures or stories from the Bible, these religious paintings were intensely 'site-specific'. That is, they were thought out with the values and aspirations of their patrons and viewing audience in mind, and were intended to respond to their specific settings. The particularities of place, patronage and viewing audience remained important in the Renaissance. But these considerations did not stand in the way of artistic innovation. Indeed, a new concern with making artworks look different from one another developed in Flanders, as elsewhere, such that by the end of the fifteenth century many works of art had taken on a unique appearance.

The impact of oils

In van Eyck's portrait a lavishly dressed young couple are shown in full length, standing in what may be their bedroom. Unlike the odd elongated and flattened figures in paintings from the thirteenth and fourteenth centuries, they are presented as lifelike individuals in recognisable everyday surroundings. When looking at the painting we completely forget that it is a flat object, so convincing is the illusion of three-dimensionality. The effect of reality is all the more astonishing given that it is conjured out of the fall of light through the window at the background left. We cannot see everything equally in the room: some things are half hidden by pools of shadow (the man's feet, for example); and at a distance they have a tendency to lose their precise outline (the view reflected in the mirror).

Key to this approach is van Eyck's use of linseed oil to mix his paint *pigments*. The impact of the given medium used in a Renaissance artwork on its final appearance should not be under-estimated. In the case of van Eyck, it was oil paint that allowed him to create so convincing an illusion of reality. Before him,

most painters in Flanders and elsewhere in Europe had used egg *tempera* to bind their pigments together. Tempera painting was characterised by unnaturally bright and opaque local colours, and was typically used in combination with flat gold-leaf backgrounds, often applied by specialist gilders. Oil paint was a comparatively cheap and easy medium to use, and this may have encouraged van Eyck to abandon gold leaf. It was also slow-drying, allowing van Eyck to be more spontaneous as he worked. Given its translucency, colours could be built up in layers and blended into one another to give an accurate impression of the textures of objects, and of the variety of tones produced when light strikes them.

Our eyes can't help but take in the subtle tones enlivening surfaces such as the back wall of the room, and objects such as the glinting rosary beads hanging next to the mirror, the elaborate chandelier, the lavish drapes of the bed, or the ornate gatherings of the woman's fur-lined sleeve. Van Eyck's oil technique makes us aware that natural appearances are always dependent on interaction between surfaces and ever-shifting patterns of light. In his painting, things such as a wall, some beads, a bed, or a sleeve are linked to living beings by these means. The same play of tones across a surface brings the male sitter's face alive, and animates the being of the little dog, which (unlike the man and woman) boldly catches our eye. It would be wrong to assume that van Eyck actually invented oil painting. But though oil had often been used before, there is no doubt that he was the first to understand its potential to bring painting very close to the appearance of real life.

The rise of portraiture and the Flemish towns

Other works from the time of the Arnolfini painting tell us that van Eyck was not the only artist to turn to portrait painting

in Flanders. The elusive Robert Campin (also known as the 'Master of Flémalle', 1378/9–1444), who worked in the town of Tournai, made a number of penetrating individualised portraits, as did his pupil Rogier van der Weyden in Brussels. Although portraits were certainly made in earlier centuries, the type became newly fashionable as the fifteenth century progressed.

The *Arnolfini portrait* features two historical persons, even if it is now unclear who they are. According to one theory, the painting shows Giovanni di Arrigo Arnolfini and Giovanna Cenami getting married, with the artist himself as a witness. The inscription on the rear wall of the room, perhaps deliberately written in a legalistic hand, and featuring the words 'Johannes de eyck fuit hic 1434' (Jan van Eyck was here 1434), is taken as evidence for this reading. So too is the 'self-portrait' of the artist that can be glimpsed in the reflection of the mirror. But there are no other examples of double portrait paintings being used as marriage documents in the period, and a document discovered in 1997 reveals that Giovanni di Arrigo and Giovanna Cenami did not marry until 1447, thirteen years after van Eyck's painting, and six after his death.

Early inventories tell us that members of the Arnolfini are depicted, so the search is on to find other possibilities within the family. The male sitter has been re-identified as Giovanni di Nicolao, a cousin of the original Giovanni, who also traded in Bruges at this time. According to one recent scholar, Giovanni di Nicolao is shown with his wife Costanza Trenta, who had died in 1433. Van Eyck had already made a memorial portrait showing a dead sculptor or musician. But given the lack of overt references to death (for instance in the form of black clothing, or an explanatory inscription), it is more likely that Giovanni di Nicolao is shown with a second, though undocumented, wife.

Whoever is depicted in the *Arnolfini portrait*, it is clear that the painting lays much emphasis on the individuals shown, and this became an important Renaissance theme in European art (see

plates 5 and 6). It is true that individuals have always existed everywhere, and that they were highly valued in many other societies. But it is also clear that in the Renaissance, a new emphasis was laid on the particulars of human appearance, as also on personality. What wider economic and social developments lie behind this new interest, and why did the new taste for portraits develop so strongly in the towns of early fifteenth-century Flanders?

By this time, the well-connected and accessible trading region of Flanders had become one of the most densely urbanised and economically vibrant parts of Europe. Bruges was the continent's largest city and also one of its most socially progressive. It was an entrepôt, whose wealth was based on the export of woven wool, but which was also the centre of a fast-growing international market in luxury goods. In van Eyck's portrait there is a careful display of the kind of high-quality manufactured goods on which the wealth of Bruges was based, although it is telling that not all the objects shown were locally produced. The convex mirror with ten inlaid roundels and the elaborate bronze chandelier may be Flemish, but the richly patterned woven rug is probably an import from Anatolia in Turkey.

The prominence of foreign families such as the Arnolfini was itself a reflection of the special position of Bruges as a centre of international trade. The family were Italian merchants from Lucca in Tuscany and this Mediterranean origin, with its whiff of exoticism, is neatly indicated by the oranges placed on the bench to the left of the painting, a luxury southern fruit not readily available in 1430s Bruges. But this internationalism should not confuse our perception of a link between the realis-tic Renaissance style used in van Eyck's portrait, and the new urban and mercantile classes of the towns. The creation of such a portrait reflects the rise of a new social class, whose money came not from inheritance, land, or military conquest, like that

of the feudal aristocracy of the medieval period, but from trade.

The rise of towns such as Bruges also offered leading inhabitants a new kind of social mobility and freedom. In the more fluid and culturally mixed market-based societies of Lowland Flanders individual people now had more opportunity to fashion themselves. This newfound freedom lies behind the growing taste for personalised painted portraits. Prominent individuals increasingly took the opportunity to shape their identities for the benefit of families, friends, competitors – and themselves.

The changing status of the Renaissance artist

In 1425, Jan van Eyck was appointed court painter to the Duke of Burgundy, Philip the Good, one of the wealthiest rulers in northern Europe. Van Eyck's employment at the prestigious Burgundian court, whose sphere of influence stretched from southern central France to the borders of Denmark, indicates that he enjoyed a very high professional profile. This is also evident in the *Arnolfini portrait*, where the artist makes two references to himself. In the first place he includes a signature. This is not at all untypical in works of the Renaissance. Van Eyck usually placed them on the frames of his paintings. In this example, however, the signature is positioned at the upper centre directly between the two sitters. Its flamboyant Gothic script is enlarged so that it presses forward from the back wall toward the picture surface. The wording boldly suggests the artist's creative presence in his work: 'Van Eyck was here' indicates his role, not as witness to a wedding, but rather as the proud inventor of a new kind of picture.

Van Eyck referred to himself again as the male figure in blue glimpsed in the mirror. Setting aside the marriage theory, the artist's double self-inscription within his painting is a sign of his

own high professional status and fame. We must be careful here, for it is clear that such references are not allowed to disturb the visual dominance of the patron figures at the front of the image: his self-portrait is little more than a tiny reflected blur. And artists' signatures in Renaissance paintings were as likely to be included as commercial-style trademarks. But van Eyck's self-references none the less challenge a common assumption held in the medieval period: that it was the rich and socially prominent patrons, rather than the makers, who were finally responsible for them. They announce the arrival of the more confident and professionally ambitious figure of the Renaissance artist.

Van Eyck's decorous yet insistent references to himself in the *Arnolfini portrait* reflect the rising professional and social profile of visual artists in the fifteenth century. Paintings, like many other artworks, had long been made in workshops, typically located in lower-class areas of town, often near to the chemists' shops where painters purchased their pigments. In these workshops, teams of artisan artists and their apprentices typically worked in collaboration with one another, and with craftsmen such as gilders and carpenters (see figure 8 below, for example). Because artists worked with their hands their art was widely seen as non-intellectual (the term used was 'mechanical'). Like other artisans, visual artists were apprenticed to their trade as young as ten or eleven, and so did not go to school or university. Painting and the other visual arts were not taught at school or in the universities, where the curriculum was based on non-practical, typically language-based, disciplines (the so-called Liberal Arts) first established in classical times.

Van Eyck was not the first artist to enjoy an elite position at a leading court and an international reputation. And we have seen that the *Arnolfini portrait*, like many other of his works, was not made for the Burgundian court. But his elevated professional position clearly had an impact on the kind of progressive paintings he made. He won renown as a uniquely creative individual

whose paintings were seen as extraordinary and unprecedented inventions of high cultural (and probably monetary) value. Like many other Renaissance artists, he often seems to draw attention to this new valuation within his works, reflecting on the nature of his craft within the painting itself. In the *Arnolfini portrait*, his elaborate signature is placed close to the mirror in which his self-portrait is glimpsed. The idea that painting itself was like a mirror in its capacity to imitate reality was becoming a commonplace in the period.

Renaissance art: north and south

We need to ask: what features make van Eyck's portrait typical of the Flemish or 'Early Netherlandish' school, as it is sometimes called? We can get at an answer by comparing it briefly with similar works made in Italy in this period. Portraiture did emerge as an important image type south of the Alps, though nothing comparable with the visual directness of van Eyck's painting appeared until much later in the fifteenth century. The painter's Lucchese patrons may have been attracted to van Eyck precisely because his style seemed novel, so very unlike what they could have expected at home. In Italy during the 1430s and 40s bronze medals featuring profile heads of aristocratic leaders appeared, and in Florence the first sculpted portrait busts were made. But these works are 'classicising', deliberately recalling the artistic models of antique Rome.

In van Eyck's paintings, the turn toward portraiture reflects a more direct concern with the world of immediate visual reality, essentially free from the influence of antique examples. And this direct interest in nature must be one reason why Flemish artists were quicker to exploit the illusionistic potential of oil paint. This leads us to another important characteristic of northern European art more generally: its very equal treatment of the

things it shows. Following the example of the ancients, Italian Renaissance artists learnt quickly how to focus their attention on the human figure at the expense of the 'lesser' forms of nature, such as settings, landscapes, or inanimate objects. But in van Eyck's *Arnolfini portrait* our concentration on the figures is challenged by the equal attention lavished on architectural frames, ornate mouldings, or piles of lush draperies. This 'all-over' effect was destined to have a long history in the art of northern Europe.

Looking at the *Arnolfini portrait* we notice that the two figures are not depicted with quite so much directness as the room they occupy. The presentation of the woman, in particular, with her white skin, high waist, and small oval head, still owes something to the Gothic style (see box on p. 2). And this kind of split between figure and setting was not unusual in Flemish art of the fifteenth century. If, in Italian art of the period, human figures were increasingly remodelled to look like ancient sculptures, in the north they retained a more traditional look, even as their settings were brought up to date. This was another way in which Flemish artists maintained a vital link with the art of the medieval past. However innovative their new realism was, they did not turn their back on older artistic traditions.

Sacred and secular, not sacred versus secular

We have assumed that van Eyck's portrait was wholly secular. And yet many natural details in the Arnolfini painting have a deeper significance, drawing on long-standing traditions of Christian symbolism. Debates regarding the overall meaning of these symbols go on, but it is clear enough that they refer to the religious piety of the sitters and to their married status. Those

who see the picture as a record of an actual marriage ceremony have emphasised the significance of details such as the dog (fidelity) and of the small wooden sculpture on the bedstead (featuring St Margaret, patron saint of childbirth). But these and other details may just refer to the sacredness of the married state, or have a still more generalised religious significance.

The two pairs of shoes (removed like those of Moses before his ascent of Mount Sinai in the Bible) suggest the sanctity of the domestic space into which we look, as does the single lit candle in the chandelier (signalling the presence of the Holy Spirit). The apple on the window-sill, tellingly placed beneath a part of the window frame that appears (from our viewpoint) like a small crucifix, must indicate the pair's pious acceptance of their Original Sin and their hope of redemption through Christ, a point re-emphasised by the tiny scenes from the Passion that surround the mirror. Such details tell us that we view a double portrait of a young married couple at home. Their intimate relationship is legitimised by their overall truthfulness to Christ and to one another. The purpose and future fruits of their sexual union are made amply apparent by the dominating bed to the right, as by the tell-tale swell of the woman's belly.

These symbols provide a moral framework for this otherwise worldly double portrait. They remind us that the material and spiritual sides of life were not divided in the minds of van Eyck and his patrons. Van Eyck's disguised symbols are there to secure a connection between the exciting new world of material consumption in 1430s Bruges and the more traditional one of religious piety. A similarly confident connection between secular and sacred is evident in *St Luke painting the Virgin* of 1435–40 by Rogier van der Weyden (figure 1). Rogier's long and very successful career in Brussels shows that the new taste for realism in Flanders was certainly not confined to van Eyck at Bruges.

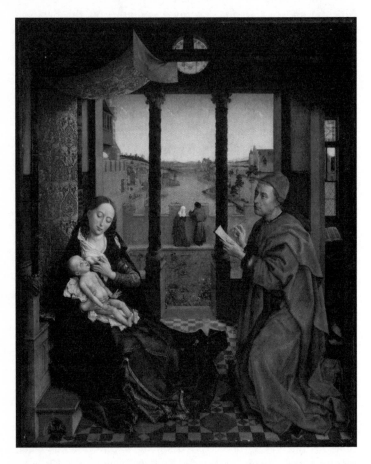

Figure 1 Rogier van der Weyden, *St Luke painting the Virgin*, 1435–40, Boston, Museum of Fine Arts/Gift of Mr and Mrs Henry Lee Higginson/The Bridgeman Art Library

Like the *Arnolfini portrait*, Rogier's *St Luke* is not quite square, but it still reminds us of a window through which we view the believable world of an interior. As in van Eyck's painting too, other apertures open off the room into which we look. At the extreme right we have a tantalising glimpse through a doorway into an adjacent room. This secondary space contains a number of objects which help to identify the male figure as St Luke, one of the four evangelists. The open book must refer to his writing of the gospel, while the ox below is his special attribute, though we do not see the wings which identify it as one of the apocalyptic beasts featured in St John's Revelation in the Bible. The omission of these unlikely appendages tells us something about the painter's concern to play down or conceal supernatural elements in his painting.

St Luke does not wear the usual halo revealing his sacred identity, and his large head, in particular, is treated like an individualised portrait. He has clearly moved through the door from his cluttered room into the more austere main one, but still carries something of its more contemporary feel with him. Turning his back on the book he has been writing, he kneels on an olive green cushion before the Virgin and Child to take their portrait. In his hand he holds a piece of parchment or *vellum* and a metal stylus known as a *silverpoint*. These were the materials most commonly used for drawing in 1430s Flanders. St Luke has momentarily stopped drawing to look in the direction of the mother and child, but he does not gaze directly at them.

The main room into which we look belongs to the Virgin and Child: their importance is suggested by the low wooden structure they sit on, as by the richly brocaded curtain that hangs behind and above them like a canopy. Seat and curtain are the only objects in the room, their appearance recalling church furnishings, particularly the baldacchinos that were hung over altars or thrones highlighting objects of special veneration. The interior we look into is to this extent transformed into a kind of

religious shrine, as is indicated by the devotional kneeling posture taken up by St Luke. If the suggestions of physical reality remind us of the work of Jan van Eyck, then in Rogier's painting they have a more insistent metaphysical dimension.

Rogier was indebted to van Eyck's recent *Virgin and Child with Chancellor Nicolas Rolin* for his overall composition, but he downplayed the older master's emphasis on materials and objects. Rogier's interior is comparatively plain and cramped, though his sacred figures have more movement, seeming to float free of their worldly confines on beds of gravity-free drapery. The Virgin's robe extends across the picture surface as if to make an intimate connection with her devotee. This connection is reinforced in colouristic terms: her rich blue drapery combines with Luke's red to form a display of her two traditional colours that contemporary viewers would immediately have recognised.

If Luke is shown with a great realism, then the Virgin, with her small pale oval-shaped head set at a slight angle to her body, her high forehead, and down-turned eyes, still recalls the conventions of Gothic art (see box on p. 2). Her seemingly natural action of breast feeding can be taken as another indication of her traditional identity: she is an example of a 'Virgo lactans', the most ancient type of Virgin and Child image, examples of which date back to the third century AD. As in many such depictions, her downward focus on the Child is contrasted with the upward direction of his gaze, back past his mother toward God in Heaven.

Rogier's inviting view through a three-part window onto a landscape beyond is based on van Eyck's *Rolin* painting: but by comparison, his landscape is simplified to its essential 'meaningful' features, most of which have a theological resonance. The tripartite division of the window probably refers to the three parts of God (the Trinity), while the view out from it is carefully composed with the significance of the foreground scene in mind. The panoramic landscape, featuring a low-lying town

with a wide river running through it, reminds us of contemporary Flanders, but the view is essentially generic: it is impossible to identify either the precise town or river. It serves primarily to establish Mary's position in a high chamber as a metaphor for her virginity, and its essential forms were much repeated in Flemish painting.

Contemporary viewers may have made a connection with the pagan princess Danaë, who featured in devotional texts as a prototype of Mary, given that she was locked away in a tower to protect her virginity. In keeping with this, the Virgin is shown as carefully protected from the 'world' down below, not only by the elevation of her tower room, but by the castellated wall, in front of which we glimpse a garden featuring the lilies commonly associated with her. The traditional reference to the Virgin as a 'hortus conclusus' (enclosed garden) may also be supported by the two little figures looking out from the wall: are they her parents, Joachim and Anna whose miraculous conception of a child in old age proved the Virgin's divinity and consequent freedom from Original Sin?

Van der Weyden's *St Luke painting the Virgin* shows us that things did not simply move forward along any one line in the Renaissance, as if progressing toward a single goal. Rogier's painting clearly follows the kind of direct approach to reality introduced by van Eyck, and is thus a typical Flemish work of the fifteenth century. But it is a painting of different type from the *Arnolfini portrait*: it is an *altarpiece* made to hang above an altar in a church or chapel. This original religious function in a place of public worship might explain the more insistent references to the sacred world noted above. In Renaissance art, style, technique, and subject-matter (iconography: see box on p. 88) were typically matched to specific picture type and function. Van Eyck's portrait was probably intended to hang in the relative privacy of the Arnolfinis' house, and the artist accordingly took a secular approach to his subject. Rogier's altarpiece,

on the other hand, would form the focus of prayer at the Mass. He therefore made more insistent reference to traditional religious ideas.

Yet the comparison with van Eyck's *Virgin and Child with Chancellor Nicolas Rolin*, also an altarpiece, shows that individual artists took different approaches to works of the same type. Van der Weyden retreats from the lavish material displays of van Eyck's model, encouraging us to penetrate more directly to spiritual meanings. Rogier's approach is more abstract and linear. While he certainly produces a convincing illusion of space, he also links his forms together at the picture surface to make semi-independent patterns or relationships. In contrast to van Eyck's static and monumental version of realism, Rogier's approach offers movement and emotion. These aspects were already very well established in Gothic art, and suggest again that even the most innovative Flemish masters of the fifteenth century conducted a careful dialogue with the past.

The importance of place and the role of the religious artist

Rogier's painting was probably intended for the chapel of St Catherine in the cathedral of St Gudule in Brussels, where the local painters' guild met for prayer, and where Rogier himself is buried. Even if we cannot directly identify the river in the background as the Senne and the town to either side as Brussels, this tells us that its imagery was of great local significance. In the Renaissance, artworks typically remained site-specific, their form and meaning closely tied to the places for which they were intended. As time went on an increasing number of visual images became portable: reproductive prints, some portraits, small devotional images, medals, and engraved gems or cameos, to name but a few. But even as late as 1600, larger-scale artistic

commissions were typically for static or fixed works, tailor-made for their given location. And Renaissance artists never lose their traditional skill in making images respond to their given physical and cultural environment.

Rogier's altarpiece was primarily intended for registered painters working in the city of Brussels, as the focus for their prayers when they took the Mass. With this audience in mind, it offers a reflection on the ideal painter's identity or role. St Luke was accepted as the patron saint of painters across Christian Europe because he had, according to legend, painted the Virgin's portrait. In Rogier's altarpiece, the saint is featured as a sacred representative of the painter's profession. His reverent figure, at work on a drawing, formed the visual focus point for all members of the guild as they joined together in prayer. St Luke was their proxy in the painting and also their intercessor with the Virgin and Christ. As we noted above, the painter-saint has a portrait-like quality. His characterful head, like the contemporary tools of the trade in his hands, has suggested to many that Rogier here depicted himself.

The self-portrait idea cannot easily be verified, given that we don't really know what Rogier looked like. But it is clear that his St Luke appears very much like a typical fifteenth-century Flemish painter. The attentive figure enjoying such close intimacy with the sacred ones also helps us to understand something about the religious role of painters in the period. Having entered into the Virgin's hallowed space the painter-saint falls devoutly to his knees. Despite the fact that he shares the Virgin's colours and that her drapery flutters up toward him, as if to sanction his presence, his gaze doesn't quite find its sacred object. This lack of direct eye contact may reflect the accepted idea that St Luke painted his inner visions rather than Mary herself. But it also conforms to an important visual convention in sacred painting across Europe in the period that helped to distinguish the main religious actors from their lesser devotees. Even

the powerful Chancellor in van Eyck's *Rolin* painting is not allowed to meet the eyes of the Virgin and Child before him.

The experience of the divine in Rogier's altarpiece is a matter of something unseen yet intensely present. And this is in keeping with the many other indications of another world hidden just beyond the perceptual or material one described in the painting. From his inner vision, then, rather than directly from nature itself, the painter St Luke makes a preliminary design. In many other depictions of this subject Luke is shown already at work with his colours on a painting. But in this example, we are returned to the very first stages of the creative process, when the idea of the subject first enters the artist's mind. Rather than being shown at work he pauses, as if to better experience his sacred vision.

It is here that we can understand something of the role of the fifteenth-century religious painter: he was seen as a privileged intermediary or interpreter, who gave visual shape to the inner world of religious experience. Following St Luke, he gave form to his sacred visions. But these inner visions inevitably took on familiar forms and colours, for it was vital to the process that they could be easily recognised by contemporary viewers. They were familiar not only from the words of sermons, from texts such as the Bible or other devotional literature, but also from existing examples of sacred art. It is no accident that in Rogier's altarpiece the Virgin and Child are shown in conventional fashion, linking his work to that of earlier artists.

In the works discussed so far we have seen a new cultural move toward portraiture. If, in the *Arnolfini portrait*, social status and material wealth are 'justified' by sacred symbolism, then Rogier's painting owes its entire meaning to the idea of portraiture: after all, it shows a religious portrait being made. Our two examples illustrate the two major picture types commissioned in fifteenth-century Flanders (portraits and altarpieces) and indicate their especially close relationship in the period. Given this

overlap, it is clear that the move toward the real cannot simply be considered as a secularising one, or that concern with the sacred necessarily limited the description of nature. More essential to Flemish art in this period is the lack of tension between realism and religious meaning, between the seen and the unseen. Flemish artists typically resolve conflicts between such potentially contradictory dimensions of life, and thus produce works governed by an underlying sense of harmony.

A new kind of religion?

This confident accommodation of secular and sacred in Flemish art was not destined to last forever. The relocation of familiar sacred figures to non-church settings reflects the spread of a newly intense kind of religion across northern Europe in the fourteenth and fifteenth centuries, one typically practised by laymen in the privacy of their homes. Despite its liturgical-style furnishings, the room containing the Virgin in Rogier's painting is more like a private house than a church. St Luke is shown alone in an isolated interior, his intimate and direct relationship to the Virgin and Child suggested by his qualities of rapt attention and active spiritual engagement.

The power and purity of Luke's inward vision is indicated by his separation from the doings of the outside world glimpsed in the low-lying landscape beyond. This physical isolation becomes a figure or metaphor for the interiorised religion he experiences. And this kind of active and personalised engagement with Christ was advocated in much-read devotional books such as Thomas à Kempis's *Imitation of Christ* of c. 1412–14 in the spiritual tradition known as the *Devotio moderna* (see box on p. 20). By the time of the Protestant Reformation, from the 1520s onwards, such an individualised form of religion would feed a less harmonious view of the relations between 'world' and 'spirit': one that

saw the two dimensions as in a state of inevitable conflict or contradiction (see chapter 5).

DEVOTIO MODERNA

Devotio moderna (a Latin phrase meaning 'Modern devotion') was a religious or spiritual movement that developed, especially in the Low Countries, from the late fourteenth century onwards and was focused on private devotion practised by the laity. Leading proponents such as Geert Groote (1340–84) and Thomas à Kempis (1380–1471) laid particular emphasis on the worshipper's personal understanding of Christ, and also stressed the importance of private meditation. The lay *Devotio* tradition, widely practised in the Flemish towns, was never intended to destroy the established church. But it is none the less often understood as a kind of precursor to the Protestant Reformation of the early sixteenth century. Like the later Reformers, followers of the *Devotio moderna* (e.g. The Brethren of the Common Life) advocated a purified individualised approach to religion, constant reading of the biblical text, and a direct approach to God based on intense faith.

Another work from Flanders that may have been influenced by the *Devotio moderna* tradition is the *Portinari altarpiece* (c. 1475, figure 2) by Hugo van der Goes, the leading painter of the later fifteenth century in the Flemish city of Ghent. The Nativity in the central panel is shown as an 'Adoration of the Child', an iconography which became popular as a result of a much-read passage in a devotional book describing the visions of St Brigit of Sweden (1303–73). Brigit saw the Virgin kneeling in prayer before the baby Jesus, 'lying on the ground naked and shining'. In van der Goes's painting the internal light (symbol of divinity and purity) is indicated by stylised strips of gold emanating from Christ's body. But it is never quite allowed to overturn the natural light of the wintry northern sky that extends across the three panels of the altarpiece.

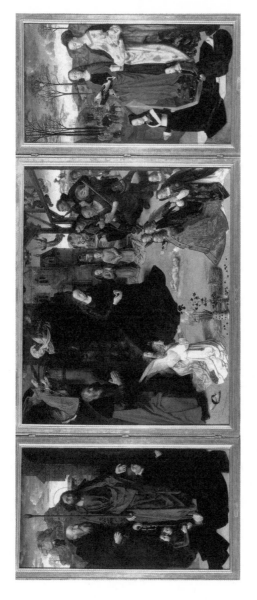

Figure 2 Hugo van der Goes, *Portinari altarpiece*, c. 1475, Florence, Galleria degli Uffizi © 1990. Photo Scala, Florence – courtesy of the Ministero Beni e Att. Culturali

The more general emphasis on quiet prayer in this work might also reflect the *Devotio moderna* tradition, but the connection cannot be pushed too far. Hugo imagined, not an isolated experience, but a whole community of worshippers engrossed in the vision before them. A wide semicircle of figures gather around the tiny baby on the ground, but the full circle can only be completed by a group of spectators praying before the painting. The repeated depiction of praying hands, some of which point directly to the vulnerable little form on the ground, indicates the kind of devotional activity that is also required of us, the viewers.

In Flemish painting Christ is often a surprisingly un-heroic figure: in Rogier's *St Luke* altarpiece he is a slightly emaciated, physically awkward baby, whose stick-like limbs seem to twitch and stiffen in an odd way as if in response to some idea about his own forthcoming death. The figure at the centre of van der Goes' *Portinari altarpiece* is similarly unimpressive. His tiny inert form makes a sharp contrast to the bulky ones that surround him in worship. As in many religious images of the Renaissance, we are encouraged to see the present scene depicted in relation to others in the Christian story.

In this example, Christ's deathly appearance, like his nakedness, reminds us of the moments after the Crucifixion, when he lies dead beneath the cross, or is entombed. Given that Hugo's *triptych* is an altarpiece this narrative connection undoubtedly had a further significance. It makes us aware that Christ is God's sacrificial offering to men on earth. An emphasis on Christ as sacrifice is the norm in Flemish altarpieces, which were, after all, works made to support the ceremony of the Mass enacted at the altar table below. The horizontal presentation of Christ's body may have been intended to replicate the raising of the Eucharistic host by the officiating priest.

The pathetic baby dominates the entire altarpiece, his sad fate setting its mournful contemplative tone. If, in Rogier's *St Luke*,

the Virgin is prominent, in the *Portinari altarpiece* she is secondary, as is suggested by her retreat from physical intimacy with her son. But her position also perfectly expresses her place between man and God, one that would have been immediately understood by worshipping viewers in the fifteenth century. She is shown as the 'Madonna Mediatrix', the motherly mediator between the secular and divine worlds. She kneels on the ground in a posture familiar in many other paintings of the time (both Flemish and Italian) to suggest her quality of humility, her total subservience to God's will. As a divine figure herself, she understands the ultimately joyful redemptive meaning of Christ's birth.

But it is her motherly feelings that are most stressed, her downcast gaze revealing inner emotions of sadness and loss. Her action makes her chief mourner, connecting her directly with all the others depicted in the three panels that join her in prayer. The two sides of her future experience regarding her son are suggested again by the presence of the fourteen winged angels who cluster around her, mimicking her kneeling and praying actions, hovering in space, or sitting poignantly on the cross-like stable beams at the upper right. Though it isn't possible to distinguish happy from sad among them, it is very likely that these angels symbolise the Virgin's seven joys and sorrows. This was a popular way of drawing together key moments in the often told story of her life (the so-called 'Life of the Virgin') that had been established as an official festival of the church by the Synod of Cologne in 1423.

The Renaissance artist's freedom

If the subject-matter of van der Goes' painting is traditional enough, its style is less so. The painter employs a broad sweep of *chiaroscuro* which generalises surfaces, highlighting certain

forms at the expense of others. The large areas of dark shadow at the left of the central panel, for example, allow the bulky praying form of St Joseph (and the ox and ass behind him) to loom out of the darkness in a manner that is closer to Leonardo da Vinci than earlier Flemish painting. It is unlikely that Leonardo was an actual influence, yet the *Portinari altarpiece*, painted in the mid-1470s, was destined for Florence, the Tuscan city where he was already working. Painted in Ghent, the triptych was commissioned by Tommaso Portinari, a Florentine banker who had worked in nearby Bruges for more than forty years. As with the *Arnolfini portrait*, the international dimensions of this Flemish work are clearly apparent.

Portinari's commission to van der Goes was dependent on the fact that he had spent most of his life in Flanders. He also commissioned works from the Bruges painter Hans Memling (1430/40–1494), showing that he had developed a specific taste for the realism of Flemish art. The confident placement of a huge Flemish triptych in a prominent Florentine church is a sign that the gap between the Italian and Flemish schools was narrowing. In the final quarter of the fifteenth century, art became increasingly international, as artists and patrons travelled more extensively, and means of communication became more reliable and sophisticated. The altarpiece is further evidence that leading Italian patrons of the fifteenth century did not make the kind of negative judgements against northern art that later became common.

The two wings feature careful portraits of the patron and his family, who kneel and pray to Christ. Portinari and his elder son Antonio are joined by their name (or onomastic) saints, Thomas and Anthony, who also protect Pigallo, the younger son. In the opposite panel are Tommaso's wife, Maria Maddalena Baroncelli, and daughter Margherita alongside their name saints, Mary Magdalene and Margaret. The presence of portraits of the patrons

in large-scale altarpieces was well established in Flemish painting, and is another example of the overlap between portraiture and religious art noted earlier. In the *Portinari* painting, the patrons' position in the wings and small scale establishes their relatively lowly place within the sacred order, though of course their very inclusion in the painting represents an extraordinary privilege.

The variation of sizes between secular and sacred figures establishes a hierarchy of importance in a way that is quite traditional in sacred art: even a very progressive painter such as Hugo took careful account of older artistic conventions. But in the central panel he manipulated scale, space, and position with much more freedom. In van Eyck's *Ghent altarpiece* the sacred figures in Heaven are raised to the upper part of the picture field and are enormous by comparison with those on earth below. Hugo simply abandons this kind of top-down hierarchy, making the smallest and least impressive visual form into the figure of greatest significance.

This inversion of the usual arrangement has a theological meaning, illustrating the essential contradiction of the Christian story, whereby the all-powerful God humbles himself by taking on frail human form. The idea that the birth of Christ overturned all existing hierarchies and expectations to stress a new moral value of humility is reinforced by the placement of the lowly shepherds so close to him. Their crude bulky forms jut forward toward Christ as if to show an especially close connection. The shepherds' treatment reveals the painter's free approach to the space in his picture, which is manipulated at will and as expressive need arises. As we will see in the following chapter, this 'subjective' approach to perspective space was very different to that used by Italian painters in the same period.

Hugo treats the shepherds' depiction carefully, emphasising their role as symbols of Christ's humility. Their coarse

features are closely individualised and they have dirty hands with thick stubby fingers. The contrast of their rough limbs and ruddy physiognomies with the pale and delicate figures of the angels nearby, or with the Virgin herself, is very deliberate. We noted earlier that a play between realistic and more stylised Gothic elements is typical of many fifteenth-century Flemish paintings. Hugo knowingly manipulates different styles to create new expressive effects, allowing different artistic languages to collide. Further stylistic contrasts within the work are provided by the massive figures of Joseph and the other male saints and the documentary-style donor portraits.

Lowly social types such as shepherds do not often appear in earlier Flemish art, where realism is limited to the close description of exclusive interiors. In keeping with the outdoor setting, Hugo introduces a new rural note that was destined to have a long afterlife in northern Renaissance art (see plate 4). This sense of the countryside is also evident in the tiny vignettes showing earlier moments in the story of the Nativity placed in the landscape background. His altarpiece coincides with the rise of small prints on paper (primarily *woodcuts* and *engravings*) that often showed everyday scenes from contemporary peasant life. These low-life *genre images* were increasingly used by sixteenth-century painters across northern Europe to situate their art in the here and now.

Hugo's play with space and scale, like his free combination of different styles, is ultimately used to reveal Christ's humility. But the boldness with which he overturned expectation suggests that leading artists of the later fifteenth century now had more expressive freedom. Hugo's preference for the visually unusual looks to the future rather than the past. The same kind of pointed confrontations of secular and sacred, ugliness and beauty, low and high, became a marked feature in the work of many later masters in northern Europe. Having said this, it is also

true that his very modern visual and conceptual juxtapositions still served a more traditional purpose.

Standing before the *Portinari altarpiece* it is hard to escape the sense that the *triptych*, like many Flemish religious paintings before it, arrives at a resolution of opposites. The bringing together of donor portraits, monumental saints, the beautiful Gothic Virgin, and a group of crude and earthy shepherds creates a sense of the wider viewing community, one made equal by their shared devotion to Christ's sacrificial body commemorated at the Eucharistic ritual of the Mass. The low take their rightful place alongside the high within the charmed semicircle, the half-formed shape that can only be completed by the viewers gathered before the altar.

Flemish art as Renaissance

Is it fair to describe the Flemish works discussed in this chapter as 'Renaissance'? Renaissance means rebirth, referring to the revival of the art of classical antiquity which had been forgotten in the so-called medieval, 'middle' or 'dark' ages. If artists such as van Eyck, van der Weyden and van der Goes had no concern with the classical models, then it may seem mistaken to insist that their works were part of the movement. But Flemish art did become very lifelike in the fifteenth century, more so even than the classicising art of Italy in the same period. In this way, at least, it fulfilled one of the basic principles of Renaissance art.

Free from the classical past, Flemish artists were able to make a more direct approach to the real world of appearances, one that put them (albeit briefly) in front of their southern counter-parts. Their art found its perfect medium in the translucent tones of oil paint, which did not take on in Italy until the 1470s. But it would be a mistake to assume that Flemish art was simply or naively 'realistic'. If their figure-types reflect the older

stylisations of Gothic art, so their apparently natural-looking settings are underpinned by more conventional religious meanings. As we will see in the next chapter, expression of sacred meanings was equally central to the art of fifteenth-century Italy.

2

Christianity and classicism: early Renaissance art in Florence

It may be no accident that the place in which Renaissance art first took root in Italy was a large trading town dominated by powerful merchants. To this extent, at least, Florence was comparable to the Flemish towns discussed in chapter 1. Conveniently situated on the banks of the river Arno in Tuscany in upper central Italy, the city was already famous as a vibrant mercantile phenomenon in the medieval period. In the centuries which followed, Florence became the home of the modern banking system, and thus played a central role in the development of early modern capitalism. Up until the 1530s, Florence was run as a commune, governed not by a prince, lord, or court, but by trade guilds of elected citizens. Florentines were intensely proud of the independence and freedom of their Republic, and these qualities fed into the vibrant local tradition of art that developed in the city.

In the early decades of the fifteenth century, this tradition underwent a marked change, as leading painters, sculptors, and architects embarked on a revival of the artistic values of classical Greece and Rome. From this time onwards, artists frequently used forms based on lifelike antique sculptures and architecture to vivify their work. In this chapter, we will see how Masaccio

(1401–28) and Donatello referred to classical sculpture in treating Christian subjects, and how Sandro Botticelli (1444/5–1510) went a step further, attempting to re-create the appearance of a classical painting.

However unlike they are in appearance, the Italian works discussed in this chapter, like the later ones discussed in chapters 3 and 6, take for granted a basic familiarity with the artistic vocabulary of classical art. This pervasive classicism was not prescriptive in kind, and did not always (or even typically) involve literal copying from surviving examples. Even when a specific classical model is quoted, the Renaissance artist confidently transforms the source, creating a work which is self-consciously new. Moreover, Italian Renaissance artists' idea of 'the classical' was different from our own more accurate, historical, or archaeological view. Even after the rediscovery of antique *grotesque* decoration in Rome and Naples around 1500, artists still had little idea of how a classical Greek or Roman painting really looked.

In classical art, the human body plays a central role, and a similar focus is apparent in the Florentine works discussed in this chapter. As a result, these artists paid relatively little attention to the surrounding environment that so interested the Flemish painters. They were very interested in the nude, an artistic theme that was destined to play a central role in Renaissance art. Interest in the nude is sometimes seen as reflecting the emergence of a more 'scientific' or secular approach to art in Florence. With its carefully plotted perspective space and proportionate human figures, Florentine art certainly moved closer to the objective and measurable reality of nature.

Florentine art of the fifteenth century, or *Quattrocento*, is characterised by qualities of clarity and order that have often led to it being likened to mathematics and rhetoric, disciplines that also generated great interest in this period. Yet two of the three works discussed in this chapter have traditional religious subjects,

a balance that accurately reflects the continuing hold of Christianity in Florence. It is also surprising to find that the Christian works by Masaccio and Donatello are decidedly more realistic than Botticelli's direct attempt to re-create a pagan classical painting.

Botticelli's example will, though, allow us to note the new connection of visual art with the world of poetry and philosophy in the Renaissance. This more educated world was dominated by literary humanists, those university-trained scholars and intellectuals busily engaged with the recovery and interpretation of the half-forgotten Greek and Latin texts of ancient Greece and Rome. As the fifteenth century wore on, a taste for all things *all'antica* emerged in Florence particularly in the circle of the leading Florentine family, the Medici.

Renaissance perspective in the service of God

A good place to begin a discussion of Florentine Renaissance art is with the famous cycle of paintings by Masaccio of 1425–8 in the Brancacci Chapel in the church of Santa Maria del Carmine (plate 2). The accuracy of the perspective in these paintings is immediately striking, and shows that Masaccio took a keen interest in the new ideas about pictorial space that were circulating in Florence early in the fifteenth century. The architect Filippo Brunelleschi (1377–1446), who was responsible for raising the enormous masonry dome over the city's cathedral, also produced two perspective panels recording with scientific precision the appearance of receding architectural forms on a flat surface. And in 1435 Leon Battista Alberti (1404–72), a university-educated humanist, published *On Painting*, a short but revolutionary treatise addressed to painters which further developed Brunelleschi's ideas.

Alberti outlined in simple mathematical terms the way to plot forms on a perspective grid disappearing to a central *vanishing point*. In place of the intuitive or casual approach to space evident in much Gothic art (see box on p. 2), Alberti advised painters to use a rational and consistent perspective based on horizontal and vertical lines. This kind of linear perspective would allow the size of the main actors in a painting to be accurately calculated in accordance with their given distance from the picture surface. This more tightly controlled perspective space had, in fact, already been employed in Masaccio's Brancacci paintings, where the figures are set firmly on a clearly established ground which recedes convincingly into depth from the lower foreground edge. This ground provides a stage-like space for the dramatic action, as well as suggesting continuity between the picture space and real space of the chapel beyond. At the same time, each scene is dominated by powerful human actors. Gestures and movements are used sparingly, and in a way that reminds us of performers in the theatre or in public debates. Their actions make clear what is happening in each story and tell us about the emotional response of those concerned.

Masaccio's pictorial approach draws attention to his subject-matter, indicating that it is deeply serious and of great importance. In the upper central scene, known as the *Tribute Money*, a Roman tax collector approaches Christ and his Apostles to demand tribute to Caesar. In reply, Christ tells St Peter to get the required coin from the mouth of a fish in the Sea of Galilee and so demonstrates the higher authority of God. With an unerring sense of the dramatic narrative, Masaccio places the confrontation between Christ and tax collector right at the centre of his composition. However, Christ's glance and gesture deflect our attention to Peter at his right. While Peter's own action mirrors that of Christ, suggesting his obedience to his master, the sharp twist of his head toward the tax man and his fierce confrontational glance express a moment of intense inner conflict.

Such indications of immediate psychological reaction, and thus of the humanity of the biblical actors, are typical of Masaccio's work and indeed of many other Renaissance paintings. It is no surprise that Alberti identified the painter as part of the Florentine avant-garde – Brunelleschi and the sculptors Lorenzo Ghiberti (1378–1455), Luca della Robbia (1399–1482), and Donatello were mentioned too – busy reviving visual art in keeping with 'our most vigorous antique past'. But just how 'antique' is Masaccio's approach? And is it true that his innovations served the scientific and secular spirit of the Renaissance, as is often assumed?

A wider view shows that the kind of optically accurate perspective promoted by Alberti and his Florentine friends is not really a feature of classical art, and that it did not consistently take on in the Renaissance. Even in Masaccio's Brancacci paintings, the sense of pictorial space is generated more by the massive three-dimensionality of the figures themselves than by Albertian principles. The painter used perspective to focus his viewer's response on the Christian stories, rather than as a display of his scientific knowledge. We have seen in chapter 1 how the realism of the Flemish masters typically served a similar religious purpose. It is no accident that in the *Tribute Money* the vanishing point of the perspective scheme is in the immediate area of Christ's head.

The Renaissance nude

The relationship of Masaccio's works to the 'antique past' is equally difficult to establish. The painter actually had no idea what classical paintings looked like. While many remains of ancient buildings and sculptures had survived, the same was not true of paintings. It was only in the eighteenth century that the excavations at Herculaneum and Pompeii revealed the true

appearance of such antique works, and inevitably they looked rather different from Renaissance paintings such as Masaccio's. Having said this, in the *Expulsion of Adam and Eve* on the upper part of the left entrance pier (plate 2), the bodies of the two figures are pioneering examples of the full-length nude, an artistic theme that was central to classical art and became widely established in the Renaissance (see figures 3, 4, 7 and 10 below and plate 3).

Given the prominence of such nudes in classical art, it may seem that this scene provides hard evidence that Masaccio took his cue from the antique. Eve's form, in particular, is clearly based on a well-known sculptural type in Greek and Roman art: the so-called *Venus pudica*, which Masaccio may have known from surviving examples in Italy (see box below). In these antique works, Venus is typically shown standing in the nude,

VENUS PUDICA

The earliest known version of the Venus pudica or 'modest Venus' is the so-called *Aphrodite of Cnidus*, a work of the fourth-century BC Athenian sculptor Praxiteles. In this sculpture, Aphrodite or Venus, shown just after she has bathed, covers her groin with her right hand, seeming to acknowledge that she is being watched. In later versions, such as the *Medici Venus* (first century BC, Florence, Galleria degli Uffizi) and the *Capitoline Venus* (2nd century AD, Rome, Capitoline Museums), the goddess also covers her breasts. Praxiteles' lifelike work was famed in antiquity for its beauty, and was copied (with many variants) by later Greek and Roman sculptors. The original, however, has not survived. Italian Renaissance artists knew a number of variants, especially the *Medici Venus*, or others similar to it. The 'modesty' of the type, as has often been noticed, is fairly superficial, with the movements of the goddess's hands serving to draw the viewer's attention to the erotic regions of her body.

though her hands move to cover her breasts and pubic region. In Masaccio's painting, the modesty of the pagan goddess of love is translated with little difficulty into the shame of the fallen woman of the Bible. This kind of visual quotation from a famous classical sculpture soon became a common habit in Italian art, one that also extended to northern Europe from around 1500 onwards.

Masaccio's particular interest in the freedom of movement found in many classical sculptures is also evident in the figure of Eve. Comparing her form with the *Venus pudica* type, it is clear that Masaccio has just slightly extended the classical *contrapposto* pose of the classical model toward a more natural effect, so that his figure now appears to walk. Yet despite these connections, Masaccio makes a very dramatic and telling departure in treating Eve's facial expression. An uncontrolled open-mouthed wail of horror distorts her face in total contrast to the classical Venus type, who is the epitome of composed elegance and beauty. The bodies of Adam and Eve are bathed in a cold light that makes them appear naked rather than nude; it exposes the imperfection and frailty of their bodies rather than showing off their physical beauty or perfection. This harsh light appears to come from the judgemental all-seeing God himself, revealing his intimate knowledge of the first humans' sinful nature.

If Eve cries out in response to its penetration, Adam can only hide his face. Masaccio was not interested simply in reviving the harmonious naturalistic ideals of the classical past. The new pictorial realism in Florence used elements from the art of antiquity to intensify the traditional Christian message, to make it more understandable in human or 'naturalistic' terms. But why include a scene from Genesis in a programme otherwise devoted to the life of St Peter? The sheer size of the figures draws further attention to this strikingly realistic image, as if to highlight its special significance.

The entire cycle emphasises the innate sinfulness of mankind and our need of the Christian church for redemption. St Peter, the leading Apostle and founding father of the Roman church, had himself denied his master three times, and is thus the ultimate example of the reformed sinner, who now goes about Christ's work. But his sinfulness, like that of the rest of humanity, was itself a direct result of the fall from grace of Adam and Eve in the Garden of Eden. Placed at the chapel entrance, the *Expulsion* scene becomes the thematic lynchpin of the entire cycle, its psychological realism showing the viewer's intimate connection with Adam and Eve. If Masaccio's art is here at its most realistic, then this is also the point at which the central Christian doctrine of Original Sin is most explicitly stated. In Masaccio's hands, the new realism of Renaissance art serves a traditional message, reminding us of the uncertain future of our souls in the penetrating light of God's judgement.

The continuity of Renaissance art with the medieval past

Masaccio's medium in these paintings is *fresco*, a type of painting that involved the bonding of pigments with a water-based solution directly onto the wet plaster of the chapel walls. Michelangelo declared fresco, or rather 'buon fresco' ('good fresco') as opposed to that painted onto dry plaster, to be the best painting medium, because it lasted longest and was the most difficult to use. In contrast with oil painting, artists had to work very quickly and with great accuracy in order to complete their work before the given section of plaster dried. They used red chalk *underdrawings* as a guide to outlines, known as *sinopie*, and, by Michelangelo's time, many preparatory drawings on paper.

In part because of the constraints of the medium, frescos typically emphasise clarity of form and outline, rather than the

surface detail and texture found in oil painting. The Brancacci Chapel paintings belong to a long-standing tradition of fresco cycles in Italian churches that was well established in Florence and had few parallels in the art of northern Europe. The use of the fresco medium connects Masaccio's work with the immediate medieval past, as does his depiction of multiple scenes from the life of a saint. Unlike *altarpieces*, religious paintings of this type were not influenced directly by the Eucharistic meaning of the Mass. In Italian fresco cycles, story rather than symbol, narrative rather than icon, had become the norm. The honed economy of Masaccio's style, like his studied commitment to the stories he tells, is not, however, typical of the Florentine fresco cycles of his time. Contemporaries may have seen the Brancacci cycle as a pointed return to the original purity of a decayed local tradition.

In particular, Masaccio's pictorial gravitas revived the style of Giotto di Bondone (1267/75–1337), the famous early fourteenth-century painter who had established the Florentine tradition of fresco painting, and whose works are typified by a similarly powerful integration of medium, style, and subject. In his fresco cycles for chapels in the Florentine church of Santa Croce of 1320–5, for example, Giotto abandoned the elongated forms and flat ornamented surfaces used by many painters of his time in favour of coherent perspective space, rounded human forms, and meaningful dramatic interchange. Giotto had many followers in the century that followed, but among these so-called 'Giottesque' painters few were able to build on the implications of his serious and monumental style. They tended rather to dilute certain of its features with more decorative elements drawn from Italian schools such as that of Siena, or the Gothic imported from France and Burgundy.

Masaccio's art is best understood as an attempt to restore the original intensity of Giotto's manner. But his 'pure' style was not to everyone's liking in fifteenth-century Florence, and relatively few artists in the city followed his lead, finding its rejection of

decorative values and physical beauty too severe. However, as a young apprentice around 1490, Michelangelo made sketches from the fresco cycles of Giotto and Masaccio, and as his style developed it owed much more to the monumentality and severity of these forebears than to the gossipy manner of his actual master, Domenico Ghirlandaio (1448/9–1494). It is hard to view Michelangelo's famous sixteenth-century frescos in the Sistine Chapel in Rome (plate 12) without thinking again of Masaccio's paintings in the Brancacci.

The impact of politics and patronage on Renaissance art

Like the Flemish paintings discussed in the previous chapter, Masaccio's frescos were 'site-specific'. Their subject-matter reflects the wishes of the Carmelite monks who ran the church of Santa Maria del Carmine. A number of them, dressed in their white robes, feature in the *St Peter enthroned as the Bishop of Antioch* at the lower right of our photograph. The Carmelite order had long been a close supporter of the papacy in Rome, so scenes from the life of St Peter, founder of the Roman church, were very appropriate. The subject-matter also neatly reflected Felice Brancacci's own role as a leading diplomat who sought a close political alliance between Florence and Rome. But paintings in side chapels also typically reflect their 'private' status, as places where continual prayers and masses were said for dead members of the families who had bought the burial rights within them. The concern to commemorate the dead is reflected in Felice's decision to honour his uncle Pietro, founder of the chapel in the mid-fourteenth century, by choosing a cycle devoted to his name saint.

Is it possible to go a step further and argue that Felice Brancacci was a particular supporter of Masaccio's manner of

painting, and thus to connect his artistic style with the wider political culture of the time? The idea is tempting, given that Brancacci was a powerful member of a new generation of Florentine merchants leading a revival of the city's economic and social fortunes. Brancacci's commission formed part of the effort to restore cultural prestige and social unity following recent unsettling events such as the so-called Black Death of 1348–9 (an outbreak of bubonic plague which had killed more than three-quarters of the population). The city had also faced a recent challenge to its internal stability when a group of lesser merchants and artisans in the city rebelled against the controlling elite in the so-called Ciompi rebellion of 1378–9.

Noting that Felice Brancacci was from a slightly lower social background than the aristocratic figure of Palla Strozzi, head of the wealthiest family in Florence in the 1420s, Marxist art historians have tried to make Renaissance style a direct issue of social class. In 1423 Strozzi commissioned Gentile da Fabriano (c. 1385–1427) to paint the *Adoration of the Magi* for his chapel in the church of Santa Trinità. With its ornate decorated surface, lack of interest in spatial illusion, and delicate elongated forms, Gentile's altarpiece is, in fact, an example of the continuing taste for Gothic art in fifteenth-century Florence.

Seeking a reason for the co-existence of these different styles, the Marxists pitched Strozzi/Gentile and Brancacci/Masaccio into a class battle, identifying two separate and opposing groups of patrons and artists: the one unreal, refined, elite, and aristocratic, the other real, direct, popular, and middle-class. However, Felice Brancacci became a member of the Strozzi family when he married Palla's daughter, Lena, in 1431. And the supposed separation of artists into opposed camps was equally untenable: Lorenzo Ghiberti, the associate of Masaccio, designed Strozzi's chapel, while Brancacci may initially have commissioned Masolino da Panicale (1383–after 1435), a Gothic painter, to fresco his chapel.

Despite their very different approaches, it seems that Masaccio and Masolino worked harmoniously alongside one other, even combining on individual frescos. All of which suggests that it is unwise to insist on fixed connections between social classes, artists, and styles when interpreting Renaissance art. The demands of powerful patrons often led artists to make politically charged images in the Renaissance. But in the solving of stylistic or technical questions, at least, they were typically left to themselves. The rise and fall of specific families and their leaders were, however, crucially important to the development of Florentine art.

When the powerful banking family of the Medici returned to the city from a short period of exile in 1434, both Strozzi and Brancacci were exiled in their turn. Masaccio had died prematurely in Rome in 1428, but the leader of the newly dominant family in the city, Cosimo de' Medici, was quick to patronise other members of the artistic 'avant-garde' (see box on p. 41). Among them, he forged a particularly close and long-lasting relationship with the extraordinary sculptor Donatello. The immediate closeness of this relationship is indicated by the fact that Cosimo allowed Donatello to live almost rent-free in an old inn that he bought in the year of his return to the city. This was on the site of what was destined to become the Palazzo Medici, the first great example of large-scale domestic Renaissance architecture to be built in Florence (1444–64).

Cosimo's palace was designed by Michelozzo di Bartolomeo (1396–1472) who had shared a workshop with Donatello since 1424–5. The two artists' special relationship with Cosimo did not stop them working for other patrons, but it did represent something of a departure from established traditions of communal artistic patronage that had dominated in the city since the late thirteenth century. As noted earlier, the government of the Florentine Republic was run by powerful mercantile guilds (the

so-called 'Arti') which also controlled public architectural and sculptural projects in the city (the wool merchants, for example, were in charge of improvements to the cathedral). In the early fifteenth century, prominent public sculptures were even commissioned by the so-called minor guilds: the young Donatello produced life-sized marble sculptures for the guilds of the linen-drapers and armourers. But from the mid-1430s onwards, the rapid emergence of the Medici family as the leaders of Florentine society meant that opportunities for more exclusive kinds of artistic patronage emerged.

THE MEDICI FAMILY

The Medici were a Florentine family who rose to prominence in the fifteenth century. Though initially trading in textiles, it was through their banking that they accrued enormous wealth and an international profile. From the mid-1430s onwards Cosimo de' Medici (1389–1464), later known as the 'pater patriae' ('father of the country'), effectively dominated Florentine political affairs, as also the city's cultural and artistic life. Cosimo's son Piero ('the gouty', 1416–69) and grandson Lorenzo ('il Magnifico', 1449–92) followed in his footsteps, being recognised as de facto rulers of the city. Though the family were exiled from Florence in the years 1494–1512 and 1528–30, their inexorable social and political rise was only temporarily interrupted. Lorenzo's son Giovanni (1475–1521) was elected as Pope Leo X in 1513, the first of three Medici popes. From the mid-1530s onwards the Medici ruled Florence as an absolutist court. Cosimo I de' Medici (1519–74) became Duke of Florence in 1537 and then Grand Duke of Tuscany in 1569. In the late sixteenth century, members of the family were in a position to marry into the French royal family: Catherine de' Medici (1519–89) became Queen of France. Throughout the Renaissance period, the Medici were leading patrons of Florentine art and architecture.

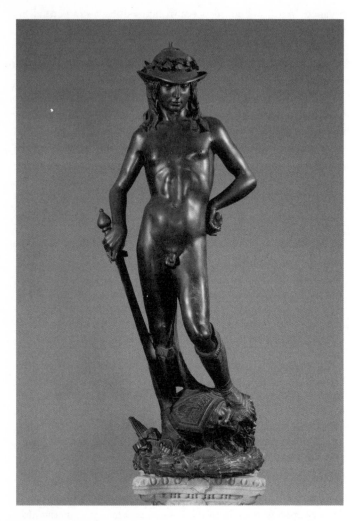

Figure 3 Donatello, *David*, 1460–5, Florence, Museo Nazionale di Bargello
© 1990. Photo Scala, Florence – courtesy of the Ministero Beni e Att.
Culturali

It is in the light of the new possibilities offered by Medici patronage that Donatello's bronze sculpture featuring *David* (probably dating from the early 1460s) is best understood (figure 3). This astonishing work was commissioned, either by Cosimo or his son Piero, to stand on a pedestal in the middle of the inner courtyard of the Palazzo Medici: that is, on the very site where Donatello had previously lived. Transformed into an elegant colonnaded space in the new Renaissance style of Brunelleschi, the architecture of the courtyard made a deliberate contrast with the imposing fortress-like exterior of the Palazzo. Its decoration with large marble medallions above the arcades suggests that the courtyard was seen as a semi-private space in which ornate and expensive decoration reflecting the owners' taste for all things classical was displayed.

These medallions may also give an important clue about Donatello's unusual approach to his *David*: like them, his sculpture brought to mind precious antiques and seems to have been based on a similar idea of unexpected enlargement. If the medallions were amplified versions of the tiny classical gems assiduously collected by the Medici, then the *David* is presented as an over-sized bronze statuette. Cosimo and Piero were among the very first fifteenth-century patrons to collect antique statuettes, while Donatello and Michelozzo were among the first Renaissance artists to re-create the type.

The originality of the Renaissance 'work of art'

Donatello was very alert to the special qualities of his medium in his Medici *David*. The finely chased and polished surfaces of the sculpture attract the light, generating a myriad of slippery reflections to give an effect of alluring liquidity. There is analogy with the feeling of soft flesh in this, but it is conjured out of a

substance that is very unlike the things it represents. Donatello plays on the difference between the dark, hard, and cold metal of the sculpture and its supposed identity as pale, soft, and warm flesh. We are made aware of the supreme artistry involved in this transformation, and this becomes part of our enjoyment of the work.

The process of casting a bronze was difficult, time-consuming, and expensive, at least by comparison with the more commonly used media for sculpture in Florence such as wood, terracotta, or wax; Donatello appears to have left it to specialist founders. But the very difficulty and expense involved gave cast bronze a certain social cachet, as did its antique prototypes. It may have been the *all'antica* qualities of bronze that encouraged Donatello to show a venerated Christian saint as a sensuous nude, in a way that clearly flouted all the expectations. For the first (but not the last) time in this book, we are looking at an object which draws attention to itself as a 'work of art', something to be enjoyed for its own sake, almost regardless of its subject-matter.

It is hard to believe that this playful near-naked boy is David, the Old Testament hero whose defeat of the giant Goliath was a symbol not only of the victory of Christian virtue but also of the Florentine Republic over princely tyranny. Political culture in fifteenth-century Italy involved an on-going power struggle between regimes dominated by individual kings and lords on the one hand (e.g. Naples and Milan) and communally run republics such as Florence, Siena, and Venice on the other. The figure of David served very well as a symbol of Florence, of the righteous victory of the 'little' citizen over the mighty tyrant, and was repeatedly shown in prominent public sculptures commissioned for the city. Indeed, in a life-size marble *David* of 1408–10 for a niche on the cathedral, Donatello had comfortably combined these sacred and civic dimensions, showing him as a fully clothed and dynamic young warrior.

Was the laconic bronze *David* also intended as a heroic sacred figure with strong patriotic overtones? An inscription once attached to the base of the sculpture announced that 'the victor is whoever defends the fatherland. God crushes the wrath of an enormous foe. Behold! A boy overcame a great tyrant. Conquer, O citizens!'

Another Donatello sculpture showing *Judith and Holofernes* was also placed in the grounds of the Palazzo Medici and was supplied with a similarly stirring inscription. If these tags are to be believed, the two bronzes were seen in an orthodox light, as illustrating the victory of the weak over the strong in the name of Christian and republican humility and virtue. But the Medici themselves had their own private, potentially tyrannical agenda, and were shortly to become the de facto princely rulers in Florence. If the patriotic inscriptions on the sculptures they commissioned trumpeted their traditional political allegiances, these can hardly be taken at face value. Perhaps the inscriptions were placatory: added to reassure doubting rivals about the family's on-going commitment to the Republic. But if the stern *Judith* more or less confirms this propagandistic message, the same cannot be said for the *David*. Its unusual appearance reveals much about the Medici's ambiguous position in Florence.

The nudity of the bronze *David* must reflect the developing taste for classical art among the Medici-dominated social elite in Florence. But part of the thrill and danger of the sculpture lies in the directness of its realism. It is no pallid or clichéd re-creation of an antique type. Donatello presents us with a much younger boy than in his marble *David*, one who is barely able to raise the heavy sword with which he has severed Goliath's head. His slight half-formed limbs have not yet taken on the key quality of masculinity which defined the ideal nudes of classical sculpture. It is telling that when later Florentine sculptors such as Andrea del Verrocchio (c. 1475) and Michelangelo (1503–4) returned to the theme, they quickly

re-introduced the *all'antica* martial tone so disturbingly missing in Donatello's work.

The more usual stress on physical and moral strength is replaced by a teasing androgynous sensuality. Many possible reasons for this have been suggested. It is sometimes said that Donatello showed himself as Goliath crushed beneath the alluring boy's feet, referring to his homosexuality. Or perhaps this self-portrait refers simply to the victory of youth over age, the way in which the one effortlessly crushes the other. Such an idea would take on added poignancy if the sculpture dates from Donatello's own old age. It has even been suggested that the sculpture does not show David at all, but rather the pagan god of springtime, Mercury; or again that David *is* shown, but in the guise of Eros, the classical boy-god of love.

This last interpretation has some credibility given that Cosimo de' Medici founded a learned academy in Florence devoted to the study of Plato and his followers, and to the application of their pagan ideas to the Christian world. In the opinion of these philosophers, physical beauty (and the love that it engenders) is the only means by which the divine spirit manifests itself in the world: perhaps Donatello's 'beautiful' *David* is best understood as a Neo-Platonic allegory of the victory of heavenly love? But however persuasive such theories appear, it may be that we should finally resist the temptation to supply a single meaning for Donatello's *David*. The qualities of ambiguity and open-endedness are its fundamental characteristics.

It is a work which plays with established categories but does not allow any one of them to be finally victorious. Whether it is seen as expressing the Christian and patriotic values of the Florentine state, as pandering to the refined *all'antica* tastes of the Medici, or the private ones of the artist himself, the *David* seems wilfully to confuse or undermine expectations. Overlaps in meaning are essential to it, revealing a new kind of freedom that emerged in the fifteenth century, not only in Florence but

elsewhere too. Leading artists now felt empowered, with their art-loving patrons' consent, to invent new kinds of work that very deliberately departed from all those that had come before. The *David* is an early proclamation of the artist's right to individuality, one that was to find many echoes in Renaissance art.

Renaissance painting as visual poetry

According to an early report, as young men Brunelleschi and Donatello took a trip to Rome to study examples of antique architecture and sculpture. Whether or not this really happened, the story suggests that the revival of antique art in modern form was becoming a kind of cultural 'must' for Florentine artists of the fifteenth century. But, as we have seen, no classical paintings were known in this period. There were, however, tantalising descriptions of such works in books by classical authors such as Pliny the Elder, Philostratus, and Lucian. In universities and elsewhere, literary humanists pored over these texts, and published new and corrected editions of them. Here, famous painters of ancient Greece such as Apelles were praised, and their works evaluated and described. But though the alluring idea of re-creating these lost works was already central to Alberti's *On Painting* of 1435, it was not until the 1470s that cultural conditions in Florence were right for the dream to be realised.

The examples of Florentine art examined so far have traditional Christian subjects, even if they have a classical look. It is sometimes thought that mythological art – subjects taken from the myths of pagan antiquity – simply replaced religious art in the Renaissance. But throughout the period mythological art remained a minority taste, closely tied to Europe's social elites, or to specific royal, princely, or courtly patrons (see figures 10 and 11). Unlike Christian art, much of it was on a small scale,

occurring in less mainstream genres and media, and was made for display in domestic interiors where it was rarely seen by the wider populace.

Even in Florence, the European city where such *all'antica* tastes were most highly developed in the fifteenth century, a vigorous communal culture founded on public piety and republican political values remained dominant. Alberti's bold proposal that the ideal painting (the 'istoria' or *history painting*) should be like classical literature or poetry, that it should feature the same pagan subjects, and that it should be created under the direction of learned humanists like himself remained largely unanswered until the final quarter of the century. By this time, Florence was dominated by Cosimo de' Medici's grandson, Lorenzo 'il Magnifico' de' Medici, a learned sophisticate and skilled poet who ran a 'court' within a city whose republican traditions had become a matter of mere outward form.

It was in this elite context that the painter Sandro Botticelli created a series of mythological paintings for Lorenzo's family which were unprecedented in size and complexity. In his *Birth of Venus* (plate 3), which probably dates from the mid-1480s, Botticelli produced a work which was as far from Masaccio's puritanical severity as it was from Donatello's heady mix of sensuality and religion. Here we see the classical goddess of Love being born from the sea, blown ashore by the west wind Zephyrus while Flora, another harbinger of spring, prepares to wrap her in a flowery cloak. Unlike many of the fifteenth-century works discussed so far, the painting reveals a striking lack of interest in natural appearances. Botticelli uses flattened and elongated forms for his figures, and is not concerned to depict features such as the sea or trees with any accuracy. His non-realistic approach is sometimes seen as a revival of the Gothic style. But Botticelli's wilful departures from reality go further, creating a parallel world which is purer and more beautiful than the one we live in.

Botticelli brings a fifteenth-century kind of sophistication to this visionary project. Like Masaccio before him, he pointedly references the classical *Venus pudica* type in picturing his goddess of love. But the antique model is quoted only to be transformed: her nude body is given impossible proportions (note the length of her neck, left arm and hair). Botticelli ignores the kind of mathematically derived spatial perspective that had so interested the older generation of Brunelleschi and Alberti. The goddess's impossible pose on the rim of an outsized scallop shell is one of the painting's most exciting features, a bold assertion of pictorial or poetic licence.

A close connection with poetry was fundamental to Botticelli's approach, and this kind of association was destined to become a feature of Renaissance art in the following century (see especially plate 9 and figure 11 below). For Botticelli, this meant both ignoring and extending the ideas in Alberti's *On Painting*. If he set aside scientific notions about accurate perspective space and bodily proportion, he was clearly very excited by the idea that a modern painting could re-create the look of those of antiquity. In a painting known as the *Calumny of Apelles*, Botticelli actually attempted to re-create a lost painting by Apelles mentioned in glowing terms by Alberti, who had himself drawn on a description of it in a book by the classical author Lucian.

The connection between painting and poetry had become a kind of commonplace in the refined Florentine circle in which Botticelli moved. In this cultural milieu, the lessons of works by classical authors were eagerly absorbed: the notion that poetry and painting were essentially the same, encapsulated in Horace's famous phrase 'ut pictura poesis' ('as is poetry, so is painting'), was widely accepted. Alberti had advised painters to 'take pleasure in the company of poets and orators, for these have many ornaments in common with the painter', and it seems that Botticelli did just that. Lorenzo de' Medici, and other poets in

his circle, such as Angelo Poliziano (1454–94), would have encouraged Botticelli to make his works appear like visual poems. And the association with learned men also released painters from their traditional humdrum social identity as unlearned artisans in the workshop, suggesting instead that they were learned and literate intellectuals.

This new connection with learning and poetry may have encouraged Botticelli to ignore the literal appearances of nature in favour of more elevated associations. His use of *tempera* to bind his pigments for the *Birth of Venus* signals his distance from the young Leonardo da Vinci, who was experimenting with the naturalistic potential of oils in the same period. In one of his notebooks, Leonardo criticised Botticelli's lack of interest in the close observation of nature, attacking his depiction of landscapes as 'very sorry'. Leonardo (who had also read Alberti) saw painting as a branch of investigative natural science. But for Botticelli the art was closer to poetry, and the abstract and linear rhythms of tempera were better suited than oils to his vision of a beauty that went beyond mere appearance.

Botticelli's use of powdered gold to highlight Venus's hair again suggests his relative lack of concern with realism compared to other Renaissance artists. Alberti and Leonardo came down firmly against the use of gold leaf in their writings, noting that it provided no opportunity for a display of the painter's skills in the imitation of nature. Gold had long been used to symbolise sacredness in medieval painting: in Botticelli's work it likewise gives the goddess's tresses a lustre that points up her supernatural origins. But gold is also a much favoured metaphor in the tradition of secular poetry that followed the work of Francesco Petrarch (1304–74), the Florentine whose sonnets were all the rage in Lorenzo's circle. In this context, Venus's golden hair would have recalled poetic descriptions of the ideal lady Laura, featured in Petrarchan love poems by Lorenzo, Poliziano, and others.

It has been suggested that Botticelli's painting was, like his *Primavera*, inspired by a poem by Poliziano written in celebration of a courtly joust held in Florence in 1475, won by Lorenzo's brother Giuliano. But the works also have an abstract dimension which suggests that they illustrate broader philosophical ideas. Seen together, the two paintings (which were probably pendants) offer a more general Neo-Platonic lesson about the virtues of following the goddess of love. Unlike many later depictions of Venus in the Renaissance, they are not powerfully erotic in tone or presentation. In the *Primavera*, Venus is fully clothed and her posture is tellingly borrowed from a depiction of the Virgin in a contemporary Florentine altarpiece. And despite Venus's nudity in the *Birth of Venus*, the goddess still possesses an air of intellectual or allegorical abstraction.

Though the impact of Neo-Platonism on Renaissance art has been seriously over-estimated, it seems very likely that Botticelli's two paintings reflect ideas borrowed from this philosophy about the twin Venuses: the one of heavenly origin, the other earthly. This idea would have been clearly understood in the Medici circle, among whom philosophising over the significance of the pagan gods was almost an obsession. In the Medici-sponsored academy mentioned earlier, Plato's idea that the physical world was wholly false was softened toward one that allowed the beauty perceived within it to be a sign or spark of the divine. In the *Birth of Venus*, the goddess is shown being born into the world, her pervasive quality of beauty a special sign of her divine origin and status. The nymphs, gods, and personifications who provide her supporting cast have a similar significance, their beautified forms indicating the existence of a higher and purer realm of ideas.

Botticelli's particular approach in his mythologies is a reflection of the interests of the circle of humanists, poets, and philosophers who gathered around Lorenzo de' Medici in Florence in the 1470s and 80s. These interests shaped Botticelli's

pictorial approach as well as the fashionable poetic and Neo-Platonic content of his work. The mythologies' free mix of Gothic and classical references gave perfect expression to the elite world of Lorenzo's 'court', one dominated by philosophising, love poetry, jousting, feasting, art collecting, and lavish marriage ceremonies. But this fragile world of sensual delight and refinement (underpinned by the enormous wealth of the Medici family) created jealousy among the family's rivals in the city. Lorenzo's beloved brother Giuliano was murdered in an attack in Florence cathedral in 1478, and the court quickly crumbled after Lorenzo's own death in 1492. In 1494, the Medici family were exiled from Florence again, to be replaced by a strict republican regime.

It seems that Botticelli himself also revolted against his earlier style in this later period, turning almost exclusively to religious subjects, and developing a plain and severe version of his earlier manner which has been described as a 'maniera devota' ('devotional manner'). This dry, petrified later style may reflect the painter's conversion to the strict moral doctrines of the Dominican monk Girolamo Savonarola (1452–98), who dominated religious life in the city for several years following the Medici's exile (before he ran foul of the city authorities and was burnt at the stake). Botticelli lived on until 1510, but his style was increasingly unfashionable. The two halves of his career, pre- and post-Lorenzo's death, were, though, more closely connected than might appear. His earlier Neo-Platonic mistrust of the real proved fertile ground for the subsequent retreat into religious purity. Leonardo's perception that Botticelli was out of step with the Renaissance exploration of nature was, to this extent, an accurate one.

3

Art and nature: central Italy around 1500

In the decades around 1500, a new generation of Italian artists in Florence and Rome served patrons who increasingly saw art as a means of securing personal and political power in a period of rapid cultural change and vaulting ambition. In Florence, the century opened with the Medici family banished from the city, though they had returned by 1512, and by the mid-1530s had established themselves as unopposed rulers of the city. In Rome, meanwhile, the resurgent Renaissance papacy asserted itself further, as the source of God-given spiritual and temporal authority. In response to the rapid progress of visual art elsewhere in Italy, the popes imported leading artists from Florence and elsewhere to get the message across.

Among artists, the idea that art should imitate nature intensified. Many now trained their young apprentices to make close studies from the nude, while some went so far as to dissect the corpses of criminals in order to learn more about the inner workings of the human body. But alongside this, artists were very aware of the art of the classical past, so that their work often has something of the dignified appearance of antique sculpture. It typically features human figures with perfect proportions in carefully contrived *contrapposto* poses.

So much suggests the continued influence of the fifteenth-century masters. The works of the new generation, dominated

by Leonardo, Michelangelo, and Raphael, owe a debt to the monumental forms and human dignity of Masaccio, reflecting something of his seriousness and heroism. But they are also characterised by a spirit of free experiment and audacious invention that recalls the approach of Donatello. Each work is different from the next, a custom-made creation which draws attention to its uniqueness. And though Botticelli's delicate elongations went out of fashion, the new generation shared his sense of the poetic possibilities of visual art. Their works were typically more scientific in their use of perspective and proportion, but they also moved beyond the close description of the specifics of nature to suggest more universal meanings.

The art of these masters brings together close study of the physical world, predominantly Christian subject-matter, a fully developed *all'antica* artistic taste, and a growing emphasis on originality, in compositions of supreme balance and resolution. It is newly ambitious, both in scale and in expressive scope. This ambition reflects the rising social status of leading artists. Though most continued to be seen (and to see themselves) as artisans, figures such Leonardo, Michelangelo, and Raphael became cultural celebrities. They won international fame as multi-talented inventors, who moved easily between artistic media and centres. Leading patrons clamoured for their services and, aided by the spread of reproductive *engravings* and *woodcuts*, knowledge of their ideas and inventions rapidly travelled far and wide. Their fame and renown fostered the idea that they were extraordinary geniuses, whose talents were God-given rather than learned, and whose works formed a perfect canon for all to follow.

The idea that Italian art had now reached a level of supreme perfection underpins early histories of art, such as Giorgio Vasari's *Lives of the Artists* (1550), mentioned in the Introduction. According to Vasari, Leonardo, Michelangelo, and Raphael took the Italian Renaissance imitation of nature to a new level of perfection. While earlier artists remained tied to

the slavish copying of specific 'bits' of nature, the new genera-
tion moved beyond this piecemeal or literal approach, creating
original forms that were lifelike, yet more perfect than in any
specific example. In works by these artists, Vasari proclaimed, art
had finally conquered nature itself. Many have taken his word
for it, such that the period is still commonly known as the 'High
Renaissance', suggesting that the art produced in Florence and
Rome in the decades around 1500 was simply better than
anything produced before or since. But we must remain very
sceptical about any such evaluation, given that it depends upon
fundamentally debatable ideas about what makes great art.

As was noted earlier, Vasari was a Florentine patriot. Writing
from that point of view, he ignored or denigrated northern
European art, and even that of rival artistic centres in Italy, such
as Venice. But recognition of Vasari's Tusco-centric bias does
not mean that the famous triumvirate discussed in this chapter
were insignificant. Closer concentration on works by Leonardo,
Michelangelo, and Raphael will quickly reveal the quality and
diversity of their contribution to Renaissance art.

The Renaissance artist as scientist and courtier

Leonardo da Vinci's sharp criticism of Botticelli's lack of inter-
est in landscape tells us much about his own artistic personality,
and what he thought art should be. It is clear from the volumi-
nous notebooks that Leonardo wrote throughout his working
life that he saw visual art as a kind of investigative science: as a
suitable medium for the interrogation of the natural world in all
its forms and appearances. Leonardo did not simply continue to
imitate nature in the manner of many other artists in the
Renaissance. He also made something new of the imitative
principle, using it to increase understanding and knowledge such

that his work often anticipates the Enlightenment development of empirical science and technology. His invention of machines such as a submarine and helicopter link him directly to our contemporary world, while his careful anatomical drawings make him a precursor of recent medical science.

Though his machines were never built and his anatomy was often inaccurate, Leonardo's link to 'modernity' cannot be doubted. His use of visual media for such scientific purposes was unprecedented. All the works discussed so far in this book have underlying symbolic and decorative functions, however realistic they may look. But in Leonardo's drawings, in particular, visual art became the tool of a more objective, empirical kind of knowledge, based on what can be seen with the human eye. The phenomena of the physical world are often depicted for their own sake, and the act of drawing made one with that of understanding. Leonardo made careful studies of individual living organisms: a single bulrush or blackberry spray, a bear, a cat; a man's head or arm. But he was also interested in water flow, knots, and human hair. He reveals the intimate connection of these phenomena, using their visual similarity to show their shared condition of organic process and transformation. Nature, for Leonardo, was not set, static, or given: it was in a state of constant motion or flux. But this also provided the ultimate challenge for the visual artist, given that *his* medium was necessarily fixed.

The depth and equality of Leonardo's interest in all things natural were very unusual in Italian Renaissance art, where the human figure and its place in a given story or narrative predominates. It has more in common with northern artists of the period than with compatriots such as Michelangelo and Raphael (see chapters 1, 4 and 5). But Leonardo's artistic personality was far from one-dimensional: it is telling that painting comes far down the list of the skills that he offers to Duke Ludovico Sforza in a letter of introduction to the Milan court in 1481. At Sforza's

court, Leonardo was much preoccupied with designing fortification architecture and armaments, as also with the production of light-hearted masques and other entertainments, though he did also get round to painting some highly finished portraits of beautiful young women. Too much emphasis on the inventor-scientist would obscure the way in which Leonardo deftly suited his work to its given purpose. If the reversed mirror-writing he used on his scientific or diagrammatic drawings suggests that he saw these as containing essentially private, hidden, or secret knowledge, then in a commissioned society portrait or sacred painting his approach brilliantly accommodates the social and religious values of his time.

Many of his paintings recall familiar types in fifteenth-century Italian art. He worked on both small and large-scale *devotional pictures* and *altarpieces*, as well as on patriotic *history paintings* and portraits, proving himself well aware of earlier examples in these genres. His early devotional pictures look a lot like those of his master, the Florentine painter and sculptor Andrea del Verrocchio, while his famous *Last Supper* recalls earlier paintings of this subject in Florentine monastic refectories. On this occasion, however, Leonardo took the extraordinary step of using egg tempera instead of the usual fresco, with disastrous results. Very soon after its completion, the paint started to peel from the wall, and the recent restoration (1978–99) has shown just how little of Leonardo's original work survives.

The Renaissance portrait as an invention of the artist's mind

What, then, of Leonardo's best-known painting of all: the iconic *Mona Lisa* (plate 5), so called after Vasari's glowing description of it in the *Lives of the Artists*? Superficially, at least, Leonardo's

famous work also conforms to type. In the past few decades documents have emerged confirming what had long been suspected: the painting shows Lisa Gherardini, the wife of the Florentine merchant Francesco del Giocondo. After an extended spell at the court of Milan, Leonardo had returned to Florence in 1500, and it seems that the portrait was begun around 1503–4. He was by then a great celebrity, particularly renowned for his portraits of Milanese ladies of the court, such as the *Cecilia Gallerani*. The *Mona Lisa* clearly began as a typical society portrait: a quick pen-and-ink sketch made after it by Raphael depicts it in this light, firming up its outlines and individualising Lisa's face.

But the surface of the picture tells us that it was not painted all at once, or even in the same decade: the *craquelure* on the face and chest is not present on the hands, which may date from a much later period, perhaps after Leonardo's move to France in 1516 to paint for King Francis I. The *Mona Lisa* was still in Leonardo's possession at his death in Cloux three years later and has remained in France ever since. Why, then, was the painting an on-going project, and why wasn't it delivered to Giocondo or his wife like any other commissioned portrait? Setting aside the romantic legends about Leonardo's involvement with the sitter (supposedly referenced in her gentle smile), it is clear that this painting, which began as a traditional portrait, became something else. It may be that the *Mona Lisa* as we see it today is a finished painting: but for a long while in Leonardo's lifetime it remained a work in progress (or better, a work *in process*) which somehow could not be completed.

It was certainly not the only commission that Leonardo failed to deliver: works such as the *Adoration of the Magi* and the *Virgin and Child with Sts Anne and John the Baptist* got no further than the planning stage. Vasari complained that Leonardo's inability to see paintings through to completion was due to his distract-ing scientific studies. But perhaps there was something more

essential about this aspect of his approach to painting. Leonardo wanted to reproduce an effect of the fluid motions and processes of nature in his art, but this stood in a state of tension with the 'fixing' effort of painting or drawing. It became difficult to reconcile his sense of nature as ever-changing flow with the more ordinary craftsman-like requirement for completed or finished works.

The *Mona Lisa* returns us to the picture type with which this book began: it is (or at least initially was) a portrait, and thus reflects Renaissance concerns with the individual. But if the typical portrait of the period offers vivid characterisation, often using bold colours and sharp contour, the *Mona Lisa* presents a more generalised form, whose lack of specific features make us doubt that we see a specific person. Yet this universal quality makes the sitter oddly powerful and attractive; the less that we see, the more we want to know. The added allure of the half-seen was, in fact, carefully described by Leonardo in his notebooks when he advised painters to 'pay attention in the street towards evening, when the weather is bad, to how much grace and sweetness can be seen in the faces of the men and women'. Elsewhere he noted that the 'face depicted with increased lights and shadows acquires much beauty'. He understood that the inaccuracy of human sight opens the door to imagination, allowing the mind to make up the visual shortfall with its own fantasies. In the case of painting, the viewer projects her or his own 'thoughts' or impressions onto those areas which are not clear or defined, and thus bonds with the image.

This subjective or even intimate connection is, in fact, one of the main reasons why the *Mona Lisa* has exerted such a hold over many generations of viewers. By comparison with other Renaissance portraits, Leonardo radically reduces what is given, in a visual (and perhaps also social) sense: everyday objects and surfaces almost disappear beneath the intensified play of lights

and shadows, while the usual references to the sitter's wealth and status have disappeared. Lisa's precise expression must also remain an enigma, given that her facial features are partially obscured by Leonardo's favoured effect of 'smokiness' or *sfumato*. This effect was dependent on the painter's use of oils, which allowed him to blend his colour tones (ochres, russet browns, olive greens, pale pinks, and blues) into one another, so that the outlines of forms dissolve.

His experiments with oils had, in fact started early in his career, in the 1470s, culminating in unprecedented chiaroscuro-based paintings such as the *Virgin of the Rocks*. But the transfer of this kind of approach to portraiture had to wait for the *Mona Lisa*, and then it seems to have proved problematic. As Leonardo put his principle of 'increased lights and shadows' into practice, his work gradually lost its identity as a recognisable portrait of a given sitter, becoming more like an open template for imaginative projection. Loosened from its basis in a bona fide likeness of Lisa Gherardini, the 'portrait' became a free pictorial experiment in the way the visual reductions of *sfumato* open the visual image up to the viewer's fantasy.

Although certain of the conventions of society portraiture remain (for example, the placement of the sitter seated before a window ledge), these are difficult to make out, appearing like the veiled remnants of an earlier, more orthodox composition. In pursuing his interests, Leonardo critiqued the ideas of the earlier generations of Renaissance artists, who had assumed that lines bind human vision together. In the *Mona Lisa*, this so-called linear perspective gives way to a watery miasma of atmosphere, which interposes itself between us and the objects we try to see. Leonardo wrote extensively about the so-called 'vapours' that came between the eye and the thing observed: objects, he noted, lose both definition and local colouration according to our distance from them. In the near distance, they appear greenish, further away they turn brown, and at the horizon they are blue.

The mysterious landscape in the *Mona Lisa* reflects these optical studies. But it is also unusually wild and dramatic, even poetic; we view an uncharted and uncertain terrain dominated by huge rocks and watery vasts. If, in many Italian Renaissance paintings, the landscape provides nothing more than a tame backdrop to the all-important human figures, in Leonardo's work it is expressive in its own right, a mysterious thing of independent power and life. In a number of disturbing drawings from his later period, Leonardo concentrated directly on the ferocious force of nature, depicting violent storms that all too easily overwhelm the earth.

In the *Mona Lisa*, nature is less immediately threatening or intimidating, but is none the less central. Using his tonal approach, Leonardo makes an intimate connection between foreground and background, sitter and landscape, the inner world of 'Mona' and the outer one of unfathomed nature. Her head becomes another mountainous form like those looming in the distance, and the neckline of her dress and wavy lines of her garments are picked up in the flowing shapes of the landscape nearer to hand. These visual connections recall that commonly made by the classical authors between the inner life of the individual and the outer universal one of nature. The relation of microcosm to macrocosm had recently become a great talking point among humanist intellectuals such as the Florentine Giovanni Pico della Mirandola (1463–94), excited by the idea that the infinite variety of outward nature implied similar complexities and depths in the consciousness of individual human beings. It also suggests Leonardo's key sense of the need for the artist to express his creative will or *fantasia* in his work.

Leonardo's criticism of Botticelli's 'very sorry' landscapes tellingly arose during a discussion of what the inventive artist sees in a chance stain on a wall: he can 'seek out in such a stain heads of men, various animals, battles, rocks, seas, clouds, woods … it can mean whatever he wants it to.' When looking at

Leonardo's work we become aware that he actively creates or invents the world he depicts. To some extent, this holds true for many of the artists who feature in this book. Rather than thinking of Renaissance artists as passive observers who simply record what is in front of them, we should see them as involved in a two-way process. Their depiction of natural forms is also an act of creative invention which generates new and unprecedented works, and thus adds to (and changes) 'the world' that is imitated.

Nature versus art: two Renaissance giants

At first sight, the heroic art of Michelangelo appears to have little in common with that of Leonardo. Their meteoric careers overlapped at certain points, especially in the first decade of the sixteenth century. According to a contemporary, the two famous artists, who worked alongside each other in Florence's town hall in 1504–5, developed a 'great disdain' for one another. The two were on different sides in the so-called *paragone* debate; Leonardo devoted many pages in his notebooks to proving that painting was superior to sculpture, while Michelangelo preferred sculpture to any other medium, and was reluctant to paint the ceiling of the Sistine Chapel in Rome because he had originally come to the city in 1506 to make a monumental free-standing tomb for the pope, Julius II. According to an early biographer, the delay and final non-completion of this grand sculptural commission, described as 'the tragedy of the tomb', left a lasting mark on Michelangelo.

If Leonardo thought that the artist had to imitate 'nature' in all its various aspects, Michelangelo was not convinced of this. He reportedly criticised Flemish painters for paying too much attention to landscape, mocking their concern with depicting

the minutiae of nature. His art, on the other hand, is dominated by the human figure, to the exclusion of just about everything else. This focus was, in part, born out of his experience as a young protégé in the intimate circle of Lorenzo de' Medici. In this context, the young Michelangelo would have imbibed Neo-Platonic ideas about the corrupted or illusionary nature of the world as seen. It was only by focusing on beauty that the pure and sacred world of 'Ideas' could be accessed.

The impact on Michelangelo of these early years around 1490 in Lorenzo's Florentine circle was profound: in later life, he claimed that he was taught only in this elite environment, though the records show that he had, in fact, originally been apprenticed in the ordinary way to the popular painter Domenico Ghirlandaio. Michelangelo's disclaimer says much about his concern to distance himself from the traditional artisan culture of the workshop in favour of a more refined and learned one. But if we must doubt early reports such as the one that has Michelangelo sitting closer to Lorenzo at dinner than his own sons, there can be no question that the culture of the Medici circle helped to shape the young sculptor's artistic interests. He even emulated the sophisticated love poetry of his 'master', remaining active in this literary genre for the rest of his life.

Michelangelo's focus on the human form – and more specifically the male nude – also reflects his obsession with the art of classical antiquity. Again, this passion seems to owe an initial debt to Lorenzo's circle: an anecdote describes how Michelangelo's copy (now lost) of an antique marble of an old faun first won him favour with 'il Magnifico'. Significantly, though, this story stresses the young artist's 'victory' over his antique model, his ability to go beyond it in the effect of naturalism. In many of Michelangelo's large-scale marbles, there is ample evidence of a deep understanding of the sculpture of classical antiquity, but also of his greater concern with the physical reality of bodies.

He made painstaking studies of the parts of the anatomy, and he is known to have dissected at least one corpse in order to understand the inner relationship of bone, sinew, tendon, and muscle. But if Michelangelo shared this objective interest in nature with Leonardo, then his concern with Neo-Platonic philosophy, poetry, and antique sculpture made him into a very different kind of artist. And whereas mention of Christianity is largely absent from Leonardo's voluminous notebooks, it formed the other great defining factor in Michelangelo's career. Leonardo made a number of very telling religious paintings, but they are none the less more interesting for their human and natural dimensions than their deep spiritual message. The same cannot be said of Michelangelo's work.

Artist and patron in Renaissance Rome

Even the most renowned artists in Renaissance Italy remained tied to the patronage system, typically making art on commission from powerful patrons whose agendas they were expected to express in their works. These high-ranking patrons were themselves representatives of important political or religious institutions, and of leading aristocratic families. It is hard to disentangle the truth about Michelangelo's relationship with Julius II, the pope from the powerful Della Rovere family, who had lured him to Rome in 1506 to work on his tomb (see box on p. 65). Early accounts talk of a stormy relationship between two Titans, whose fearsome temperaments clashed, but who ultimately recognised and respected each other as powerful equals. The historical reality was almost certainly very different. Though Michelangelo certainly had a temper, he tended to lose it with minor officials, rather than the pope himself.

POPE JULIUS II AND
THE RENAISSANCE PAPACY

Giuliano della Rovere (c. 1443–1513) was elected pope in 1503. Known as *Il Papa Terrible* ('The Terrible Pope'), he was renowned for his fierce temper and driving worldly ambition. Under his rule, the papacy re-established and extended its control over the so-called Papal States in central Italy and thus expanded its temporal interests. Julius's stated aim was to rid Italy of all foreign powers. Against papal tradition and canon law, he grew a long beard and vowed not to cut it off until this was achieved. Julius's belligerent worldly ambition has its context in the previous weakness of the Roman papacy, which had long struggled to assert its authority over European Catholicism and dissenting foreign bishops. During the fifteenth century, it had gradually reasserted itself. Following in the footsteps of his uncle, Pope Sixtus IV (1414–84), who had built the Sistine Chapel, Julius brought leading Italian Renaissance artists and architects to Rome with the task of transforming the city into an imposing centre of the Catholic faith. Playing on the identification with Julius Caesar suggested in his name, Pope Julius was a particular supporter of the High Renaissance style, which drew much from the imposing scale and forms of ancient Rome in its Imperial period.

When work on the papal tomb quickly foundered, Michelangelo returned to Florence without the pope's permission: but by his own later account, he soon had to apologise and was summoned to go before Julius in Bologna 'with a rope around my neck to beg his pardon'. Following this, Michelangelo often complained about his lack of payment and physical exhaustion as he toiled away on the Sistine ceiling frescos between 1508 and 1512, but the story that he locked Julius out of the chapel while he worked was circulated only to raise the artist's profile. In reality Michelangelo, like the other artists Julius had brought to Rome – the architect

Donato Bramante (1444–1514) and the painter Raphael among them – worked in the papal service, and was ultimately subject to the pope's will. The impressive buildings, sculptures, and paintings these artists produced give powerful expression to Julius's ideology. They spoke of the new-found power and ambition of the papacy, using monumental classical forms to make the Renaissance church appear as the natural successor to the mighty Rome of the ancient past. Even the pope's name made the connection: the new Julius promising a revived Christian empire every bit as impressive as that of Julius Caesar himself.

The many meanings of a Renaissance sculpture

Flattery of the pope played a significant role in Michelangelo's marble sculpture known as the *Dying Slave* (figure 4). Like its pendant, the so-called *Rebellious Slave*, this work dates from the years just after Julius's death in 1513, and was made in response to a new scheme for the tomb. But despite what has just been said, Michelangelo himself controlled the formal realisation of his work, and therefore still had room to express his own artistic and spiritual preoccupations. The *Dying Slave* features Michelangelo's essential subject: a life-sized male nude in his favourite medium of marble. It must immediately remind us of the sculptures of classical Greece and Rome, given the figure's idealised 'Roman' facial features and hair, carefully proportionate body, and contrasting tense and relaxed limbs. But the excitement of the sculpture lies more in our sense that it is a living thing. However 'classical' in form, the sculpture possesses an immediate presence, seeming to exist in the here and now, rather than in some remote antique past.

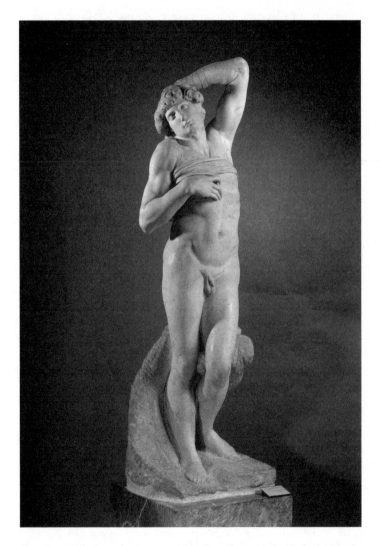

Figure 4 Michelangelo Buonarroti, *Dying Slave*, 1513–16, Paris, Musée du Louvre © 1995. Photo Scala, Florence

By comparison with classical sculptures, Michelangelo's typically have larger heads, feet, and hands, which are used to increase the sense of their reality. The surfaces of his sculptures also reflect the artist's close study of real bodies: small details reveal his acute understanding of the relationship between fleshy surfaces and the corporeal structure of veins, sinews, and bones lying beneath them. Michelangelo's bodies also behave in very plausible ways, interacting with the three-dimensional space they occupy. So much reminds us that Michelangelo was a Renaissance artist, in a tradition committed to the imitation of nature that sometimes made art seem like a branch of natural science. But Michelangelo's forms are never literal, never quite the images of real or specific bodies that they seem. Their ideal or universal quality takes them beyond the more straightforward imitations of much fifteenth-century Renaissance art.

The *Dying Slave* marks a turning point in Michelangelo's career and – given its widespread influence – in Italian Renaissance art more generally. With its odd stretching movement the figure differs from the still and harmonious forms of works from his early period such as the *David* of 1503–4. Michelangelo's new approach owed much to the discovery of a classical sculpture some years before: the artist was watching as the so-called *Laocoön*, a first-century AD marble copy of a Greek bronze from Rhodes, was dug out of a Roman garden in 1506. This discovery led artists and patrons to rethink the meaning of their beloved antique art, which had until then been imagined in terms of the anodyne rationalism of works such as the *Apollo Belvedere*. The *Laocoön* was, in contrast, intensely melodramatic, its complex rippling forms reflecting physical and emotional agony. It shows a Trojan high priest and his sons in their death throes, as the life is squeezed out of their writhing bodies by a giant snake.

The disturbed forms of Michelangelo's two Slaves are based fairly closely on the struggling figures of the *Laocoön* group. The

precise meaning of the two works is, though, less clear. Vasari said that they show personifications of the provinces enslaved by Julius, the warrior pope, whose aim was to extend direct papal control across all the regions of Italy. Another early interpretation tells us that the sculptures represent the Liberal Arts, enslaved after the pope's death. According to this view, the *Dying Slave* represents 'Painting'. There is a problem here, given that painting was still not considered a Liberal Art in the early sixteenth century, whatever the artists had to say about it. But the presence of an ape holding a mirror behind the Slave's legs does lend this interpretation some credence. The idea of visual art as 'the ape of nature' was a commonplace in the Renaissance, and we have already seen that mirrors could similarly refer to art's special ability to imitate.

Renaissance artists often reflected on their own practice in their works. Michelangelo was particularly reflective, and was increasingly concerned about the status and goal of his artistic activities, and how they might appear to an all-knowing God. As he got older, he doubted his early belief that the beauty of art provided a gateway to the divine. In many of his later religious works, his forms take on a heavy, even ugly, appearance, as if he sought to escape from the allure of visual beauty. In his poetry, he wrote in self-accusing fashion that he had 'made an idol out of art'. In a much earlier work such as the *Dying Slave*, where sensuality still predominates, there is already a restless, yearning quality that may reflect a sense of the limitations of beautiful art in the quest for spiritual fulfilment.

Even if the sculpture does not contain any such autobiographical meanings, it is likely that it reflects Christian Neo-Platonic ideas about man's essential struggle between his lower physical self and the pure world of the spirit to which he aspires. The token fetters that bind the figure across his chest, shoulders, and wrist could not realistically restrain the powerful young man: Michelangelo insists that we understand them on a non-literal

level, as expressing an internal spiritual conflict. The ape, in this interpretation, is a symbol of evil, or of man's 'lower soul', to use the Neo-Platonic vocabulary. Such pagan ideas intermeshed easily with more orthodox Christian ones about the struggle between body and soul, flesh and spirit, and would not have seemed out of place in a major church monument such as a papal tomb.

Tomb imagery typically dwelt on the passing of time and the transitory nature of earthly or fleshly existence, contrasting this with eternal life in the hereafter. The conflicted figures of Michelangelo's 'Slaves' share this essential condition of temporality, the dreamy languor of the *Dying Slave* making a visual contrast to the tormented wakefulness of its pendant. Taken together, they refer to the recurring sequence of night and day, and thus to the passing of time in worldly existence, and to the end of the flesh in death. In his later series of allegorical sculptures for the tombs of the Medici in Florence, Michelangelo returned to this theme, showing *Dawn*, *Day*, *Dusk*, and *Night*. Such imagery reminded the viewers that time on earth is limited, even for 'greats' such as the Medici or Julius, its pleasures illusory. The sole hope of eternal life lies in the repentance of sin and the hope of a Resurrection of the soul after death offered by Christ's sacrifice.

But Michelangelo's work was far from dogmatic. Much of its allure lies in the way that it holds different meanings together in the manner of a poem. Here, we are back to the approach to visual art introduced by Botticelli: it is no accident that Michelangelo owed so much to the very same cultural circle in Florence that had nurtured the older artist. The suggestive mix of pleasure and pain in the *Dying Slave* is a recurring theme in Michelangelo's own poetry. In his sonnets he imagined life in the body as a kind of prison-house ('what prison is the body, what soul's crypt') and sleep as the image of death, the means of escape from the illusions of the flesh ('dear to me is sleep … not to see, not to feel, is bliss'). The influence of such poetic musings

on the *Dying Slave* warns us against the recent tendency to understand the work in literal terms, as a homo-erotic image of a young man in a state of near orgasmic ecstasy. While orgasm was often described as 'a little death' in the sixteenth century, the heightened sensuality of Michelangelo's sculpture is not the same thing as sexuality.

Does the slave dream, or is he about to wake? Is the vague movement of his right hand across his fetters a sign of the blissful release from consciousness granted by sleep? Does he experience pleasure or pain? Or does our uncertainty in this regard speak of the closeness of these two archetypal human states? Although fifteenth-century art could occasionally match that of Michelangelo in its capacity to provoke complex questions (Donatello's bronze *David* is a good example) it was typically more simple and direct in its approach. In its open-endedness the *Dying Slave* belongs decisively to the sixteenth century, and has more in common with Leonardo's *Mona Lisa* or, as we shall see, with Giorgione's *Tempest*. As in those works, ambiguity becomes part of the game. Do we see enslavement as a sign of papal dominion, as a comment on the state of the arts following the death of a great patron, or as a symbol of the essential condition of man on earth? Does the *Slave*'s sleep refer to the pain of death, or to pleasurable release from the torments of the flesh and the promise of everlasting life in Heaven? The meaning of the work is no longer singular and apparent, but depends on something of all these possibilities. It only comes alive when the viewer begins to question and to connect.

Drawing and design in the Renaissance art of central Italy

Though no preparatory studies survive to help explain the artistic genesis of the *Dying Slave*, drawing played a vital role in

Michelangelo's art, helping him to achieve the rich expressive effects we have been describing. Vasari accurately noted the central role of 'drawing' – or *disegno* – in Florentine and Roman art, giving the word a wide meaning. As well as preparatory studies, *disegno* referred to the strongly emphasised outlines of forms in the finished work; and also to the inner idea for it in the artist's mind prior to execution. All three aspects are amply evident in Michelangelo's work, though it is difficult to generalise from his example: Leonardo, for example, tended to dissolve the edges of his forms, and took a far more organic approach to developing his compositions. However, drawings – in the more usual sense of small-scale sketches or studies – were certainly important to his artistic activity. They were equally vital to the work of these two masters' younger contemporary, Raphael.

In making drawing central to their artistic practice, Michelangelo, Leonardo, and Raphael developed a trend that had been gathering strength in Florence and in certain other parts of Italy since the mid-fifteenth century. Key to this development was the availability of relatively cheap paper, a by-product of the emergence of the printing presses from the 1450s onwards. Though artists had long used small-scale studies in preparing their works, these were typically limited in number, featuring carefully drawn images of things like animals, birds, and clothing on highly prepared parchment or *vellum* sheets. The availability of paper greatly multiplied the number of preparatory studies an artist could use, allowing him to tailor-make them in relation to the demands of a specific composition. It dramatically widened the scope and nature of preparatory work, allowing artists to arrange the composition and details of their work in advance of its actual execution. This greatly contributed to the studied, balanced, and refined look of art from the later fifteenth century onwards.

In the hands of most artists, drawings remained closely tied to the workshop, and were considered part of its 'furniture'.

Sometimes books of carefully made drawings were inherited by the sons when the artist-father died, so that the old master's style could be continued beyond his death. But as they multiplied in number, drawings also became more disposable: many were simply thrown away after use. This reveals an important point about Renaissance art more generally: however sophisticated and highly sought-after the work of the leading artists became, its status as a kind of craft remained strong. And, as was the case with the products of other skilled craftsmen, the finished work was the thing that was valued, not the preparatory process by which it had been produced. Most artists would have been mortified to see their rapid sketches for paintings and sculptures displayed on the walls of public galleries, as they often are today.

We may be tempted to find the brief and intimate qualities of a rough preparatory sketch more exciting than the finished artwork. But Renaissance artists would not have understood this kind of valuation. It is true that Michelangelo's reputation rose so high that patrons became desperate to get their hands on any kind of work by his hand. In the 1530s he made a series of 'Presentation' drawings which he sent as gifts to close friends. But tellingly, these were carefully finished and look little like his preparatory sketches. Leonardo is a different case again. He greatly expanded the range of uses that drawing could be put to, his graphic work going way beyond its more practical function as a preparatory tool in the workshop. But this does not mean that his drawings were made for public display, or indeed to be seen by anyone other than the artist himself. While his diagrammatic technical, mechanical, and anatomical studies, for example, are highly finished, carefully annotated, and complete in themselves, it seems that Leonardo (probably rightly) did not anticipate a market for, or an understanding of, what he was doing in such works.

The balance between art and nature in a Renaissance painting

Both Michelangelo and Leonardo also used drawings in more orthodox ways, as preparatory tools in the realisation of their public commissions. Such studies proved a vital means of analysing the fall of light and shade on a piece of drapery, or the appearance of the human form, whether in its entirety or in its details (individual limbs, faces, etc.). It was through drawing, whether with *silverpoint,* pen and ink, or (increasingly) red and black chalk, that these artists brought their finished paintings and sculptures very close to the actual appearances of nature. This lesson was very quickly learned by their younger contemporary Raphael, who arrived in Florence from Perugia in 1504. Many of his drawings from this time onwards are preparatory works, but he also made a number of studies for their own sake, and used the medium to record responses to contemporary works by Leonardo and Michelangelo. His quick sketch after the *Mona Lisa* was noted earlier, and he also made telling pen-and-ink studies of Michelangelo's *David.*

Drawing became central to Raphael's artistic process, as is evident from the more than 400 examples that survive today. Though trained in the decorative Umbrian traditions of Giovanni Santi (his father, d. 1494) and Pietro Perugino (c. 1450–1523) Raphael proved a uniquely subtle interpreter and translator of the two great Florentine innovators, Leonardo and Michelangelo. If it is true that the younger artist typically retreated from their experimentalism, he must be credited with integrating their work into the on-going traditions of Renaissance art in Florence and Rome. If he was never quite the 'mortal god' that Vasari imagined him, he did play an important role in holding together a tradition that threatened to disintegrate in the drive toward individualistic expression.

Vasari's stress on Raphael's 'courtesy' both to patrons and to fellow artists expresses this cementing role very well. It is evident too in the way that he did not simply abandon the rich colours, idealised faces, and symmetrical compositions of Umbrian painting in favour of Tuscan naturalism and classicism following his arrival in Florence. Rather he brought the two traditions together in a new synthesis, maintaining something of the simplicity and purity of the older tradition even as he responded to Leonardo and Michelangelo's progressive example. As well as portraits and altarpieces, Raphael specialised in smaller-scale *devotional pictures* featuring the traditional figures of Madonna and Child, either alone, with Joseph, or with the infant John the Baptist. Many of these were commissioned for private houses or chapels, and are testimony to his immediate popularity among the leading patrons in Florentine society, who must have found his careful mix of traditionalism and innovation particularly appealing.

In the *Bridgewater Madonna* illustrated here (figure 5) mother and child are shown alone in an interior, an intimate setting which may have encouraged Raphael to experiment with the kind of heightened *chiaroscuro* advocated by Leonardo. Restoration of the painting in 1992 brought to light interesting details in the background, such as the two blind arches, and the wall behind the figures. But it also showed that Raphael had always meant his figures to appear to emerge out of a penumbra of shadows into the light. As we saw, Leonardo had suggested that such a technique could be used to heighten the beauty of figures. And Raphael's Madonna, with her lowered eyelids, looking downwards to her right, is very close to the heroine in the older master's chiaroscuro-based *Virgin of the Rocks*.

The sprawling posture of the child draws, rather, on Michelangelo's so-called *Taddei Tondo*, a circular *relief sculpture* begun around 1503. The many preparatory drawings for the

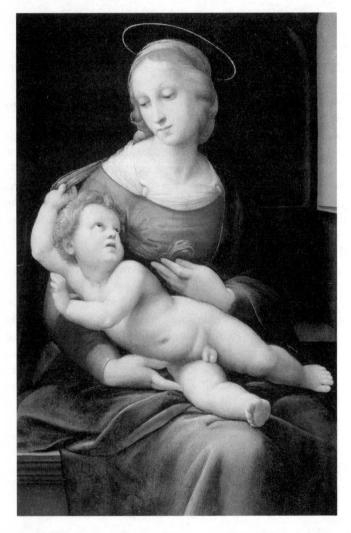

Figure 5 Raphael, *Bridgewater Madonna*, c. 1507–8, Edinburgh, National Gallery of Art Edinburgh, National Gallery of Scotland (Bridgewater Loan, 1945)

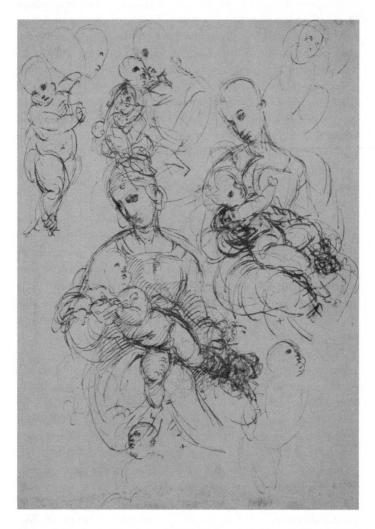

Figure 6 Raphael, *Drawing of Madonna and Child*, c. 1507, London, British Museum/The Bridgeman Art Library

Bridgewater Madonna show that Michelangelo's sculpture was in Raphael's mind from an early point in the process of design. The pen-and-ink drawing illustrated here (figure 6) may represent Raphael's first idea of using Michelangelo's unusual child in his painting. But in the main image on the sheet, vital changes have already been made: the child's position has been reversed, and Michelangelo's remote profile view of the Madonna is replaced by a more revealing three-quarter view. These small changes allow Raphael to establish an intimate human glance between mother and child that is missing in Michelangelo's relief.

But this sheet is home to repeated rapid studies relating to a number of different paintings of the Madonna and Child by Raphael. The higher of the two larger studies, in which the child lies on his back, is close to the *Colonna Madonna*; that toward the top of the sheet showing the heads of the mother and child touching was used for the *Tempi Madonna*. Raphael clearly used drawings such as this as the basis for a number of different paintings that he was thinking about simultaneously. The connections with the paintings mentioned above suggest that the *Bridgewater Madonna* was (like these) painted in 1507–8, perhaps just before Raphael left Florence for Rome.

The obvious spontaneity of the sketches on this sheet, the sense that they were made within a very short space of time, and record a series of unpremeditated movements, complicates things further. Despite the connections with works by Leonardo and Michelangelo, and with Raphael's own future paintings, it is likely that these are 'life drawings', done in the studio using a real baby and perhaps a male apprentice taking the role of the Madonna. This tells us that in Raphael's artistic process ideas originally derived from other works of art, or to be used within subsequent paintings, were tested against nature as the work of preparation proceeded. It was only by this process of controlling the original idea against reality that he was able to arrive at the kind of synthesis evident in his finished works.

The other surviving studies that relate to the *Bridgewater Madonna* speak of the centrality of drawing to his creation of a painting. This was a matter of refinement rather than pedantry. In subsequent studies, for example, the position of the child straddling the Madonna's knee was abandoned, probably because it seemed too coarse, or disrupted the flow of repeated circular forms uniting mother and child. Again, such modifications show how Raphael, through the process of drawing, reconciled Michelangelo's more 'difficult' disruptive and individualistic invention with more traditional values of naturalism and pictorial harmony. The position of the child's right arm remains unclear in the British Museum drawing. But by the time of the final painting the problem had been fully resolved. Here, it is raised behind his head to re-emphasise his gaze back up into the Madonna's face.

The care taken over such details indicates that the process of checking against nature did not mean that it was given the final say. Despite his integration of the conventional and experimental sides of the Renaissance tradition, Raphael was an artist who (unlike his master Perugino) moved decisively into the sixteenth century during his Florentine and Roman periods. Like Leonardo and Michelangelo, Raphael felt free to make the natural facts fit into his conception. Asked about the beautiful women in his paintings, Raphael playfully explained that it was necessary for him to see many of them: 'but since there is a scarcity ... I make use of a certain idea which comes into my mind'. This kind of freedom to manipulate the raw data of nature in keeping with a beautiful inner 'idea' was set to become an expectation in the work of the many artists who were influenced by Raphael over the course of the next three centuries.

We may think, when looking at Raphael's *Bridgewater Madonna*, that the two changes just mentioned introduce an element of the unlikely into the composition. The Madonna's legs now seems too long, while it isn't quite clear if the child's

upper body can actually be supported by his grasp of her mantle. More generally, we might fairly wonder why Christ sprawls in the way that he does. In Michelangelo's relief, his movement was explained by the disturbing presence of a bird (probably a goldfinch) presented by John the Baptist, which he recognised as symbolic of his coming Crucifixion. But John and the bird do not feature in Raphael's painting, and thus Christ's motion has no apparent or outward cause. Arguably, the removal of the bird generates a new level of sophistication, making the child's movement a matter of inward thought or consciousness. His troubled posture (like his imploring upward glance toward his mother) now refers to a moment of inner self-realisation, during which his humanity rebels against the harsh fate that awaits him.

Raphael was in many ways a more typical Italian artist of his time than either Leonardo or Michelangelo. He was, in an important sense, the great translator or interpreter of these lonely towering figures, integrating their more obscure or unusual inventions into a language that could be more widely understood. His society portraits, devotional paintings, and altarpieces more demonstrably conform to established types and styles of art in Italy, and give clearer expression to the values of his patrons. If the work of Leonardo and Michelangelo was often overtly experimental and individualistic, Raphael integrated and synthesised, and could in general be relied on to complete the commissions he was given. After moving to Rome in 1508 to work on monumental frescos for rooms in the Vatican (the so-called *Stanze*), Raphael organised a large, successful, and influential workshop which continued to promote his very poised style beyond his death in 1520. Tellingly, it was Raphael's work (rather than that of his two 'difficult' compatriots) that was most readily and successfully copied, exported, and developed by the generations of artists that followed.

4

Another Renaissance: Venice and the north

Renaissance painting in the lagoon city of Venice in north-east Italy may appear to follow along the same lines as Florence and Rome, at least in so far as it imitates nature, featuring rounded figures placed in convincing three-dimensional spaces. But closer attention reveals that Venice (like so many other artistic centres across Italy and Europe) had its own very particular approach to making art. With its long-standing political and trading connections in the east (most importantly the spice trade with the Levant area on the Black Sea) Venice's cultural orientation was very different from that of Florence or Rome.

The famous onion domes of its main church of St Mark's were based on those of the Orthodox church of Hagia Sophia in Constantinople (Istanbul); inside, glittering medieval mosaics on the walls and ceilings recalled the churches of Byzantium rather than Rome. Venice was to this extent distanced from the westward-looking culture of other parts of Italy. Although its artists certainly moved toward illusionistic naturalism from the middle of the fifteenth century onwards, the local tradition maintained a vital connection with the sensual values of the east, granting colour, texture, and surface a central expressive role. The *disegno*-based intellectual classicism of Central Italy can appear cold and formal when compared with Venetian colour or *colore*.

If artists in Florence and Rome used an increasingly selective kind of naturalism based on the sculptural models of classical antiquity, then the approach to nature of leading Venetian painters such as Giovanni Bellini (1431/6–1516) and his pupil Giorgione (1478/80–1510) remained more direct. Their paintings were based more closely on immediate sensual appearances than on abstracted or intellectualised forms or ideas. In this regard, the work of the Venetian school was closer to that of contemporary artists working in Flanders or Germany. Venetian trading connections with northern Europe were particularly strong, and the interchange of artistic ideas across the Alps once more followed established economic links. It is no accident that the great painter and printmaker Albrecht Dürer (1471–1528) of Nuremberg chose to base himself in Venice rather than Florence or Rome on his two extended visits to Italy.

Dürer enjoyed and responded to a vibrant artistic culture in Venice which had already proved responsive to the direct kind of realism in northern art. But Dürer was a truly international figure, and was more widely interested in Italian Renaissance artistic culture, such that he also engaged with current Central Italian ideas about perspective, ideal proportion, and the need to emulate classical sculptural models. In his synthetic approach he was unusual among German artists of his time. The other northern master discussed in this chapter was simply not concerned with the kind of art being produced in Florence and Rome, and probably knew little about it. The intricate yet monumental limewood sculptures of Tilman Riemenschneider (c. 1460–1531), who worked predominantly in Würzburg, are very far from Michelangelo's muscular marbles. But Riemenschneider's confident independence from Italian classicism tells us something very important about the way that localism continued to provide the lifeblood of Renaissance art around 1500.

The Venetian Renaissance altarpiece

Artists in Venice were aware of, and actively responded to, developments in Florence from the mid-fifteenth century onwards. One only has to look at Giovanni Bellini's large painting of 1478–80 known as the *San Giobbe altarpiece* to see the ease with which the Venetian painter handles three-dimensional space (plate 7). Giovanni's mastery of linear perspective owed much to his training in the workshop of his father, Jacopo Bellini (c. 1400–71), who made two sketchbooks full of detailed drawings which are demonstration models of one-point linear perspective. Jacopo clearly knew of Leon Battista Alberti's directives to painters in this regard, and must have used his studies as teaching aids in his family workshop. But if Giovanni's altarpiece is based on a sound understanding of Albertian pictorial space, with all the forms arranged according to their due place within a box-like construction receding to a single central vanishing point, it is light rather than line which binds the composition together.

Giovanni's soft golden light, with its reference back to the mosaics of St Mark's, was set to become a trademark of his mature style in the altarpieces and smaller *devotional pictures* he specialised in. Its softening action on the surfaces it touches, like its almost tangible presence in the air that moves between Bellini's sacred figures, makes his paintings look very different from those of both his father and his elder brother Gentile (c. 1429–1507). If their work remained linear, overly detailed, and minute, Giovanni's achieves a new measure of breadth and simplicity, as well as atmosphere. Giovanni's advance in this regard was reliant on his use of oil paint, rather than the more traditional *tempera* that he had used in his father's workshop and in early paintings such as his *Pietà* of the late 1460s. The catalyst for this change of medium was the visit to Venice in 1475–6 of Antonello da Messina (c. 1430–79), a Sicilian painter who had

travelled north to Flanders to learn Jan van Eyck's method of oil painting.

Antonello's main commission in Venice was for a large painting known as the *San Cassiano altarpiece*, only a fragment of which now survives. Both this work and Bellini's response to it in the *San Giobbe* painting are early examples of an essentially new kind of Renaissance *altarpiece*, which offers a more immediate relationship with the viewer. In these works, the traditional multi-panelled form (known as a *polyptych*, *triptych*, or *diptych*; see figure 2 and plate 11, for example) was abandoned in favour of an expanded single and vertical pictorial field. In traditional altarpieces, ornately carved and moulded frames had predominated over the painted fields, their richly gilded architectural shapes separating the painted figures off from the surrounding space, as if to confirm their otherworldliness. In the new type introduced by Antonello and Bellini, in contrast, image dominates over frame, such that the viewer responds more directly to the painted scene.

In both paintings, we see the enthroned Virgin and Child surrounded by a gathering of saints, a so-called *sacra conversazione* ('sacred conversation'). This iconography was not in itself new, but the underlying idea that the sacred figures occupy a single unified space that is continuous with our own certainly was. Bellini's painting was originally placed over a side altar in the Franciscan church of San Giobbe: the viewer/worshipper was invited to think that he or she looked into an actual chapel issuing off the nave of the church: the perspective, established above all by the mouldings of the painted architecture, is arranged to suggest continuity with the stone frame of the altarpiece (still in situ), and beyond that with the real space of the church.

It is this underlying implication that the familiar sacred figures have come down to earth in order to co-exist with the worshipful viewer that is so new in Bellini's altarpiece. It provides the key to the overall naturalism of his picture. The

Virgin remains enthroned (referring to her role as Queen of Heaven); the saints are solemn, do not chat or (apart from St Francis) acknowledge the viewer; and the music-making angels tell us that the scene takes place in Heaven. But it is hard not to feel that these divine figures are very close, present in a domain that is intimately connected to our own world. The point is reinforced by St Francis's turn outwards toward the viewer, his communicative expression and imploring gesture inviting us to participate in the devotional meditations going on in the fictive chapel. In a way that recalls the Flemish artists discussed in chapter 1, Bellini uses naturalism to intensify our sense that the divine is closely adjacent, sensuously palpable in the reality about us.

Despite his debts to the 'Eyckian' manner, Bellini replaced Flemish meticulousness and accuracy with a more generalising approach, reminding us that he was, after all, an Italian artist. Instead of a cumulative approach to the visual world, built up from small details, and differentiating a wide range of textures and visual effects, Bellini used oils to bind figures, objects and spaces together in broader masses to create a new sense of monumentality. He used *pigments* that are very close to one another in the colour scale, his tonal approach drawing the various elements of his composition together so that each object or figure appears to occupy the same warmly emotional world.

This structural use of oil paint to create a coherent and unified composition in the *San Giobbe altarpiece* makes it a fine early example of Venetian Renaissance *colore* ('colour'). It may be, however, that the related Italian word *colorito* ('colouring') gives a truer sense of this approach, given that it better suggests the Venetian artist's active manipulation of the paint on the picture surface. After all, bright, sometimes unmixed colour abounds in Florentine and Roman paintings of the period. What distinguishes the Venetian tradition from Bellini onwards is not so much the use of intense colour, or even of a wide range of

pigments, but rather the extent to which the given painting was arranged, perhaps even thought out, at the painting stage. Instead of using extensive preparatory drawings on paper to arrange the composition before painting began (like Raphael, for example), Venetian painters exploited the slow-drying quality of oil paint to develop a more integrated or even improvisatory approach.

In the *San Giobbe altarpiece*, Bellini certainly used a charcoal *underdrawing* to establish the main compositional outlines, but the final effect of his painting is dependent on the subsequent stage: on the layers of oil paint that he then applied. Exploiting the translucence of oils in the technique known as *glazing* (one colour showing through another placed on top of it), Bellini made his manipulation of paint itself central to his working procedure, and to the subtle appearance of his finished paintings. His talented pupils Giorgione and Titian took this approach even further, as we shall see. But why did oil painting, increasingly on a canvas support, become so central in Venetian Renaissance painting? To some extent, the answer may be found in the Venetian climate. Neither *tempera* (typically used on a wooden panel support) nor *fresco* was suited to the damp and saline environment of the Venetian lagoon. Though many frescos were painted to decorate the facades of Venetian buildings, artists and their patrons fully understood that these paintings would not last long in the salty and corrosive air. Oil paintings on canvas, on the other hand, promised great durability, and quickly gained a much higher aesthetic and monetary value in the city.

The hidden subject: a 'private' Renaissance painting

Local climatic considerations do not, however, really explain the radically loose oil-based style developed by Bellini's pupil

Giorgione in the first decade of the sixteenth century. In order to understand his paintings, we have also to take into account factors such as patronage. In fifteenth-century Venice, painting had a predominantly public face: it was large-scale and typically religious or patriotic in its subject-matter. Large and crowded *history paintings* adorned the walls of the Ducal Palace in the centre of the island city, where the Republican government met under the leadership of an elected nobleman known as the Doge. They were also present in large numbers in the lavish meeting houses of the city's so-called Scuole ('schools'), power-ful charitable confraternities of religious-minded citizens. In the city's more than 200 churches, grand religious paintings (like Bellini's painting from San Giobbe) adorned the altars, forming a focus for communal prayer.

Giovanni Bellini himself fostered a growing taste for more private paintings, making a number of individual portraits and specialising in smaller half-length paintings of the Madonna and Child. Many of Bellini's Madonnas were commissioned to hang in family chapels or bedrooms of more wealthy private citizens, where they were the focus of private prayer or devotion. But this kind of image does not quite prepare us for works such as Giorgione's *Tempest* (plate 9). In this intimate little panel, the more usual public or communal orientation of Venetian art is abandoned altogether. Instead we peer at a little landscape whose colours and forms are transfigured by the arrival of a storm and a sudden flash of lightning.

A man with a pike and a semi-naked woman suckling a child occupy the foreground, but it is the landscape that dominates. The relation of the figures to one another, their precise identity and wider meaning, remain obscure. All at once, it seems that Renaissance painting has lost its usual role as a carrier of identi-fiable and significant subject-matter or iconography (see box on p. 88). The long tradition of monumental religious or patriotic pictures featuring famous actors and significant events in

Venetian art has been replaced by an altogether more intimate, esoteric, and private kind of art.

The *Tempest* is one of a very small number of surviving paintings by an elusive master whose career was tragically cut short by the plague of 1510 (he died in his early thirties, after little more than a decade as an independent master). It is typical of Giorgione in its small scale, very loose handling of paint, and ambiguous meaning. In 1530 the painting was described by Marcantonio Michiel (1484–1552), a Venetian art enthusiast and collector, as the 'little landscape with the storm and the gypsy'. But many have sought to interpret further, seeing it as a classical mythology, a Christian narrative painting, or a moral or political allegory. Others have wanted to respect Michiel's indication

ICONOGRAPHY

The term 'iconography' refers to the subject-matter, as opposed to the form, of a work of art. It was first properly defined in art history by the German scholar Erwin Panofsky (1892–1968), who worked primarily on the Renaissance period. Panofsky noted that the vast majority of Renaissance works had subjects that could be traced back to one written text or another: not only the Bible or later devotional books, but also classical and Renaissance writings dealing with a wide array of topics. Visual images fell into patterns or types according to the given textual source that was followed by the artist. Up until Panofsky's time, art history had been largely concerned with the style or form of the work, and had paid relatively little attention to subject-matter. Now it became possible to interpret many features of works of art with reference to written descriptions in books, with the result that their original meanings became clear. The study of iconography has since become a major tool in the interpretation of Renaissance art, given that most works from the period have a discernible subject. But in works such as Giorgione's *Tempest* this kind of approach has not got scholars very far.

that the painting does not have a subject at all, considering it to be a *genre image*, or as one of the first landscapes in Western art. Whatever the truth of the matter, it is evident that Giorgione, as in many of his other known works, very deliberately departed from the expected, producing an image that was self-consciously novel and therefore difficult to interpret.

Giorgione's association with a small group of art patrons from leading Venetian families may provide the key to his new kind of painting. When Michiel saw the *Tempest* in 1530, it was in the private art collection of the Venetian nobleman Gabriele Vendramin, though it is not clear whether or not he was the original patron. Vendramin was, though, a relative of others who owned paintings by Giorgione, and seems to have been part of a social clique that bears some resemblance to Lorenzo de' Medici's circle, though this group certainly did not have political control in Venice, as Lorenzo did in Florence. The circle was dominated by wealthy and fashionable members of the city's leading families, in a position to withdraw from their more humdrum mercantile and public duties into a world of refined leisure and poetic contemplation. And here too an interest in poetry quickly developed: the bucolic pastoral works of Virgil seem to have been particularly popular, and the genre was actively revived by Venetian poets such as Pietro Bembo (1470–1547). This poetic tradition recounts the loves and losses of simple nymphs and shepherds who live innocently in the fields and forests, far beyond the cares of the city: its imagery may have had an impact on Giorgione's paintings, which often have rural settings and a 'pastoral' look.

The new kind of patron would have wanted a new kind of painting, one with less obvious or explicit meanings than those on offer in crowded *altarpieces* and *history paintings*. To this extent, it may be that the difficulty we have in interpreting Giorgione's *Tempest* is, and always was, part of the work's meaning. It may be best to see it as a kind of picture puzzle made

for a patron who preferred poetic suggestion to anything more direct or obvious. We might recognise such literate patrons, and the ambiguous work they enjoyed, as distinctly more 'modern' than their fifteenth-century forebears. They had a ready appreciation of works of art as objects to be enjoyed for their own sake: to be collected alongside other precious curiosities and pored over in private, their possible meanings generating lively discourse between learned friends. Giorgione's new 'sophisticated' approach to painting has something in common with a number of other Italian masters of the Renaissance, such as the sculptor Bertoldo di Giovanni (c. 1420–91), who worked on a small scale in the service of Lorenzo de' Medici.

While Giorgione's oil-based style still reflects that of Bellini, it is by comparison very free in its treatment of space, anatomical correctness, and overall clarity of composition. More readily than his master, Giorgione sacrificed the underlying reality of forms, blurring their edges and revealing the individual brush stroke on the picture surface. The fluidity or lack of stability of Giorgione's pictorial language takes the painterly possibilities of the oil medium a step further, such that his *colorito* no longer works in a structural way. In his pictures, the radical uncertainties of human sight become newly significant: natural forms are merely glimpsed under ever-changing conditions of atmosphere and light.

Giorgione's concern with naturalism is also evident in his turn to landscape: although figures, buildings, or even distant towns are typically included, his paintings often feature extensive rural views or settings that challenge the usual dominance given to human figures in Italian Renaissance painting (see, for example, his *Sunset landscape*). His interest in landscape did not, though, come out of the blue: Bellini often included sharply lit views of the countryside in his religious paintings, and sometimes reduced the scale of his figures in order to emphasise natural setting (see his *St Francis in the desert*). But in Bellini's

work the landscape typically provides ballast to the sacred story, intensifying our sense of the presence and authority of the sacred figures in the real world. Giorgione's landscape is fundamentally more independent of the religious subject and often ambiguous or multi-dimensional in its meaning: in his religious paintings it threatens to distract us from the figures placed within it (see his *Castelfranco altarpiece*). When it features in secular subjects, it becomes more independently significant again, though also more generalised and poetic.

Though Giorgione follows his master in referring to the landscapes of the Veneto or 'terrafirma', the rural hinterland of Venice, he rarely alludes to specific places (though it has recently been claimed that the town in the *Tempest* is Padua). It was into this pleasant rural area that Giorgione's patrons retreated from the pressures of life in metropolitan Venice. The prime time of Veneto villa culture came later in the sixteenth century when the famous architect Andrea Palladio (1508–80) created a stunning sequence of glorified farmhouses in a classical style. But already in Giorgione's day an important cultural circle, which included the pastoral poet Pietro Bembo mentioned earlier, had gathered in a country villa near the village of Asolo that was home to the exiled Queen of Cyprus, Caterina Cornaro (1454–1510). It may be that Giorgione's hazy sunlit landscapes served to remind such viewers of the Veneto and its sensuous and poetic pleasures. But something rather different is on offer in the *Tempest*, which features a more immediate and dramatic impression of a dramatic weather effect.

Venetian colour versus Central Italian design

Giorgione's depiction of a lightning strike was perhaps an attempt to outdo a lost marvel of antique painting, given that

Apelles' depiction of a thunderbolt was much celebrated in the classical literature. But we should not underestimate Giorgione's sense of the immediacy and power of the storm. Its explosive force and transformative impact on the world below is very far from Bellini's confident incorporation of natural phenomena into the sacred schema. Giorgione's depiction reminds us more of Leonardo da Vinci's depictions of violent storms or deluges in the group of drawings mentioned in the previous chapter. A work such as the *Tempest* suggests that Giorgione, like Leonardo, perceived nature in a new way, as something in a state of essential flux or flow, but also of enormous strength or power, with the potential to suddenly rise up and assert its dominance over the world. The connection with Leonardo has other dimensions too. Giorgione's careful description of the way the arrival of a storm changes colours and dissolves forms was dependent on his exploitation of the fluid possibilities of oil paint, the medium that Leonardo had experimented so effectively with.

Many viewers have been struck by the visual similarities between Giorgione and Leonardo, noting their shared habit of dissolving the hard edges and underlying structure of forms in their paintings. As early as 1550, in his *Lives of the Artists*, Vasari claimed that Giorgione based his new style directly on Leonardo, who had briefly visited Venice in 1500. Ever the patriot, Vasari may have exaggerated this Tuscan influence in order to give the Florentine school priority over that of Venice. Having established Giorgione's role in the progression of Venetian painting as directly equivalent to that of Leonardo in the Florentine, as ushering in a 'modern' and perfect phase of Renaissance art, Vasari then went on the attack.

While Leonardo and the other leading Florentines are exalted as masters of *disegno*, Giorgione is criticised for his lack of preparatory drawing. According to Vasari, drawing allowed the Renaissance artist not only to record what he saw in nature, but also to improve it, in accordance with his own idea of artis-

tic perfection, a procedure that we have already seen at work in the art of Raphael. The Venetian painter's lack of drawing, on the other hand, meant that he was slavishly tied to the depiction of what was directly in front of him, and thus to all its imperfections.

The controversy between the Central Italian *disegno* and Venetian *colore* stirred up by Vasari was probably of little concern to Leonardo or Giorgione, though it certainly had a major impact on the practice and theory of European art in the centuries that followed. In the present context we simply need to note that the approaches and discoveries of Leonardo and Giorgione were not so different from one another. *X-radiography* has revealed that Giorgione originally painted a woman at the lower left of the *Tempest*: he clearly changed his mind about the positioning of his figures in the course of painting. The appearance of discarded or radically altered figures beneath the surface of many other Venetian Renaissance paintings indicates that Vasari was in certain ways right. Venetian painters used preparatory drawings less frequently or systematically than their Florentine equivalents, and did not so clearly separate invention from execution. Yet this more improvisatory approach hardly tied them to the individual motif in nature as Vasari presumed. Rather, it allowed them to continue 'inventing' as painting proceeded, and thereby to capture subtle natural effects that are often lost in the *disegno*-bound art of Central Italy.

Giorgione's artistic process may not, however, have been an additive one, or have been based on progressive clarification of the given subject. On the contrary, Giorgione – like Leonardo in works such as the *Mona Lisa* – seems to have understood that a decrease in the amount of information given in a painting could result in an increase in its suggestiveness to the viewer. Lack of clarity is more alluring in a painting than too much: the thing half-seen or understood more likely to stimulate interest and discourse. In the *Tempest*, forms and textures are suggested,

but Giorgione's free brushwork undermines their precise identity. In place of close description and definition something emerges that is more ineffable, but also more open to interpretation.

A Renaissance synthesis of German and Italian styles

Figure 7 shows Albrecht Dürer's *Hercules at the crossroads*: it is one of a number of increasingly masterful prints from the artist's early period and a good example of the spread of Renaissance values to the north. Made in the city of Nuremberg, it provides evidence of a vibrant culture with classical and humanist interests in southern Germany (Franconia) around 1500. It is probably a classical allegory, showing the Greek hero Hercules (the standing man with the winged helmet) between Virtue (also standing) and Vice. The landscape has been organised with this theme in mind: leaving behind him the pleasures of the soft river valley glimpsed below to the right, Hercules must overcome the lolling 'Voluptas' who lies across his path on the lap of a lecherous satyr (half-man, half-goat). Aided by the primly clad Virtue, he must continue on up the path toward his goal, symbolised by the steep landscape to the left. The dramatic 270-degree twist in Hercules's direction of travel symbolises in spatial terms the extent of his moral turnabout.

The meticulous detail of the *Hercules* is immediately noticeable: Dürer exploits the variation of line available when working with the *burin* to indicate minute differences of texture, surface, and light. The vivacious clump of trees and bushes offers something more than a foil to the illuminated bodes of the main actors. Dürer dwells lovingly on the particularities of the foliage and on the dynamic and organic twisting growth of trunks and branches. The same kind of attention is paid to the bodies of the

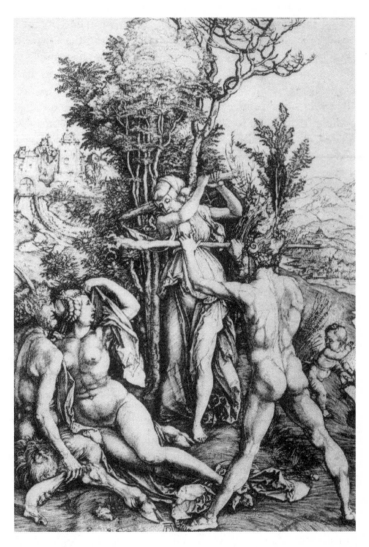

Figure 7 Albrecht Dürer, *Hercules at the crossroads*, c. 1498, engraving

actors. Variations in the diagonal cross-hatching on their surfaces reveal the different qualities of their flesh. A careful contrast is made between the feathery diffuse hatching across the surface of Vice's body (to indicate its softness) and the structural and precise modelling of Hercules's form, which reveals its hard musculature.

Dürer's careful attention to textures and surfaces, and the fall of light upon them, recalls the fifteenth-century Flemish masters' use of oils for similar ends. Such minuteness of description is rather different from the generalising effect of the *colorito* of Bellini and Giorgione, and reminds us that Dürer was a northern artist. But many local viewers would none the less have been struck by how very different this image looked from the kind they were used to. In contrast to the static depictions of heavily draped sacred figures in altarpieces and devotional pictures, Dürer features predominantly naked or semi-naked figures in very mobile postures, who vigorously interact with one another. In spite of its allegorical meaning, Dürer insists on giving his scene the immediacy of a sudden dramatic event. His *Hercules* is, in fact, far closer to the kind of *all'antica* art being produced in contemporary Italy than it is to other works from northern Europe of the 1490s.

Dürer's *Hercules* was made just a few years after his return from a visit to Venice and is clearly a response to his time in the south. It is telling, though, that he modelled the main figures on works by non-Venetian artists, as if to display his more general interest in antique and Italian Renaissance art. The figures of Vice and Virtue follow recent Italian engravings based on antique models which he had recorded in careful drawings. The hero himself recalls in more generic fashion the dynamic male nudes featured in the work of the Florentine artists Antonio and Piero Pollaiuolo (c. 1432–98, c. 1441–c. 1496): a very appropriate source, given that, in Florence at least, the figure of Hercules had become almost synonymous with the Pollaiuolo

brothers following their completion of three large paintings featuring the hero for the Palazzo Medici (1460s, now lost).

Dürer's rather self-conscious display of his new knowledge of the art of contemporary Italy needs to be considered in context. The classical quotations, which would certainly have been recognised by more discerning viewers, were studiously brought together with the more conventionally 'northern' features noted earlier. The new combination offered German art a place at the Renaissance table, suggesting that the two traditions, north and south, could now live together. The formation of an international composite style was, indeed, one of Dürer's lasting ambitions, and was deepened further by a second visit to Italy in 1504–6. Yet he had to remain sensitive to the wider public that he courted.

Works such as the *Hercules*, with its blatant nudity and pagan theme, would have been disturbing to many pious northern viewers. It may be significant that Dürer gave his classical print a moral meaning, acceptable to the devout Christian. In other engravings of the period, such as the *Four witches* (1497) and the *Dream of the doctor* (c. 1498), Dürer 'justified' erotic images of nudity by including allegorical meanings which condemn the display of feminine flesh. This approach was subsequently taken up by followers of Dürer in Germany such as Lucas Cranach, who specialised in such 'moral nudes'.

The rise of the Renaissance print

Dürer's *Hercules* is a precociously new kind of work aimed at a wide international audience. Despite the classical theme, Dürer did not seek to serve the social elite with works such as this. Unlike Giorgione's *Tempest*, Dürer's *Hercules* was not made on the request of a specific patron: it was not tailor-made to suit a particular set of cultural interests. For all its pictorial qualities

and its classical subject-matter, the *Hercules* was made to be reproduced, its small scale and ready availability anticipating a potentially broad and diverse viewing audience. It may have been among the copies of Dürer's prints that members of his family sold in the local market in Nuremberg, for example. If Giorgione's short career involved a retreat into a more 'private' cultural field, Dürer's went in the opposite direction. He attempted to expand the visual domain, anticipating the widening interest of a new art-loving public, both at home and abroad. It was this that lay behind his attempt to synthesise diverse artistic styles. The natural medium for such an enterprise was the reproductive print.

Prints were immediately smaller, cheaper, and more quickly produced than traditional works of art: based on the principle of replication, they co-existed in many places at once and were easily transportable, contradicting the fixed or site-specific qualities of, for example, large-scale *altarpieces* or sculptures. The ease and rapidity with which prints were produced and consumed promised the visual image a new measure of ubiquity, and made it a suitable carrier for an expanded range of meanings and ideas. In addition to the more traditional diet of stories from the Bible, or from the lives of the Virgin and saints, printmaking artists often depicted topical or 'contemporary' subjects: accurate views of famous towns, cities, and monuments, for example, or images recording the appearances and dress of the people of different regions. Social types, from emperors, kings, and popes down to peasants and beggars (see figure 9) became valid subjects for the Renaissance print, as did important social and natural events and unusual occurrences. Even if it does not have a topical subject, Dürer's *Hercules* has its place within this dramatic widening of the established subject-matter of visual art within print culture.

The reproductive print formed part of the wider communications revolution that followed the spread of the printing

presses across Europe in the mid-fifteenth century. The discovery of moveable type allowed for the text to be brought into a new alliance with the printed image. But when, in 1498, Dürer published an illustrated book featuring sixteen woodcuts drawn from St John's Revelation – known as the *Apocalypse* – he made a very significant change. Though John's text was included, the words were relegated to the back (or verso) of each sheet, with pride of place given to Dürer's large and complex images on the front (recto). The more usual priority allowed to the text in early printed books was undone, with the 'illustrations' taking on a new place of independence and authority.

The publication of the *Apocalypse* was a great success across Europe, quickly making Dürer famous. The young artist, originally trained in the workshop of his goldsmith-father, had seen and quickly exploited the huge potential of the new medium of reproductive print. Initiating the *Apocalypse* project himself – rather than waiting to be asked to work by a patron – the young Dürer understood not only that prints offered artists a new measure of creative freedom, but also that the medium opened up an international market for visual art. Further series of religious woodcuts quickly followed, including the *Life of the Virgin* (1500–5) and the *Large* (c. 1497–1511) and *Small Passion* (1511).

In these extensive cycles, Dürer almost seamlessly translated the 'core' Christian stories into the new medium, brilliantly exploiting the linear possibilities of *woodcut* to create dramatic narratives every bit as engaging and impressive as those familiar from monumental paintings and sculptures. It is typical of him that he granted small-scale black and white woodcuts a kind of expressive equality with more traditional and exalted image-types. Comparison of his woodcut cycles with the paintings (including portraits and *altarpieces*) that he also produced even suggests that he was more at home with prints. Dürer clearly did not prioritise one artistic medium above another, and a similar

kind of equality is evident in his approach to different subject-matters. He lavished great care and attention on images of humble animals and plants, for example, as can be seen in his superb watercolour drawings of a *Young hare*, a *Piece of turf* and a *Stag beetle*.

Dürer's attention to the visual specifics of such 'trivial' subjects may remind us of the realism of earlier northern masters in the Flemish tradition. But at the same time, he transforms the significance of these familiar examples of nature by making them the sole focus of our attention in a way that recalls the 'scientific' Leonardo in Italy. Like him, Dürer treated drawing as a semi-independent medium that was not closely or necessarily related to his paintings. He used drawing as a means of getting very close to the complex reality of nature around him. Leonardo had a more precise influence on Dürer's art during his second visit to Italy, but the Nuremberg master's intense interest in all things natural had developed quite independently. On his return from his first journey in 1495, he had made a series of evocative watercolours showing the lonely heights and valleys of the Alps, which are among the first independent landscape paintings in the Western tradition (e.g. *Alpine landscape*). These wholly independent images of nature are borne out of a very modern sense of the inherent value and interest of the world at large.

Renaissance Gothic

But here we need to take a reality check. Elsewhere in Franconia, in the region of Würzburg, an artist was at work who has a good claim to be more typical of his time and place than the 'international' Dürer. In contrast to the Nuremberg master, Tilman Riemenschneider didn't travel to Italy and did not become an international printmaker. Instead, he remained in his native town and the immediate area, producing more than

twenty large and complex church altarpieces or retables for local churches in the traditional medium of limewood.

Unlike Dürer's little prints, these wooden structures are physically monumental and intensely site-specific in their imagery and meaning. They are often rather nervously described as 'Late Gothic' in style. But given that Riemenschneider's altarpieces span the years 1483–1515, the very period of the so-called 'High Renaissance', the term seems inadequate. Riemenschneider's example offers an important corrective to the common idea that in the Renaissance the classical style of Italy simply came to dominate across Europe. We have seen in earlier chapters that there was a continuing taste for the Gothic (see box on p. 2) in the Renaissance period. But examination of Riemenschneider's example allows us to appreciate that the two styles were not really opposed to one another, and that they could happily co-exist together in a single work.

Riemenschneider's works may seem to have little in common with the artistic developments we have been following in this book. But further attention suggests that (as in the Brancacci Chapel or in Botticelli's mythologies) 'Gothic' and 'Renaissance' styles were closely entwined. On first appearances the *Holy Blood altar* of 1499–1505 looks entirely Gothic in form and conception (figure 8). This is especially the case in the area above the main images, which achieves an effect of delicate, almost transparent, verticality through the use of elaborately extended decorative features such as recesses or *niches* and decorative *finials*. But there is a clear visual contrast between this superstructure and the more solid horizontal, box-like area below, in which large figures and narratives predominate. Above each scene in this lower area, *tracery* is included that deliberately recalls Gothic architecture. But a closer view reveals twining branches rippling with life, including ripe buds, thistle blossoms, and even birds. The mimicry of stone readily gives way to a description of nature which reflects the organic vitality of the

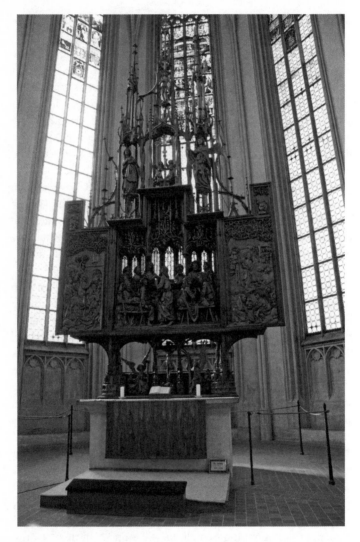

Figure 8 Tilman Riemenschneider, *Holy Blood altar*, 1499–1505, Rothenburg, St Jakob. Alimdi.net

sculptor's material. The initial reference to traditional church architecture cannot contain the sculptor's avid interest in natural forms, one that reminds us more of Renaissance artists such as Leonardo and Dürer than of the medieval past.

In the main scene showing the *Last Supper*, the bodies of the main actors are thin and narrow with sloping shoulders. Comparison with Leonardo's famous version of the subject of 1495–8 shows that Tilman's forms lack the broad expansive qualities of the Italian master, and that his treatment of drapery is fussy and complex, tending to form decorative folds that defy gravity, rather than suggesting the underlying form beneath. Yet the same play between abstract and real noted in the tracery is apparent again in these human figures. If the intricate flowing lines of their draperies take on an abstract life of their own, this is interspersed with passages of intense naturalism. As in Leonardo's fresco, Tilman's Apostles are caught in mid-action; at the right, an animated conversation has broken out, while the momentary glance of the Apostle Philip just to the left of centre is particularly striking.

Like many *altarpieces*, the *Holy Blood altar* has a pointedly Eucharistic meaning: indeed, the sacraments of the bread and wine are physically displayed upon it (in a container known as a *monstrance* at the centre of the *Crucifixion* below the main scene and in a glass cross holding a relic of the Holy Blood higher up). There was an especially strong veneration of the 'Holy Blood' in the town of Rothenburg, after some consecrated wine spilled onto the special cloth on which it is placed during the Mass (the corporal) and left miraculous traces. But this only makes it more surprising that Riemenschneider did not emphasize this in the central panel. Once again like Leonardo, he ignored the more obvious doctrinal moment of the institution of the Eucharist in favour of the dramatic historical one of the annunciation of the betrayal: 'In truth, in very truth I tell you, one of you is going to betray me'. Perhaps more astonishing still is Tilman's

placement of Judas, rather than Christ, at the very centre of his composition.

In this regard he even went a step further than Leonardo, who maintained the absolute centrality of Christ in keeping with his primary theological importance. Riemenschneider's freedom may bring to mind the kind of compositional inversion noted in chapter 1 in the *Portinari altarpiece* by Hugo van der Goes (figure 2). For all their piety and sense of the debt owed to the art of the past, the northern masters felt freer to manipulate their compositions for expressive effect than the 'classical' Italians. In Riemenschneider's *Last Supper*, the table top tilts up against all spatial logic to help highlight Christ's action as he reaches over to hand Judas a piece of bread, while the latter holds up his money bag to identify his role as the betrayer. There is a further purpose to Judas's visual prominence. As the sinner who cheats Christ he becomes the viewer's representative in the image.

Our identification with Judas is reconfirmed by the gesture of Philip, who turns meaningfully toward the viewer while pointing out the central exchange. But why did Riemenschneider lay such emphasis on the 'Judas communion', as it has been called? Was it intended as a stark warning to the faithful in front of the altar not to take communion unworthily? It is difficult to prove any such thing. Yet the dark sense of mankind as full of sin, more like the traitor Judas who sold his master for thirty pieces of silver, than the saintly Apostles, finds echoes in other northern works from the period, such as those of the Flemish master Hieronymus Bosch (c. 1450–1516). The grim perception of man's essential cupidity also led to calls for a spiritual renewal based on individual purity and faith. That is, to the Reformation.

Discussion of the *Holy Blood altar* has shown that Riemenschneider readily mixed traditional and new, with little sense that 'Gothic' and 'Renaissance' elements in his art contradicted each other. On one level, of course, the whole structure

is very readily distinguishable from contemporary art in Florence, Rome, or Venice; and unlike Dürer's *Hercules* engraving it betrays precious little interest in the newly international revival of classical forms or subject-matter. It is, in fact, a very well documented work, closely tied to the traditional civic and religious culture of Rothenburg. The city counsellors who commissioned and paid for it would have required a work that looked like the other altarpieces Tilman had made for churches in Würzburg and elsewhere in the area. And the control over artistic individualism is also apparent from the fact that much of the altarpiece other than the figures (including the decorative carving on the superstructure and the fenestrated cabinet containing the main scene) were the work of Erhart Harschner, a local carpenter.

Sculptor and carpenter apparently worked independently of one another, but they were paid a similar amount of money, indicating that the local patrons did not readily distinguish between one craftsman and another. Low evaluation of figurative artists was very traditional, and was just the kind of thing that Dürer, who had recently painted two self-portraits showing himself in the guise of a gentleman and a god-like creator, sought to overturn. Dürer noted in a letter from Venice that he was treated like a gentleman there, while at home he was considered a mere craftsman. Yet Riemenschneider was clearly undisturbed by such issues and worked harmoniously alongside Harschner the joiner on the *Holy Blood altar*. As we have seen, his traditional artisan identity did not stop him innovating and inventing in his vividly expressive image of the *Last Supper*.

5

Renaissance and reformation: northern art of the sixteenth century

In a popular almanac published in the German city of Ulm in 1499, the astrologer and university teacher Johannes Stöffler (1452–1531) confidently predicted that the world would come to an end on 25 February 1524. Stöffler's dire prediction had its context in a cultural climate of growing terror and loathing that had spread across much of northern Europe. Worsening social conditions, including wars, food shortages, poverty, and the arrival of new diseases such as ergotism (caused by fungi-infected cereals and resulting in burning pains and gangrene), were important in generating this darkening atmosphere. But it was typically understood by contemporaries in religious terms.

The increasingly absolute control of Christianity in Europe from Rome, far away in Italy, fostered resentments in the north, and the widespread perception of corruption within Roman Catholicism further fanned the flames of discontent. Of particular concern was the church's practice of granting remission for sins in return for money: the sale of so-called 'indulgences'. The older spiritual tradition known as the *Devotio moderna* mentioned in chapter 1 may also have fed into this crisis, given that it had long advocated a personalised kind of religious practice that mentally distanced its followers from the established public

institutions of the church. On a deeper level still, many were simply persuaded, like Stöffler, that the end of the world was nigh, and that mankind's endless sinning was to blame.

The disturbing imagery of Hieronymus Bosch reflects this troubled cultural atmosphere: one that very soon led to the rebellion against the established church known as the Protestant Reformation. In 1517, Martin Luther nailed his 95 theses or complaints on the door of Wittenberg Cathedral and so initiated a rejection of Roman Catholicism that was destined to divide European Christianity as never before. What was the impact of this fundamental religious change on the further development of Renaissance art? The movement was not fundamentally driven by religious values; but neither was it opposed to them. As we have seen, the realistic artistic styles of the fifteenth and early sixteenth centuries often served to visualise traditional Christian principles in newly affective ways. But with the coming of the Reformation, this kind of easy alliance between art and religion was directly challenged.

From the 1520s onwards, many Reformers questioned the established place of visual art in religious life, and artists were forced to take their careers in different directions. Leading figures in the north such as Lucas van Leyden (c. 1494–1533), Lucas Cranach (1472–1553), Hans Holbein (1497/8–1543), and Pieter Bruegel (c. 1525–69) none the less managed to carve out successful careers. Religious art did not simply end with the Reformation: artists such as Cranach invented new kinds of religious iconography (see box on p. 88) that served the reformed religion. But both he and the others discussed in this chapter also developed 'empirical' kinds of art (such as portraiture, *genre images*, and landscape) that referred more directly to the present world. The Renaissance has often been seen as 'secularising' the religious Middle Ages. But this move had to wait for the Reformation before really taking root in north European art.

A Renaissance eccentric?

Hieronymus Bosch is often seen as one of the most eccentric figures of the Renaissance whose paintings have little to do with those of other artists of the period. His frequent use of bizarre half-human half-animal forms, of strange outsized objects both man-made and natural, and of weird fleshy shapes sculpted into fountain-like structures (see particularly the mysterious triptych known as the *Garden of earthly delights*) has led many to see him as a kind of proto-surrealist whose art has more to do with inward morbid fantasies than with the confident and progressive culture of the Renaissance. Yet there is little evidence that Bosch was the strange outsider this modern view advances. On the contrary, the records show that his career, like that of Riemenschneider and many other artists across northern Europe, was firmly rooted in his local town: in this case 's-Hertogenbosch (now in Holland, but then in the Spanish Netherlands), where he was born and died, and from which he took his name.

Bosch was a long-standing member of the confraternity of Notre Dame in the town, which suggests his identity as a respectable and pious-minded citizen. He seems to have become something of a celebrity who often painted for the confraternity, but also for princely patrons from beyond 's-Hertogenbosch. He had a large number of followers who copied his works, which were quickly engraved, ensuring the wider dissemination of his ideas. The patrons of many of his religious paintings are not known, but his work soon found favour with no less a family than the Habsburgs, then rulers of the Spanish Netherlands. It isn't clear when this royal interest began, but later in the sixteenth century Bosch's works were avidly collected by King Philip II of Spain (1527–98), who liked them so much that he hung examples in his private bedroom at the royal palace of El Escorial near Madrid. It is ironic that Philip, the great protector

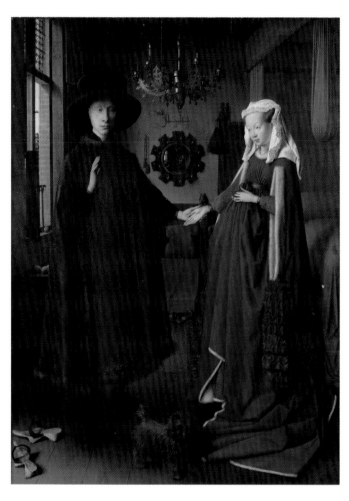

Plate 1 Jan van Eyck, *Arnolfini portrait*, 1434, London, National Gallery
© 2009. Copyright The National Gallery London/Scala, Florence

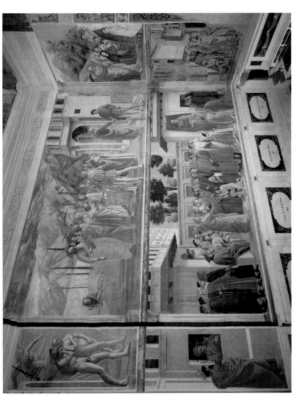

Plate 2 Masaccio, frescos on the left wall of the Brancacci Chapel, 1425–8, Florence, Santa Maria del Carmine © 1991.
Photo Scala, Florence/Fondo Edifici di Culto – Min. dell'Interno

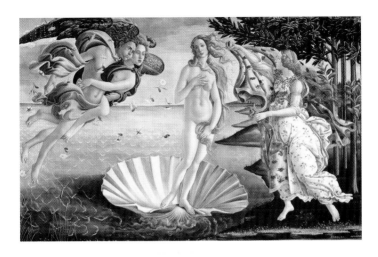

Plate 3 Sandro Botticelli, *Birth of Venus*, c. 1485, Florence, Galleria degli Uffizi © The Gallery Collection/CORBIS

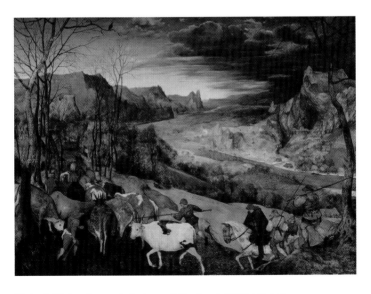

Plate 4 Pieter Bruegel, *Return of the herd*, 1565, Vienna, Kunsthistorisches Museum/The Bridgeman Art Library

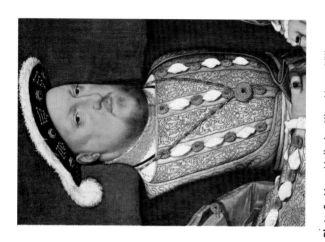

Plate 6 Hans Holbein, *King Henry VIII*, c. 1536, Madrid, Thyssen-Bornemisza Collection/The Bridgeman Art Library

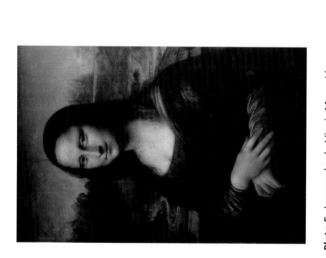

Plate 5 Leonardo da Vinci, *Mona Lisa*, 1503–16, Paris, Musée du Louvre © 1990. Photo Scala, Florence

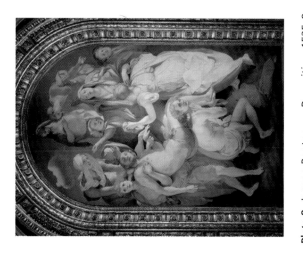

Plate 8 Jacopo Pontormo, *Deposition*, 1525–8, Florence, Santa Felicità © 2000. Photo Scala, Florence

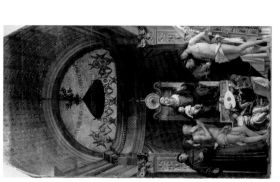

Plate 7 Giovanni Bellini, *San Giobbe altarpiece*, c. 1478–80, Venice, Gallerie dell'Accademia © 2000. Photo Scala, Florence – courtesy of the Ministero Beni e Att. Culturali

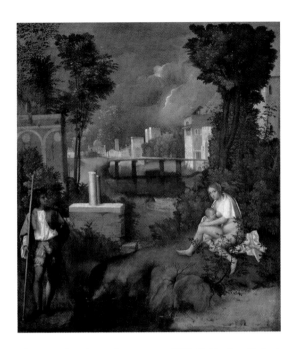

Plate 9 Giorgione, *Tempest*, c. 1508–9, Venice, Gallerie dell'Accademia © 2009. Photo Scala, Florence – courtesy of the Ministero Beni e Att. Culturali

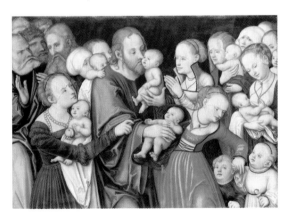

Plate 10 Lucas Cranach, *Christ blessing the children*, c. 1535, Frankfurt, © Städel Museum–ARTOTHEK

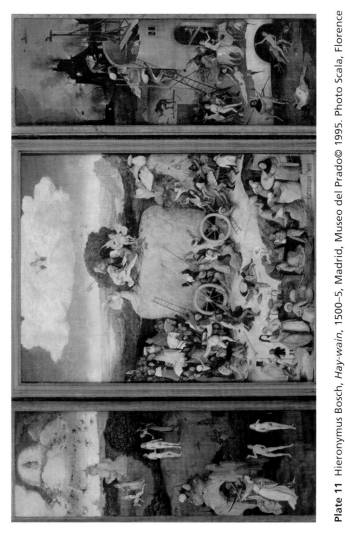

Plate 11 Hieronymus Bosch, *Hay-wain*, 1500–5, Madrid, Museo del Prado© 1995. Photo Scala, Florence

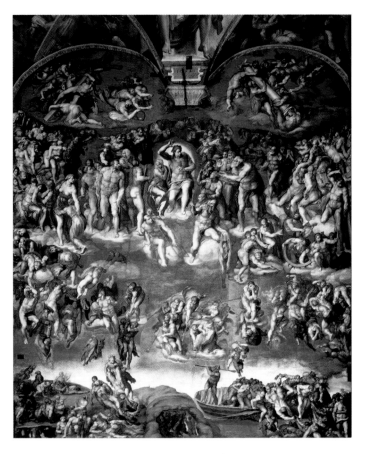

Plate 12 Michelangelo Buonarroti, *Last Judgement*, 1536–41, Rome, Vatican, Sistine Chapel. Courtesy of Vatican Museums

of the traditional Catholic faith, became so enamoured, given that Bosch's paintings give clear expression to the spiritual malaise that was to lead to the Protestant Reformation. Yet Philip would have related to the didacticism of the paintings, to their fixation on man's essential sinfulness, and to Bosch's powerful depictions of the Hell and damnation to follow. Perhaps the fastidious Philip also identified with Bosch's morbid fascination with the wicked ways of the world.

However this may be, it seems likely that many of Bosch's contemporaries would not have been confused by his paintings, however odd they appear to us today. In certain ways, indeed, Bosch's paintings give a more trenchant or pointed expression to 'the state of the times' than those of other artists of the Renaissance. For example, Bosch gave commonly used proverbs, current sayings and figures of speech a newly central place in his work, adding a popular or topical twist to the older northern liking for symbols. He invented a kind of 'picture-writing' that made his paintings appear like visual equivalents to contemporary speech. In order to achieve this, he readily departed from natural appearances to clarify meanings. Thus, we might be surprised to see a man with a pig's head, or with a nose shaped like a trumpet: but the meaning of the image is simply that the one is 'pig-headed' and the other 'blows his own trumpet'. Our problem is that while these particular proverbial expressions have remained in use until today, others have not and so the meaning of the imagery becomes obscure. For contemporaries around 1500, however, the explicit connection of many of Bosch's forms with commonplace sayings must have made their meanings quite clear, once they had grasped the essentials of his approach.

Another indicator that Bosch's works were intended to be understood by his original viewers is the very deliberate flavour of the present that he gives them. In one of his very earliest paintings, the *Seven deadly sins* tabletop, each sin is illustrated by

a telling vignette from the everyday life of late fifteenth-century Flanders. Thus, 'Ire' features a drunken fight outside an inn, 'Gluttony' a family over-eating in their front room, 'Pride' a woman admiring herself in her bedroom mirror held up by a devil and so on. These views of contemporary settings and interiors clearly draw on the new realism of the Flemish tradition of painting discussed in chapter 1. But reality is no longer presented as a setting for sacred figures or portraits of wealthy individuals: it becomes newly important in its own right.

Bosch's vignettes are to be taken as 'typical' scenes of the time: that is, as *genre images* recording familiar instances from everyday life. But the dark satirical meaning of Bosch's scenes is equally significant, and is rather different in tone from the more 'positive' uses of realism in earlier Flemish painting (as indicators of sacred presence or high social status). The room in the image of 'Pride' on the *Seven deadly sins* tabletop insistently recalls the *Arnolfini portrait* (plate 1). But given that it is now a setting for an instance of sin, we might even take it that Bosch deliberately satirised van Eyck's earlier painting, with its proud display of worldly wealth.

Medieval morality in Renaissance art

Bosch's *Hay-wain* (plate 11) is populated by a race of small stick-like figures, often shown in the midst of vigorous action and spread throughout the picture space. The high viewpoint and horizon generate a panoramic view, and create space for still more figures. Bosch's little beings lack internal modelling or three-dimensionality, appearing more like the humorous *drolleries* found in the margins of medieval manuscripts. But his visually reductive approach also allows him to catch the essential character of each form with the minimum of fuss, rather like the skilled animator or cartoonist of today.

It is hard to remember that Bosch's painting is, like many of his religious works, presented in the familiar *triptych* form of the *altarpiece*, with a central panel and two narrower wings made to close over the main image. Flemish works of this type usually feature a small number of large and rounded static figures placed close to us, and the central panel is reserved for exalted sacred actors, such as the Virgin and Child, a saint (figure 1), or a scene from the Bible (figure 2). In Bosch's work, it is turned over to a very unholy-looking mob of contemporaries who surround a massive hay-wain or cart. The relatively small size of the altar-piece and of the painted figures themselves seems to indicate that the painting was made to be seen from close up. The secularised imagery and avoidance of the usual iconography may further indicate a private patron, or an original location in a chapel or house. But this would not quite explain the most radical departure from the norm in this altarpiece: its lack of any direct reference to the Eucharistic ritual that it must have served.

Despite the newness of Bosch's imagery, the overall theme of the *Hay-wain* is not difficult to follow. As in most of his triptychs, we must 'read' from left to right. The left panel features four well-known episodes from the book of Genesis in the Bible using the medieval technique of *simultaneous narrative*. Bosch's pictorial cleverness is evident from the fact that the panel can be read from top to bottom, from background to foreground, and (at the front) from left to right. These movements also trace the temporal one through the text of Genesis. Thus, we move from the earliest point in the story, the fall of the rebel angels from Heaven, at distant top, through God's creation of Eve out of Adam's rib, the temptation at the Tree of Knowledge, ending with the expulsion from Paradise in the lower foreground. The sudden reorientation of this final scene leads our eye in toward the panels to the right: Eve already stands contemplating the central panel, as if acknowledging her responsibility for the terrible events that take place there.

In the central panel, the consequences of Adam and Eve's fall from grace or 'Original Sin' are lived out in the present. In order to confirm this further temporal leap, Bosch bases his scene on a contemporary popular proverb: 'the world is a heap of hay: everyone grabs it while he may'. What we see in this panel is an allegorical – or, better, satirical – image of 'the world' identified in this cynical proverb. Given the saying's generalising application it is hard to know exactly where the scene takes place. Yet the inclusion of a broad landscape with pastures and rivers, everyday implements, and recognisable social types strongly indicates that this is 'the world' of the here and now in Flanders around 1500. The scene is one of often violent struggle and of corrupt human interaction. Around the base of the enormous cart, which is dragged inexorably toward 'Hell', shown in the right-hand panel, peasants grasp the hay, try to mount ladders onto it, or to pick it off with their hoes. Fights have broken out over it: highlighted in the centre foreground is a scene of vicious murder in which one man mercilessly slits another's throat for the miserable reward of a sheaf or two of hay.

The efforts of these peasants to get at the hay are particularly desperate and violent: their immediate proximity to the cart may suggest that Bosch satirises 'the world' only of those lowest in the social hierarchy. But a closer look shows that the upper classes also feed off the hay, albeit at a more decorous distance from the cart itself. Thus a surreptitious exchange of hay between serving woman and aristocratic lady takes place at the foreground left, while at the lower right a fat monk already has great quantities of the stuff brought to him at table by subservient nuns. Most telling of all in this regard are the two dignified equestrian figures following the cart at the left. These are, in fact, the leaders of the sacred and secular world of the late fifteenth century, respectively the pope and the Holy Roman Emperor.

Bosch is thus carefully inclusive in his sense of just how dominant 'the heap of hay' is over all mankind, including its

exalted leaders. It is sometimes said that by including the pope and the emperor, Bosch offered a radical political criticism of all worldly authority, including the established church. But it was, in fact, not unusual to see high-ranking officials of church and state included in religious imagery dealing with omnipresent sin and death: indeed, the core Christian doctrine of 'Original Sin' (carefully depicted in the left-hand panel of the triptych) demanded as much. Bosch's inclusion of *all* mankind in his painting was central to his underlying point: given that sin is the very pre-condition of 'the world', at the core of human existence, then almost by definition no-one is exempt from it. The only adequate response in the face of sinfulness is immediate and continual repentance, and this is the uncompromising message of Bosch's altarpiece.

Atop the cart, a group of music-makers seem to rise above the doings of 'the world' below them, protected from the scenes of struggle and violence by their elevated spatial position and by the screen of a bush behind them. The music they make can be taken as a euphemism for love, especially as the lutenist languorously drapes his legs across those of the singing young woman to his left. Does Bosch allow, here, for the redeeming quality of human love? An angel looks imploringly up at the little figure of Christ in the sky as if to plead the lovers' case. But on the other side a devilish winged figure (reminiscent of the insect-like fallen angels in the left-hand panel) dances delightedly to their music, and the 'pastoral' scene is mocked once more by the two obscenely groping figures (looking suspiciously like the two main music-makers in front of them) half buried in the bush: music-making might seem innocent enough, Bosch insists, but in reality it does little more than fan the sordid flames of lust. And the whole group rides onwards on the haycart destined for Hell.

On the right-hand side of the central panel the cart is dragged in this direction by a striding group of zoomorphic

creatures (men with fishes' or birds' heads, for example) whose 'unnatural' mixed forms now give explicit expression to their depraved identity. The sudden almost seamless shift from normal or everyday human appearances to these animalistic creatures was intended to shock, and was a device used by Bosch in many of his triptychs. It is left deliberately unclear whether these creatures are an overspill from Hell, depicted just to the right, come to drag all mankind into their realm, or were themselves once men who have finally lost their human visage. The group is carefully continued across into the 'Hell' panel, where they quickly take to tormenting naked, bound, and helpless new arrivals. The creatures enjoy themselves in sadistic fashion, hanging up humans on sticks, impaling them, biting their flesh, and grabbing their genitals. Meanwhile, in the background, Hell is presented as a demonic building site: under a fiery sky, it is being rapidly expanded in order to house its myriad of new arrivals from the central panel.

Bosch drew on depictions of the Last Judgement in earlier Flemish altarpieces, where the damned are often shown being dragged off to Hell by zoomorphic demons. This is the case, for example, in Rogier van der Weyden's *Beaune altarpiece* of 1445–8. But Rogier's painting features the moment of Judgement, and the scene is dominated by the divine order of the sacred figures, especially Christ. Everything that happens is under Christ's control and he is accordingly shown as a massive and commanding figure at the upper centre of the work. The example of those being marched off to Hell is balanced by those to Christ's right, who are saved from the torment and are shown ascending to Heaven. In Bosch's triptych, in contrast, there is no reference to the saved: all travel inexorably from left to right. Christ is a tiny and distant figure, who is completely unnoticed by those in the world below. He appears to see everything but remains passive, doing nothing to halt the terrible progress of events. This lack of intervention is central to Bosch's didactic

message, throwing the onus of responsibility back to the viewer, who must identify himself with the human sinners obsessing over the cart. Drawing on the central Christian idea of man's freewill, Bosch lays the blame for the general progression of 'the world' toward damnation firmly at the feet of human beings.

On the outside of the wings of the *Hay-wain*, which close over the central panel, Bosch painted an impoverished-looking figure walking in the same direction as those following the cart. The shared direction of his movement gives a strong clue that this figure is also Hell-bound, though his precise identity has often been disputed. It seems likely that the viewer is meant to see him as representative of man's depravity, as the archetypal human sinner walking the hard road of life. In Bosch's favoured vicious circle, he is both responsible for the sins in the world, and subject to the terrible hardships these cause. Behind him, a man is tied up and robbed while lustful peasants dance on obliviously to the music of a bagpiper. At the foreground left, sinister carrion birds pick over bones, while the 'Wanderer' seems unaware that he is about to step on a cracked bridge. In the far distance, but directly above his head, is a gallows, another sign of the figure's dark fate.

Just as in the three panels of the altarpiece below, Bosch's concern with sin and death is everywhere apparent here. It would have encouraged him to employ an image of a well-known social type for his memorable representative of fallen Man. The widely recognised figure of the wandering vagrant (or 'vagabond', to use the sixteenth-century term) provided a suitable picture of human misery, with his heavy load on his back, his emaciated limbs, his ragged clothes, and telling facial expression of a guilty conscience. In a typically radical move, Bosch insists that we (however respectable, rich, or pious) must see him as our true likeness. He is our representative, the one who best mirrors the perilous state of our souls. Contemporaries would have found this kind of identification

particularly shocking, given that the shameless behaviour of such roving tramps was fast becoming one of the great scandals of the age.

The rise of genre images in Renaissance art

Vast numbers of the poor, made up of unemployed journeymen, ex-soldiers, and landless peasants, of the diseased and disabled, had taken to the road across Europe, and now wandered from place to place begging for alms. Didactic books appeared identifying the various tricks used by these 'vagabonds' in the pursuit of money, and recommending respectable citizens not to give them relief. Bosch must have known satirical works such as Sebastian Brant's *Ship of Fools* (Basle, 1494), which contained a chapter 'On foolish beggars' headed by a woodcut showing a roving vagabond family moving through a landscape. Lucas van Leyden's *Beggars* print of 1520 was more definitely based on the Brant woodcut, though it is also clear that Lucas knew of Bosch's interest in roguish beggars (figure 9). In a number of paintings and drawings, Bosch had shown beggars as owls, using the association to show them as creatures of darkness, or as 'fly-by-nights'. In Lucas's print the sinister boy who appears to lead the group forward has an owl perched on his left shoulder.

Lucas's *Beggars* can be taken as an early example of Bosch's widespread influence on artists working in the Low Countries in the sixteenth century. (As his name suggests, Lucas worked in the university town of Leiden, just some sixty miles north of 's-Hertogenbosch). It also provides a further example of the role of reproductive prints in the spread of 'topical' subject-matter. Lucas's image gives visual expression to an issue of immediate social concern in the early sixteenth century, and shows us how Renaissance art had become newly responsive to the realities of

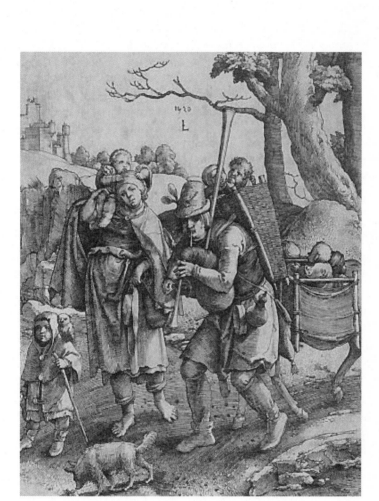

Figure 9 Lucas van Leyden, *Beggars*, 1520, engraving/etching

the 'here and now'. But its subject–matter also indicates the very high level of social mistrust that had developed in northern Europe in the period of the Reformation. Beggars had long appeared in Christian art as the deserving recipients of charity, dutifully doled out by saints or by rich almsgivers. Even in Bosch's *Hay-wain* altarpiece, we must identify with the 'Wanderer' on the outer wings, recognising in his ragged figure a reflection of our own moral identity. But in Lucas's print, the beggars are depicted in a harsher light, as sinister social outsiders, immoral 'others' whom we must define ourselves against.

In keeping with the old Flemish technique of 'disguised symbolism', Lucas hides signs of the depravity of his beggars in the details. There is the leading figure's bagpipes (a common symbol of lust that Bosch had used in his 'Wanderer'), the awl in his hat (indicating his idleness with reference to lazy cobblers), and the many children who are carried along by the couple. This probably refers to Brant's comment in the *Ship of Fools* describing the false beggar's habit of stealing children 'by the score, so he'll have mouths to feed galore'. It may seem that Lucas's print is at some remove from the concerns of the religious Reformers, yet other details of the image suggest a connection. Thus, the leading beggar also has a cockleshell (a symbol of St James of Compostella) and a tiny image of Christ's face (a so-called *veronica*) attached to his hat: both indicate that he and his 'family' are pilgrims, or at least pretend to be. Luther, as is well known, mounted a concerted attack on the whole culture of pilgrimage to shrines, seeing it as a form of corrupt manipulation by the church authorities. He advised that the main sites should simply be levelled to the ground.

It also appears that the beggar boy with the owl in Lucas's print is wearing a monk's cowl. This may be a reference to the many religious orders, such as the Franciscans and Dominicans, who took a vow of poverty, but lived well off the gifts or alms given to them by the wider population. Luther and his

followers particularly detested these so-called 'begging orders' and made little distinction between them and the vagabonds or false pilgrims who also went around demanding alms. Luther would surely have approved of Lucas's print, given his own very active engagement with the fight against vagrants in the 1520s, when he helped draft anti-beggar legislation in German towns, and provided a preface to a new edition of the *Liber vagatorum* ('Book of Vagrants'), a particularly merciless anti-beggar text exposing thirty-three different types of false poor and their tricks.

Luther and his followers were very careful to distinguish false roving beggars from the local and 'true' parish poor, who should always be helped. The Reformers' particular hatred for wandering or 'outside' beggars had to do with the perceived connection of such tricksters with the whole apparatus of the established church, with its worldly culture of manipulative monetary exchange, 'good works' and 'begging' to God for spiritual advantage. Luther's mantra in response to this was 'justification by faith alone'. There is also an interesting link between the Reformers' dislike of begging and their mistrust of religious images. The third commandment in Exodus had clearly stated that 'thou shalt not make unto thee any graven image, or any likeness of any thing that is in Heaven above, or that is in the earth beneath' (20:4). But the place of religious works of art in Christian churches had been secured in the sixth century by a proclamation of the Church Father Gregory the Great that they served as the 'bibles of the illiterate'. Now the very literate Reformers challenged this idea. Though Luther remained ambivalent on the issue, more radical followers such as Andreas von Karlstadt orchestrated an iconoclastic attack on religious works in Wittenberg Cathedral.

In an inflammatory pamphlet published in 1522, Karlstadt pointedly brought together an attack on beggars with one on religious images, arguing that both should be banished from the

'true church'. Far away to the west, the printmaker Lucas van Leyden gave visual shape to a similar set of values in his *Beggars* of 1520. We have seen how Lucas showed his vagrants as knowing cheats and rogues, and his placement of them wandering in a landscape, far away from the church door where they were more usually depicted in religious art, is equally telling, suggesting their status as social exiles. Lucas's print is very definitely not a religious image, and its secularising departure from the more usual depictions of sacred almsgiving to the poor is very pointed. Yet the print is visually attractive, and despite its satirical subject-matter, it is an appealing and buyable work. Its more didactic meanings are carefully concealed (with reference to the tradition of van Eyck) beneath a subtle and skilful display of visual realism which gives a rich visual effect. The *Beggars* is relatively large as prints go (it is quarto size); and its pictorial quality is dependent on Lucas's combination of *engraving* with *etching*, a more refined technique that allowed artists to avoid linearity.

The highly wrought and technically accomplished quality of the *Beggars* shows that Lucas wanted to strongly assert its identity and value as an independent work of art. Perhaps it was even made with a new kind of art patron in mind: a discerning print collector who would have enjoyed teasing out the veiled criticism of the ragged protagonists, but would also have enjoyed the display of technical skill and traditional northern realism. When the great seventeenth-century painter and printmaker Rembrandt van Rijn (1606–69) saw a copy of the *Beggars* in an Amsterdam market in 1642 he paid as much as 179 guilders for it, indicating just how highly prized Lucas's prints had become. In its more immediate context, however, the *Beggars* provides evidence that the impulse to make exquisite works of art, independently of the church, was stimulated rather than destroyed by the coming of the Reformation. It is true that the established tradition of large-scale religious church art was

seriously disrupted (or even destroyed altogether) in certain reformed areas of northern Europe. But the disruption also generated a veritable explosion of innovative works of art in the secular sphere.

Reformist painting at a German Renaissance court

The long and very successful career of the German painter and printmaker Lucas Cranach was based primarily on his ability to adapt to the new conditions for visual artists. For more than forty-five years, Cranach worked as court artist to the Electors of Saxony at Wittenberg. The secular and erotic tone of many of his works was undoubtedly triggered by this role, which involved him in the frequent depiction of leading figures of the court (such as Frederick the Wise and his brother John the Steadfast), and also more mundane tasks such as decorating equipment for tournaments and hunts (which he often recorded in *woodcuts* and paintings). His many paintings featuring nudes were probably commissioned by leading humanists and others at Frederick's court, a refined social elite who would have enjoyed their erotic frisson as much as their indications of classical learning.

Wittenberg was the home of the Lutheran Reformation, and can stand as an early example of a successful reformed court. It harboured a culture in which a new level of separation between the religious and non-religious domains of life quickly developed. As the religious sphere was disentangled from that of the wider world, so new opportunities emerged to create wholly secular works of art which were 'protected' or justified precisely by the firm sense that they did not form part of the machinery of the Reformed church.

The intimate link between Cranach's art and the values of the Reformation cannot really be doubted, even if the painter

often worked happily enough for the enemies of the new religion (see, for example, his *Cardinal Albrecht of Brandenburg as St Jerome*). Cranach enjoyed a close personal relationship with Luther himself, who was godfather to one of his children. But the stream of engraved and painted portraits of the great reformer that Cranach produced from as early as 1520 onwards must also be considered propagandistic (see, for example, the *Portrait of Luther as an Augustinian monk*): as offering the wider world a sympathetic image of the controversial apostate monk who had initiated the religious rebellion.

Cranach's portraits of Luther show an approachable young man with soft features, a gentle non-confrontational gaze, and none of the usual indications of high status or power. These pointedly 'ordinary' images of Luther would have served an important placatory purpose, playing their part in persuading a suspicious world of the radical reformer's humanity and humility. Like many other painters of the sixteenth century, Cranach perceived that portraiture could provide society's leaders with a convincing public image in ways that words could not. But Cranach's service to the Lutheran cause did not stop at portraiture: he was also one of the first artists to develop new kinds of religious iconography to reflect the reformer's ideals. Despite the brief interlude of iconoclasm in Wittenberg inspired by Karlstadt, it soon became clear that the Lutheran church was not wholly opposed to the use of religious images in Christian worship. From around 1530 onwards, Cranach and his workshop accordingly developed a number of religious themes with 'reformed' meanings.

One such theme was *Christ blessing the children*, which survives in no fewer than twenty versions dating from around 1535 onwards. Plate 10 shows one of the earliest examples, featuring Christ surrounded by young mothers and their babies. One of the features of reformed iconography was its truth to the texts of the Gospels: thus, Christ was preferred to the Virgin

Mary, who had, after all, played a relatively minor role in the New Testament. So while the subject-matter of *Christ blessing the children* was completely new to Renaissance painting, it was justified by its source in the Gospels of Matthew, Mark, and Luke. The painting depicts the biblical episode when Christ rebukes the Apostles who had turned away women and children, saying: 'Suffer the little children to come unto me, and forbid them not: for of such is the kingdom of God. Verily I say unto you, Whosoever shall not receive the kingdom of God as a little child, he shall not enter therein.'

It has been suggested that Cranach's painting reflects a specific theological debate within the Reformation, supporting the traditional baptism of children against the adult baptisms advocated by the Anabaptist sect in the 1530s. The child at the foreground left holding an apple, symbol of Original Sin, lends support to this theory. But the wider message of the painting is in accord with Christ's words in the Gospel: a close approach to God can only be made when sinful mankind emulates the simple innocence of children. In support of this, Cranach pointedly places the Apostles away at the upper background left of the painting, their visual marginalisation echoing Christ's warning. Christ turns his back on them in favour of the women and children, who enjoy immediate and unmediated physical and emotional access to his love.

In Cranach's painting, Christ is truly a man of the people offering open house to all those who approach him on the basis of 'faith alone'. This idea of a Christian religion turned outwards, inclusive rather than based on hierarchy, rank, or position, was one of the great ideals of the Reformation, even if it was all too quickly betrayed. In Cranach's painting, the cutting off of forms at the right-hand edge emphasises the idea of an almost limitless crowd of innocents pushing forward to receive Christ's freely given blessing. This contrasts with the aged and disgruntled Apostles to the left, among whom St Peter raises his

hand in a gesture which seems to reflect his consternation and objection. Peter was, of course, the Apostle most closely identified with the Roman Catholic Church.

Cranach's image of the victory of innocence over knowingness, youth over age, the weak over the strong, and of faith over all, makes this work a very typical example of the religious art of the early Reformation. One might add to this list, the victory of present over past, for as usual Cranach is very careful to give his painting an air of the here and now. Christ is very much alive, and the women around him, however generic in facial type, are pointedly dressed in contemporary clothes, sporting the fashionable jewellery and coiffures of 1530s Wittenberg. It would be too much to say that *Christ blessing the children* is a *genre image*: but it certainly promotes a homely atmosphere of freely given love and intimacy. Christ is not picked out from the human throng; his sensitive hands caress the soft human flesh of the infants he cradles. Gone is the sacred distance or 'otherness' so familiar in traditional religious painting, with its sense of hierarchy and decorum, of the remove of the sacred to a higher domain.

Religious paintings such as *Christ blessing the children* were not intended as church *altarpieces* (although Cranach did paint a number of these, especially in his early pre-Reformation years). The lateral shape and relatively small size indicate that it was intended for a private home, where it would have stimulated the kind of passionately felt family-based devotion to Christ that Luther and his followers most approved of. This new domestic context for sacred art is also suggested by the multiple versions of the work. Clearly, many reformed households were keen to have a devotional focus for their prayers, and the Cranach workshop strove hard to fulfil the demand.

More generally, Cranach's output has a noticeable production-line aspect, with a relatively limited number of subjects repeated many times, although with variations. It seems that he, like other northern artists such as Dürer and Lucas van Leyden,

was very keenly aware of the developing market possibilities for visual art, and was prepared to make paintings without a commission, much as these masters supplied prints. Operating a basic principle of repetition he may have seen painting as similar to reproductive printmaking, a field in which he was also very active. His paintings have something of the economy and linearity of woodcuts and engravings, juxtaposing areas of light and dark in a cursive way that reminds us of the print medium. As if to confirm this connection, some of them are based directly on reproductive prints.

The Renaissance ruler portrait

Another example of the revitalisation of secular art under the impact of the Reformation can be found in the career of Hans Holbein the Younger, a German artist born in Augsburg whose career reached its climax in London. Holbein was certainly not the first north European artist to work in England, but his impact there, especially as a portrait painter, was enormous, setting the tone for much of the art produced in Britain for the rest of the century. Following an initial visit between 1526 and 1528, during which he made a number of portraits of prominent individuals such as the future Chancellor, *Thomas More*, Holbein finally moved to London on a permanent basis in 1532. Here he painted a succession of superb portraits of leading figures of the English court, including his famous image of *King Henry VIII* (plate 6). Like Cranach in Wittenberg, Holbein in London became court painter in a city that was an important centre of Protestant reform. And though Holbein painted relatively few 'reformed' religious paintings (although see his *Gospel and Law* of c. 1532) he was equally successful and inventive as a painter of secular court pictures.

Although Holbein produced images of many kinds, his career was much more narrowly defined by portraiture than Cranach's. In earlier discussions of portraits we have seen that this kind of work appears to reveal the Renaissance obsession with the individual. Certain questions must follow from this, though: we must ask what kind of 'individuals', exactly, made it into Renaissance portraits; and if these portraits were more concerned with establishing recognisable social position or identity than defining 'individuality' in its own right. The Renaissance portrait can be understood as promoting either 'memoria' or 'gloria', that is as preserving the memory of the dead or promoting the glory of those still alive. But these two functions presuppose that the individual life concerned was worthy of being remembered or glorified. And in the hierarchical societies of the fifteenth and sixteenth centuries most people's simply were not.

Renaissance portraiture focused primarily on the ruling classes, although in trading centres such as Bruges and Florence these people were more likely to be merchants than aristocrats (see plates 1 and 5). The social elitism of the genre did, however, dissipate somewhat in the sixteenth century, when men and women from a wider social spectrum found their way into portraits. This directly reflects the massive increase in the number of portraits commissioned after 1500, such that artists like Holbein were increasingly able to specialise, basing their professional careers on the production of works of this type.

Holbein had started out as an artist in the Swiss city of Basle producing a wide variety of work, including church *altarpieces* of fairly orthodox type. But with the coming of the rather severe variety of religious reform introduced in the 1520s by Huldrych Zwingli (1484–1531), commissions for art in Basle diminished, and Holbein was lured to the up-and-coming court of Henry VIII in London. But the religious Reformation, about which Holbein himself appears to have been rather ambivalent,

followed him to his adopted city in the 1530s. So Holbein became a painter of court portraits, whose status as bona fide secular images protected his career from the iconoclastic tendencies of the time.

Renaissance artists often used portraiture (or rather self-portraiture) as a means of making the case for an elevation in their own social status. Dürer exploited the elevating associations of the genre to suggest that he was less an artisan working with his hands than a god-like creator or a learned gentleman. But if this speaks of Renaissance portraiture as a tool of social ambition, or as a field that had come to reflect the wider social aspirations of mainstream European society, this did not deter those at the very top of the social pile from continuing to exploit its capacities to elevate and dignify. Indeed, the Holbein illustrated here is a great example of the use of portraiture to send out a message about the power and authority of a leading Renaissance ruler.

Examination of Holbein's *Henry VIII* begs the question whether the Renaissance portrait is 'realistic'. This was an aspect that Holbein's royal sitter was certainly very interested in. King Henry VIII appointed Holbein as his court painter in 1536, around the time of this painting. In the years immediately following, the king seems to have used Holbein's famed visual accuracy in the increasingly desperate search to find a new queen to provide him with an heir. Holbein's portraits of *Christina of Denmark* (1538) and *Anne of Cleves* (c. 1538–9) portray possible successors to Henry's current wife, Jane Seymour. But a closer look at Holbein's portrait of the king himself shows the painter's ability to shape the raw facts of reality before him without appearing to do so: the ultimate skill, after all, required of the painter-as-courtier.

The Madrid portrait is an example of Holbein's later style (he died just six or seven years after it was painted). In his earlier portraits of the 1520s, he had used naturalistic settings in

perspective, and included everyday objects that served as attributes of his sitters' work or personality. In portraits such as the *Thomas More*, Holbein presents his sitter as a living person, caught in the midst of his busy life. In the *Henry VIII*, by contrast, the king's image is dominated by flattened, highly decorated artificial surfaces. The ornate blackwork patterns of Henry's dress are painstakingly transcribed, in a manner that resurrects the meticulousness of the Eyckian tradition in fifteenth-century Flanders. Henry's body is at once flattened and made monumental by this technique. The literalism of the surface detail, like the lack of internal modelling using light and shade, makes Henry's form appear massive and solid, more like a piece of highly decorated architecture than a real human body.

The angled three-quarter view used in earlier works such as the *More* portrait gives way to a static frontal presentation, and the form of the sitter is moved so close that it does not fit within the frame of the picture. Henry's shoulders, arms, and hands break its bounds in a way that more classically orientated artists, such as Leonardo da Vinci, would have instinctively avoided (see plate 5). But Holbein's calculated shrinkage of space is used for expressive effect, again suggesting the king's imposing physical presence. Despite the sense that Henry cannot quite be contained by his image, Holbein does not allow us to meet his eye: the proximity of his form is contradicted by the distance implied by his outward gaze. We have little sense of where, exactly, Henry is, but the intensity of the blue background removes him from the immediacy of 'the world', and may even have been chosen to recall the sacred blue of Heaven used in so many depictions of sacred figures. (A similar 'heavenly' blue background is used in other courtly ruler portraits of the period, such as Agnolo Bronzino's *Eleonara de Toledo with her son* of c. 1545.) However this may be, the unnatural but decorative colour serves to remove Henry from the everyday: Holbein

seeks to create a striking and lasting image of the king that sets him beyond the usual human co-ordinates of time and place.

Holbein's very deliberate departures from the naturalistic traditions of the Renaissance portrait are further evidence of his protean ability to adapt to a new kind of sitter, with new demands. The comparative realism of the *Thomas More* portrait may have suited his humanist sitter, who was shortly to pay the ultimate price for his refusal to embrace Henry's break from the Roman church. But by the mid-1530s, something different was needed. For a portrait of the king himself, now supremely powerful, an image was required that expressed both his immediate presence and his difference from ordinary men. In one sense, Holbein's painting promotes Henry as a unique individual. The essential accuracy with which the facial features are recorded, for example, cannot be doubted, while the way his form expands beyond the picture space must also reference the king's massive weight. But these potentially inconvenient realities are subtly manipulated to create a lasting image of personal power and authority.

Given Henry's unbridled power over state and church in England at the time of this portrait, it may seem surprising that Holbein did not reference these roles more directly. But in this respect he demonstrated his sophistication and international experience. He pictured Henry not as the cruel and fickle dictator that he really was, but rather as a confident European-style monarch, the equal of royal rulers all across the Continent. Holbein presented Henry as a true Renaissance prince, and as a man of leisure and sophistication. He combined the imposing formal qualities noted above with the essential idea that Henry was a 'gentleman', perhaps drawing on fashionable etiquette manuals such as Baldassare Castiglione's *The Courtier* (1527). Henry sports furs and silks rather than armour and weapons, his fine clothing appearing like a proof of his cultural superiority.

The rise of landscape painting in the Renaissance

In this chapter we have seen how new empirical kinds of visual art drawing directly on something seen or experienced took a hold in northern Europe during the sixteenth century. In addition to *genre images* such as that by Lucas van Leyden (figure 9) and portraits such as Holbein's (plate 6), the first 'pure' landscapes began to appear. Dürer's watercolours have already been mentioned, and as the sixteenth century progressed 'specialists' emerged, such as Antwerp artist Joachim Patinir (d. 1524), who went so far as to provide landscapes for paintings by other artists. In his own works, Patinir always included a mythological or religious subject, even if the landscape dominated (see his *triptych* with the *Baptism of Christ, Penitence of St Jerome and Temptation of St Anthony*).

But when, in 1565, Pieter Bruegel painted his series of landscapes known collectively as the *Months*, all reference to iconography (see box on p. 88) was dropped. In the *Return of the herd* (plate 4) from this series, we look in vain for a 'subject'. A group of anonymous herders and hunters drive cattle toward a village to the left, and there is plenty of other evidence of man's activity (riverside buildings, including a church, and some boats in the deep valley to the right, for example) but the scene is none the less dominated by the expansive and dramatic sweep of the landscape. The human figures are easily upstaged by the powerful forms of nature, their activities and identity dependent on its brooding force.

Jettisoning all extraneous subject-matter, Bruegel establishes his theme as more essential: this painting (like all the others in the series) seems to be about man's relationship with nature, and nothing else. The abandonment of subject also has the effect of setting this relationship in the present, of freeing it from 'history' or 'text'. Bruegel's concern with landscape can be traced back to

his earliest works in the 1550s, but it is also an aspect of his wider interest in contemporary life. It developed alongside his *genre imagery*. In an important sense, a work such as the *Return of the herd* still *is* a genre painting: that is, a typical scene of the every-day, which the viewer could recognise without reference to the past or to books. Bruegel's realism suggests that his paintings show something 'normal' or actual, often experienced by the viewer in the ordinary course of life. Even when Bruegel painted a scene from classical mythology (such as the *Fall of Icarus*) or the Bible (such as the *Procession to Calvary*), he made sure to give it a flavour of the 'here and now'. This kind of realism was clearly much appreciated by his circle of supporters: his friend, the famous cartographer Abraham Ortelius (1527–98), claimed that Bruegel's were 'hardly works of art, but rather works of nature'.

It is surprising that it took so long for landscape to become established as a bona fide subject for visual art, given the presid-ing Renaissance interest in the imitation of nature. But Christian art was, for obvious doctrinal reasons, dominated by sacred figures, while that of classical antiquity laid more or less exclu-sive emphasis on the human body. An artist like Michelangelo, who so convincingly brought these two traditions together (see figure 4), had nothing but contempt for landscape painters. According to an early source, he mocked those northern artists who naively depicted 'the green grass of the fields'. But the aesthetic obsession with the human form in the classicising south went alongside an equally deep-seated religious mistrust of nature among certain northern artists, with its origins in the medieval idea that the world was possessed by the devil, death, and sin. We have seen how this moralised conception underpins the work of Bosch, who often used landscape as a fitting setting for his harsh allegories of human depravity.

Like many Flemish artists of the sixteenth century, Bruegel was deeply influenced by Bosch's paintings. Until late in his

career, he employed a high panoramic viewpoint similar to Bosch's (see plate 11), using it to establish the wider moral significance of his paintings. Like Bosch, he thought of each work as a 'Theatrum Mundi' ('theatre of the world') from which basic lessons about human behaviour could be learned. His frequent use of popular sayings and parables was also Boschian. In paintings such as *Netherlandish proverbs* and *Children's games* he presented veritable catalogues of mid-sixteenth-century Flemish popular culture. But despite the satirical and allegorical elements in these works it is already more difficult to find a definite underlying moral schema, however revealing they are about the many pitfalls of 'human nature'. In his *Battle between Carnival and Lent* resigned laughter seems to be the only response to the ridiculous antics enacted in the town square, given that the lean and pious 'lenten' figures to the right are fully equal in their grotesquery to the carnival types they do battle with in a mock joust in the foreground.

Though examples of folly and cruelty are often present in Bruegel's works, these aspects do not wholly complete the meaning. It is as if the simple moral schema of Bosch's didacticism cannot contain the later artist's realist interest in the world around him. Or that a presiding secular interest in 'human nature' keeps him from turning to the kind of sacred schema of sin and punishment that underpinned Bosch's work. In the final few years of his career, cut short by his early death in 1569, Bruegel's instinct for realism took him into new territory, such that the visual fabric of the Boschian style broke down. In works such as the *Peasant dance* and *Peasant wedding*, the lofty distance of the panoramic viewpoint was abandoned, as Bruegel brought the viewer right up close to his peasant subjects.

Bruegel's attitude to the peasants he so often depicts is, in fact, central to our understanding of his art. It appears to have been essentially ambivalent. The early historian of Netherlandish art Karel van Mander claimed in 1604 that Bruegel was born a

peasant, thus identifying the artist directly with his lowly subjects (on this assumption he was long known as 'Peasant Bruegel'). From the outset of his career, his works have an earthy 'rural' or agricultural flavour, and even when they are set in a village we are aware that we are viewing a country scene. But it has more recently been realised that Bruegel was, in fact, a city man of some culture and learning. Though his origins remain obscure, he lived and worked in the major international metropolises of Antwerp and Brussels, where he was commissioned by leading humanists and courtly patrons such as Ortelius and the banker and royal official Niclaes Jonghelinck (for whom he painted the *Months* in 1565). Bruegel, it turns out, was very far from the simple peasant that van Mander identified. He was, rather, a sophisticated cosmopolite, a widely travelled city-dweller who moved in highly cultured circles.

As such, Bruegel was at least to some degree removed or distanced from the rural peasantry who were his artistic subject-matter. It may be that his favoured high viewpoint, allowing an overview of the rural panorama, is an aspect of this cultural distance. Perhaps it even traces or figures a kind of social condescension: the well-established metropolitan habit of 'looking down' on country or parochial people that would have been well engrained in the urbanites who bought and enjoyed Bruegel's paintings. The tradition of showing peasants as foolish, lazy, violent, or bad in Flemish art went back at least as far as Bosch (see plate 11), and says something about the social or class boundaries of visual art more generally in the Renaissance. By heaping contempt on those toward the bottom of the social hierarchy, those further up (who owned and admired art) maintained their own sense of moral and cultural superiority. Yet Bruegel's attitude to his 'villeins' (as peasants were often described in the period) was more complex than this would imply.

As noted above, Bruegel used peasants to illustrate moral points about human behaviour: that is, as 'representatives' of

mankind, or of the ways of the world. Peasants, he may have reasoned, were uneducated, and thus unable to conceal their motivations or to control themselves. Their 'doings' were thus more obvious and served very well as illustrative examples of human folly. But this usage required of the educated viewer not the cold distancing described just now, but rather that the peasantry were understood as his surrogates. He had to recognise their basic humanity, and to identify their failings as essentially similar to his own. Arguments about any such interpretation will no doubt continue, but it is clear that in late works such as the *Peasant dance* and *Peasant wedding* mentioned above, the viewer is pointedly placed on the same spatial level as the dancing and celebrating protagonists, plunged into the midst of a vibrant and dynamic multi-sensual peasant world. Thinking visually, as always, Bruegel sought to close the gap between sophisticated urban viewer and simple rural peasant once and for all.

It may be, however, that the 'gap' (between urban and rural, elite and popular, viewer and subject) was just too large to be filled in: judgements are still to be made about the cavorting and drinking outside the inn, or the dumb show of the simple wedding. It is probably still evident in the series of the *Months*, where peasants are once more the protagonists. In these paintings, however, there is no sense that their behaviour is under scrutiny. A much more positive view of peasant life is given here: they are shown as literally embedded into the landscapes, their activities in full accord with the deep rhythms of nature.

We are tempted to think of this as more 'realistic'. But we need to be careful here, given that three of the five surviving paintings from the series (including the *Return of the herd*) are structured very similarly, with a high view down past foreground figures to a distant river valley which widens in the distance, and mountains to the right. These landscapes are, in part at least, the artist's own inventions. If the scintillating details of trees, foliage, weather conditions, livestock, agricultural

produce, and buildings give a sense of the contemporary rural world of Flanders, the dramatic mountainous structures of the landscapes are closer to the Alpine views Bruegel had seen and drawn on his trip to Italy some fifteen or so years before.

The perception that Bruegel's landscapes are 'constructed' is important to our understanding of the *Months*, which were probably originally a series of six paintings, each showing two months of the year (the *Return of the herd* shows October/November). The respectful – or at least non-judgemental – depiction of the working peasants in the series reveals Bruegel's debt to the old medieval tradition of illustrating the 'Labours of the Months' in illuminated *manuscripts*, the most famous of which is the Limburg brothers' *Très Riches Heures* of 1412–16 owned by the Duc de Berry. In these miniaturist works, peasants are shown working in landscapes, their varying activities marking the changes of season. There is typically no social satire; rather the peasant is simply depicted as part of nature, obeying its rhythms and responding to its demands as the year passes by. Bruegel's *Months* are, of course, on a much larger scale than such illuminations. If those illustrations acted as visual mnemonics for the reciting of the sacred words of the religious text, Bruegel's paintings were modern free-standing works, intended to open up free and sophisticated discourse. But the reference to this much older sacred tradition was none the less very deliberate, and gives a clue to the wider meaning of the *Months*.

Bruegel's *Months* picture an old world of order, harmony, and continuity, and these qualities have played an important part in their lasting appeal for the modern viewer. The paintings offer the very comforting sense of man living in tandem with nature: we know that the lives of these peasants are tied into the repetitive cycle of the months, seasons, and years. They have performed their 'labours' many times before and will do so many times again. Bruegel is careful not to be too anodyne about all this: nature is vast and powerful, and can be terrifying and cruel,

while man is small, vulnerable, and subservient. The darkening sky over the harsh mountains to the right of the *Return of the herd* is full of ominous threat, chasing the herdsmen and their animals back into the safety of the village and cattle sheds. Its deathly powers are suggested by the dark carrion bird placed menacingly above the little figures on the already dead tree. But we have no doubt that men and animals will make it home in time: even if the coming winter is hard and long (as is shown in the next two scenes, known as *Hunters in the snow* and *Gloomy day*), the warmth of spring will eventually return with this simple rural society more or less intact.

But there is in all this an appeal to a world already gone by, an underlying nostalgia for something lost, or already culturally distant. The peasants' concerns and priorities are not those of the viewers in the opulent privacy of the wealthy banker Niclaes Jonghelinck's home in Antwerp. Is something of this cultural difference or splitting between viewer and image evident from the high panoramic viewpoint Bruegel still employs? It creates a sense that we hover, bird-like, above each scene, rather than directly occupying its world. The very act of representing these archetypal images of an intimate connection between man and nature presupposes a measure of detachment from this relationship, a stepping outside of the physically engaged world depicted.

Bruegel's *Months* are, in the end, products of their time and place. Despite their apparently simple and rural subject-matter, they are productions of the decidedly complex urban culture that flourished in the socially advanced cities of the Low Countries in the mid-sixteenth century. Antwerp in particular was a major entrepôt, a centre of international trade, and a crucible of early modern capitalism. In this fervid trading environment, some artists (though probably not Bruegel) made works 'on spec' rather than commission, and sold them in markets or through dealers.

It was a world of monetary exchange and (for successful merchants and bankers manipulating capital) material luxury, one increasingly far removed from the age-old rhythms of man and nature described in the *Months*. But if the modern world was forged in such metropolises, and Bruegel and his patron were inevitably part of it, then there was also a new need to look back at what 'progress' had left in its wake. Bruegel's series of *Months* perfectly expresses the very modern desire for something simpler: a more innocent world based on the certainties of the annual cycle of the year, and on the promptings and ultimate provision of nature. Ironically, this world of rural harmony was one that the Renaissance, with its more urban, mercantile, and individualistic values, had begun to undermine.

6

Between court and reform: Italian Renaissance art after 1520

Despite the mercantile power of the Low Countries, European culture gradually became orientated around the courts after 1520. Italy's loss of political independence to the increasingly powerful court-dominated countries of France and Spain had a role to play here, as did the continued strength of the papal court in Rome. By the mid-century even the once proud republic of Florence had been transformed into a court with the Medici installed as ruling family. Elsewhere, long-established court cities such as Milan, Naples, Ferrara, and Urbino increasingly fell under the influence of larger, foreign ones.

Having said this, the cultural and artistic profile of Italy continued to rise, such that Italian artists were employed on work for the newly powerful courts abroad. The French king, Francis I, imported leading Italian painters and sculptors to decorate his palace at Fontainebleau near Paris, while the powerful Habsburg court in Spain patronised the great Venetian painter Titian (c. 1490–1576). A cycle of mythologies by Antonio Allegri, known as Correggio (c. 1489–1534), was commissioned by the small Gonzaga court at Mantua in the Po valley, but the paintings were intended as a diplomatic gift to the

Habsburgs. The example neatly shows the newly subservient or 'satellite' relationship that the once prominent courts of northern Italy now had with those abroad.

In Correggio's works, the Renaissance obsession with the nude which we have noted in earlier chapters (see plates 2, 3, and 9 and figures 3, 4, and 7) became a matter of explicit erotic invitation, with the excited male viewer in mind. But if Correggio's paintings appealed to the sensual elitism of court culture, the cycle of mythologies known as the *poesie* that Titian sent to King Philip II of Spain were rather different. In these works, the usual references to classical antiquity and sex are laced with suggestions of violence and death in a manner which upsets the bucolic 'courtly' tone. The dark expressive quality of Titian's late mythologies reflects the changing world of the sixteenth century, with its new dimensions of conflict, division, and instability.

In the 1520s and 30s interest in Luther's call for change was widespread, and some Italians at least clearly sympathised with his demand for a spiritual purification. This newly charged religious climate is increasingly apparent in art of the time, for example in the strange paintings of the Florentine Jacopo Pontormo (1494–1556). The Roman church eventually responded to the Protestant rebellion by calling the Council of Trent (see box on p. 140), a meeting of leading churchmen from across Europe, at which it was decided to reaffirm all the traditional teachings and doctrines of the established church, and to proclaim the Protestant Reformation 'anathema'. There followed a period of so-called Counter-Reformation, during which spiritual austerity and doctrinal correctness became predominant across Italy.

The churchmen now began to question the very presence of the nude in art, especially in religious works, arguing that it would stimulate impure thoughts in the worshipper. If the nude remained central to the mythological paintings of Correggio and

Titian, its place in sacred images was now directly challenged. Within a few years of its unveiling in 1541, Michelangelo's *Last Judgement* fresco in the Sistine Chapel in Rome (plate 12) was the subject of fierce controversy. In this later stage of his life, Michelangelo was possessed by an intense desire for spiritual purification, and his fresco looks very different from earlier 'sensual' works such as the *Dying Slave* (figure 4). Yet he also remained true to his Renaissance inheritance in that his fresco featured massive and dynamic nudes in movement. This astonishing work is very far from the kind of doctrinal 'painting-by-numbers' (or, more accurately, *letters*) found in late sixteenth-century religious painting of the Counter-Reformation.

THE COUNCIL OF TRENT

The Council of Trent was a meeting of Catholic bishops from across Europe that met periodically between 1545 and 1563 in the town of Trento in the northernmost part of Italy. In the face of the Protestant attack, it reaffirmed the established church's teachings on major topics such as Scripture and Tradition, Original Sin and the Sacraments. Of particular importance was the Council's reaffirmation of *transubstantiation* during the Eucharistic Mass, which had been directly challenged by the Reformers: The Council declared that Christ is 'really, truly, substantially present' in the consecrated forms. For art history, the Council's late ruling on images (3–4 December 1563) is most significant. The decree reaffirmed the legitimate place of images in churches, with reference to the Church Father Gregory the Great's (c. 540–604) assertion that such depictions served as the 'bibles of the illiterate'. But the Council did require artists to paint more simply in ways that could be easily understood by worshippers. In the years after the Council closed, a number of prominent churchmen published didactic books expanding on the Council's decision regarding images, requesting artists to maintain due decorum in their religious works, and to avoid using obscure, confusing, or inappropriate forms.

Art and pornography: the Renaissance erotic nude

In the early 1530s Correggio painted a series of four mytholog-
ical paintings showing the *Loves of Jupiter. Jupiter and Io, The rape
of Ganymede, Leda and the swan* and *Danaë. Jupiter and Io* (figure
10) features a naked young woman in the throes of lovemaking.
Her partner is not, though, a man but a cloud; or rather he is
Jupiter, supreme ruler of the pagan gods, who has assumed this
disguise to hide his amorous activities from his jealous wife,
Juno. Anyone who has read popular classical texts such as Ovid's
Metamorphoses will know that this kind of trick was typical of
Jupiter in his pursuit of young women: he appears as a swan to
Leda, a bull to Europa, a shower of gold to Danaë, and a satyr
to Antiope. In this case, however, the deceit got nowhere: the
jealous Juno turned the unfortunate Io into a heifer (referenced
by the cow peering into the scene at the lower right), and she
was later pursued around the world by a gadfly.

In Correggio's painting, the disguise looks effective enough,
though Jupiter's presence is evident from the ghostly face that
steals a kiss from his lover, from the hand that reaches round to
grasp her side, and from the sudden movements of the young
woman's body, which seems to spasm involuntarily under his
hidden touch. It has been pointed out (particularly by feminist art
historians) that erotic Renaissance mythologies such as these are
products of male sexual fantasy, and perhaps little better than soft
porn. Others (usually men) have robustly defended such works as
subtle and unique works of art, whose artistry transforms their
lascivious subject-matter into something noble and timeless. Both
sides of this argument do little to help us understand such paint-
ings: simply accusing the sixteenth century of sexism reveals
more about our own preoccupations than about erotic art of the
Renaissance; and it seems clear that in this period 'art' was not a
wholly distinct category from 'pornography'.

Figure 10 Correggio, *Jupiter and Io*, 1530–3, Vienna, Kunsthistorisches
Museum © 2006. Photo Austrian Archive/Scala, Florence

Correggio's *Loves of Jupiter* series is very untypical of his wider activity: as with most other *Cinquecento* artists, religious subjects easily outnumber mythological ones in his oeuvre. As was noted in chapter 2, the taste for mythological art in the Renaissance remained an elite one. It may be that 'lesser' patrons occasionally commissioned mythologies with erotic content: Correggio's follower Parmigianino (1503–40) painted a sexually charged image of *Cupid* for a minor nobleman in Parma in the same years, for example. But the patronage of Correggio's series was more typical: the paintings were a commission from Federico II Gonzaga (1500–40), the fifth Marchese of Mantua, though the painter must have known that his patron intended them as a present for a still higher-ranking nobleman: the Habsburg Holy Roman Emperor, Charles V (1500–58).

It is sometimes thought that they were given to Charles on one of his visits to Mantua in 1530 and 1532: but it is just as likely that they were sent directly to Spain. Quite apart from what this tells us about the use of paintings as diplomatic gifts, it indicates that such erotic works were circulated among the very highest social circles. It comes as no surprise that the production and reception of such works did not involve women, even if their revealed and sexualised bodies form the true subject-matter. It was Federico's mother, the Marchesa Isabella d'Este (1474–1539), who first established the fashion for mythological series in the north Italian courts. But the series she commissioned for her 'studiolo' or study in the Ducal Palace at Mantua were learned allegories rather than invitations to erotic stimulation (see, for example, Andrea Mantegna, *Pallas expelling the vices from the garden of virtue*).

Federico II's new paintings were closer to the tone of a cycle recently commissioned by his uncle, Alfonso d'Este (1476–1534), the Duke of Ferrara, than to his mother's staid allegories. Titian had supplied Alfonso with a series of 'classical' paintings (known as the *Bacchanals*) for a room in his palace

featuring Bacchus (god of wine) and Venus (god of love) that celebrate bodily rather than intellectual pleasures (see *The worship of Venus*, *The Andrians*, and *Bacchus and Ariadne*). With their focus on single nudes, seen close up and in the midst of sexual passion, Correggio's new cycle went even further than Titian's.

Correggio's paintings are not, though, as explicit as they might have been, and work their visual charm through their euphemistic approach. Correggio exploits the essentially unlikely nature of his subject to show off his special skills with pictorial illusionism, which had recently been well proved by his multi-figured decoration of the dome of Parma Cathedral (1522–30). In *Jupiter and Io*, the god's kiss is on the cheek rather than the mouth, and the positioning of Io's body away from the viewer conceals her from our gaze. Her open-legged posture, ecstatic expression with head thrown back, and the way her limbs twitch with delight as she feels the god's touch on her body all refer to sexual intercourse: but Correggio does not show the act itself.

Comparison with the dull mechanics of the series of sexually explicit prints known as *I modi* ('the positions') designed by the Mantuan court artist Giulio Romano (c. 1499–1546) in the same period reveals the comparative subtlety of Correggio's approach. The printmaker Marcantonio Raimondi (c. 1480–1534), who engraved and circulated Giulio's inventions around 1524, spent a spell in prison for his pains, a fate that tells us much about the decided limits to the acceptability of erotic art in sixteenth-century Italian society. In the guise of 'learned' classical mythologies, euphemistically presented and commissioned by or for those at the very top of the social hierarchy, the taboo topics of sex and desire could certainly feature. But in the popularising medium of the reproductive print they were seen as an inadmissible affront to public morality.

The court context of Renaissance mythological painting

Like certain other artists discussed in this book, Correggio took his name from the local town where he was born. But his *Loves of Jupiter* were intended for a leading foreign patron thousands of miles away in Spain. As such, he suppressed all traces of the quirkiness of local style, producing instead a series of works conceived as cultural exports that showcased Italy's renowned tradition of art to a patron still on a learning curve in this regard. The painters of the Habsburg court were Austrian artists such as Jacob Seisenegger (1504/5–67) whose style displayed little understanding of the ways of Italian classicism. Now Correggio intervened, with a series of works well calculated to 'educate' the emperor in this regard. The cycle also flattered him on a thematic level: the focus was carefully chosen, for Jupiter's eagle was Charles's personal symbol, identifying him with the supreme ruler of the classical gods.

Charles was thus invited to imaginatively substitute himself for Jupiter in the paintings, and thus (by proxy at least) to enjoy the pleasures taken by the god. This kind of erotic projection became a commonplace in later mythologies for leading courtly patrons, as we shall see in our discussion of Titian's *poesie*. The commissioning of Titian's cycle by Charles's son, King Philip II of Spain, is evidence of Correggio's success in instilling a lasting love of Italian mythological painting in the Habsburg family. Philip's brother, Emperor Maximillian II (1527–76), owned a set of copies after Titian's paintings, while Maximillian's son, Rudolf II (1552–1612), commissioned many mythologies for his vibrant court at Prague, and tried hard to acquire Correggio's *Loves of Jupiter*, owned by his maternal grandfather. All of which tells us that the development of erotic mythological art in the sixteenth century owes a great deal to the patronage of a single royal family.

However, Charles V did not commission Correggio's cycle: the paintings were originally intended as a diplomatic gift, and thus had their place in court politics around 1530. Charles elevated Federico to Duke of Mantua on his visit of 1530, and it is tempting to see the gift as a 'thank you'. The Gonzaga court (like others in northern Italy) needed to restate its traditional allegiance to the Holy Roman Emperor, in order to align itself with the rising star of the Habsburgs. Since medieval times the cities and towns of Italy had owed allegiance either to the pope (the 'Guelphs') or the Emperor (the 'Ghibellines'); but by 1530, such gifts were more about the need to establish a place within the wider international network of courts. Federico's paintings for Charles were a form of courtly homage which acknowledged the Emperor's supremacy as 'ruler of the gods', while also asserting his own position as a faithful vassal. The clever decision to use painting to 'network' in this way indicates that Italian Renaissance art now had an important part to play in European court culture.

International classicism and Mannerism

The sophisticated eclecticism of Correggio's style is central to his appeal and this, along with his special skill with illusionism, has led many to see his work as a forerunner of the Baroque style of the following century. In creating his artistic synthesis, Correggio drew on the softening *sfumato* of Leonardo: 'smokiness' is, in fact, central to his theme in *Jupiter and Io*, and suits the indirect approach to erotic subject-matter described above. His rich and warm palette also indicates his awareness of Venetian *colore*. Like the Venetians, Correggio drew relatively little, building up his compositions by exploiting the translucency of oil paint.

But the figure of the nymph also carefully references the *disegno*-orientated tradition of central Italy. Her complex shape is, after all, a tour de force of formal *difficoltà*. Note, for example, the careful placement of her right foot, so as to create the whole impression of what we don't see of her corresponding leg; or the way her entire twisting body appears to pivot on the ball of her left foot. Correggio's *Io* is, in fact, an improvisation on Michelangelo's *Libyan Sybil* on the Sistine Chapel ceiling. Like most of the artists of his time, Correggio was very aware of the older master's towering example.

The international dimension of Renaissance art has often been mentioned in this book. By the mid-sixteenth century the shared language of classicism provided a new kind of visual 'glue' that bound artists more firmly together across the older divisions of language, nationality, or custom. It was taken as a kind of cultural birthright, a common store of perfect artistic forms that could (and should) be freely plundered in the search for perfected artistic style. This common artistic currency readily (and increasingly) broke down the old barriers of localism to generate new networks of influence and cross-reference. Even across northern Europe, and despite the independence of the major artists discussed in the last chapter, *all'antica* artistic culture gained ground, with many artists integrating classical or 'Italianate' motifs into their work.

Essential to this international culture of art was the common focus on depiction of the nude human body, whether the source for this was anatomical study of the living model, the sculpture of classical antiquity, or the works of revered Renaissance masters such as Michelangelo. Indeed the prevalence of Michelangelo-style nudes in European art after 1520 led eighteenth-century commentators to describe the period as one of 'Mannerism'. The assumption was that many sixteenth-century artists did little more than copy Michelangelo's 'manner' in a slavish way.

More recently, however, the Mannerist *style label* has been used in less derogatory ways, to describe an approach to art that was characterised less by tame academic subservience to the great masters of the past than by a new sense of the licence to be original, to have one's own manner or 'maniera', even if this meant departing from the raw facts of nature. The unnatural elements in Correggio's painting (evident in the treatment of the cloud, or in the 'indoors' tonality) indicate a knowing and sophisticated move beyond strictly natural phenomena to arrive at an exciting or striking artistic effect. Like many works of the Mannerist period, it is playfully artificial and precociously original.

The status of leading Italian Renaissance artists reaches new heights

From the very outset, Correggio's cycle lacked site-specific fixity. A very similar kind of internationalism is evident in the cycle of mythologies that the Venetian painter Titian sent to Spain between 1553 and 1562. These works were not made with a particular room or setting in mind, and were subsequently moved around Europe by their patron, King Philip II of Spain. Yet Titian's *poesie* lack the smooth eclecticism of Correggio's *Jupiter* cycle, and do not quite fit the bill as exports of Italian classicism. Their extraordinary thematic, emotional, and technical complexity means that it is hard to read them simply as courtly invitations to erotic fantasy. They are better understood as individualistic experiments that defy the very categories they refer to.

Titian's long and very successful career picks up the story of Venetian Renaissance art that was begun in chapter 4. A pupil of Giovanni Bellini and close associate of Giorgione in his

youth, Titian had, by the 1520s, become the leading painter in Venice. By this time, he was already painting for the north Italian courts of Ferrara and Mantua and from 1530 onwards (following a meeting with Charles V in Mantua) his activity was increasingly dominated by commissions from the Habsburg court. Titian's career thus provides another example of a successful sixteenth-century artist coming under the sway of international court culture, and in the process outgrowing the local tradition of the town in which he was trained and worked. Yet it is clear from Titian's colour-based style and technique that he did not simply abandon the Venetian tradition.

The series was apparently thought up when Titian met Philip, the future king of Spain, at Augsburg in Germany in 1550–1. By this point, the painter was already around sixty years old, with an international reputation, based in part at least on two decades of work for Charles V. Philip, on the other hand, was still a young prince, waiting in the wings for succession to the throne. Titian's wider fame as a leading European painter was based not so much on the string of innovative works he had produced in Venice (for example, the huge altarpieces showing the *Assumption of the Virgin* and *St Peter Martyr*) but rather on his creation of a new type of aristocratic portraiture that had been hugely successful with the courts.

In Titian's *Federico Gonzaga* the patron of Correggio's *Jupiter* cycle is shown with a degree of intimacy and informality unprecedented in Italian Renaissance portraiture. Laying aside more explicit emphasis on rank or status, Titian shows Federigo as a handsome and approachable young man, who none the less possesses indications of innate refinement and breeding. Painted just a few years after the publication of Castiglione's *The Courtier*, Titian's portrait gives perfect expression to the kind of values promoted in the book (based on a conversation that supposedly occurred at the court of Urbino). Federigo's perfect ease and casualness in Titian's portrait are actually a sign of his

courtly manners, his nonchalance or *'sprezzatura'*, to adopt Castiglione's favoured word.

Titian's extraordinary reputation by 1550 was above all based on his close relationship with Philip II's father, although it is hard to disentangle myth from reality in this regard. Charles V and his immediate family certainly commissioned Titian to paint portraits and mythologies for them on a very regular basis in the 1530s and 40s, and anecdotes circulated regarding the mutual friendship and support of emperor and painter. On one occasion, we hear, Charles instinctively stooped to pick up Titian's brush at a sitting for a portrait, though this sign of a leading patron's deep respect for a painter was in fact wholly conventionalised: the classical author Pliny the Elder reports the same circumstance, though with Alexander the Great and Apelles as the two protagonists.

Similar 'status' anecdotes surround Michelangelo, including the one mentioned in chapter 3 in which the young artist was honoured by sitting closer to Lorenzo il Magnifico at table than his own sons. Such stories were often put about by artists in the Renaissance in order to indicate their high status and may have little basis in fact. Yet it is undoubtedly true that the social standing of visual artists reached new heights in figures such as Michelangelo and Titian. As early as 1533, Charles V had, in fact, ennobled Titian, making him 'Count Palatine' and 'Knight of the Golden Spur'. It is telling that this new level of elevation was dependent on close association with the all-powerful ruler of Europe's leading court. Such high status for the Renaissance artist ran against the grain in republican states, where visual artists were typically seen in their more traditional role as artisans. It is no accident that a certain tension emerged between Titian's international courtly identity and the more 'ordinary' status ascribed to him by the Venetian Republic, where he lived and worked.

There were complaints on both sides. Titian often left Venetian state commissions incomplete, and argued with local

patrons over the relatively meagre prices they were willing to pay for his paintings. But despite calls for him to transfer to Madrid to become a 'proper' court artist, Titian stayed put in Venice. His distance from the stifling culture of the court in Madrid was vital to the artistic success of works such as the *poesie*, and says much about the measure of creative freedom enjoyed by artists in Venice. Though the republics may not have granted their artists the possibility of becoming courtiers, they were less interfering or prescriptive. Titian's series for Philip was a court commission from a non-court artist, and many of its special qualities emerged from this situation.

Renaissance mythological paintings as visual poems

In Titian's six *poesie*, produced over a period of ten or eleven years after the meeting with Philip, Titian brought all the powers of his invention as a naturalistic painter in the Venetian Renaissance tradition to bear on a foreign court commission for erotic mythologies. He apparently had an unusual degree of freedom over the subject-matter and approach to the series, and the paintings emerged slowly, and at irregular intervals, each displaying different pictorial qualities. They seem to have been loosely conceived in complementary pairs: thus *Danaë* was paired with *Venus and Adonis*, and the *Diana and Actaeon* shown here (figure 11) was pendant to *Diana and Callisto*. But while the subjects of this latter pair have an obvious thematic link, given that they both feature the punishment of mortals by Diana, goddess of hunting and chastity, those of the other paintings do not. All the paintings are, however, based on scenes from Ovid's *Metamorphoses*, the famous Latin collection of Greek mythologies.

It was Titian himself who, in a letter to Philip of 1554, described the series as 'poesie' ('poetries'), a term that was

Figure 11 Titian, *Diana and Actaeon*, 1556–9, Edinburgh, National Gallery of Art. Purchased jointly by the National Galleries of Scotland and the National Gallery, London, with the aid of the Scottish Government, the National Heritage Memorial Fund, The Monument Trust, The Art Fund, and through public appeal, 2009

familiar enough in Venice, where it had often been used to describe paintings from the time of Giorgione onwards. It is, however, less easy to determine what exactly Titian meant by the word. It may be that he simply referred to the fact that the mythologies were based on classical poetry. But we have already seen that Renaissance artists such as Donatello, Botticelli, and Michelangelo conceived of their work as broadly equivalent to 'poetry' (figures 3 and 4 and plate 3). This idea had an important place within the classical literary tradition more generally, and was encapsulated in the famous phrase of the ancient author Horace already mentioned in connection with Botticelli in chapter 2: 'ut pictura poesis' ('as is poetry, so is painting'). The elevation of painting to the intellectual and emotional heights of poetry was an aspect of the wider rise in status of the visual artist and his works in the Renaissance, and would have been in keeping with the special freedoms allowed to Titian in Philip's commission.

The word may also give us a clue about how to 'read' or understand the paintings. Rather than searching after singular or apparent meanings, we should approach the *poesie* as we would poetry; that is, as open-ended evocations, whose associative power is more significant than their 'message'. Further clues in this regard may lie in the very loose painting technique Titian used for the *poesie*, and his departure from the more literal or logical aspects of Renaissance realism such as the accurate perspective and anatomical proportion that he had used in his earlier work. In the *poesia* illustrated here, the huntsman Actaeon stumbles across the goddess Diana and her nymphs. As we saw in Correggio's *Jupiter and Io* and other works, there was an established Renaissance tradition of showing naked young women in mythological paintings, and at first sight Titian's work seems little different. The nudes are shown in a variety of postures, reclining and crouching, recalling a comment in Titian's letter of 1554 where he explained that the arrangement of the nudes

in the first pair of *poesie* was based on contrasting views of them from the back and front.

As with earlier erotic mythologies, there is clearly an invitation to ogle at expanses of young female flesh in this work, and it may be that Philip was supposed to identify with Actaeon, who occupies a forward plane of pictorial space, and is half-turned into the picture as if he were its 'viewer'. His patron may also have enjoyed the references to classical sculptures in certain of the poses of the nymphs. References to antique works are common in all the *poesie* and are broadly in keeping with more traditional works of this type, such as Titian's own series of *Bacchanals* mentioned earlier in this chapter. The habit of referring to sculptures in paintings may reflect Titian's interest in the so-called *paragone*, the favourite Renaissance debate as to whether painting was superior to sculpture or vice versa. In the *Diana and Actaeon*, Titian's fluid brushwork and brilliant naturalism in the individuation of the bodies of his nymphs proclaim the inevitable victory of painting. And, of course, he includes a *relief sculpture* at the centre of his composition, though it seems about to sink into the wonderfully illusionistic stream under the weight of the nymphs' bodies.

The Renaissance nude becomes more meaningful

But the theme of the picture is less comfortable than these erotic and academic elements would make it seem. There is an electric tension in the air, generated above all by the piercing and savage glance of Diana back across the empty foreground space of the picture toward the astonished Actaeon. He seems frozen by the goddess's look, as if all at once comprehending the terrible fate that must follow from his transgressive gaze. Titian brilliantly captures the point at which the hunter becomes the hunted.

Details such as the stag's head on the pillar above the nymphs, and the fallen bow pointing back in the direction of the young man indicate a grim future for the unwitting voyeur: Actaeon will be turned into a stag and hunted down by his own hounds.

Titian uses oil paint, long a special medium in Venetian art, with unprecedented freedom, varying his approach between areas of thick *impasto* (perhaps applied with thumbs or fingers) and brush marks that are so thinly applied that the weave of the underlying canvas is visible. The colours are broken into a myriad of related tones that none the less combine (when viewed from a certain distance) to create an overall effect of autumnal movement and change, and this indication of the season is picked up by the brown leaves of the trees and the troubled sky in the background. Again, Titian's palette is very carefully chosen, expressing his theme of sudden transformation and the dark times ahead (he later depicted the actual scene of Actaeon's death, but never sent it to Philip). Instead of the sensual idyll of Correggio's cycle, with its freely taken pleasures and exclusive concentration on the present moment, Titian opens up erotic painting to the passing of time and the darker consequences of desire. But if this suggests that there is an underlying moral meaning to Titian's painting, then this is difficult to make out. It is very hard to blame Actaeon for his misdemeanour, while the unfeeling harshness of the goddess of chastity is made apparent from her vicious glance across the painting toward her young victim.

Titian's *poesie* have sometimes been seen as Christian allegories along the lines of a 'moralised Ovid', a literary tradition that had begun in medieval times. In these books, Ovid's erotic pagan tales were given pointed Christian meanings. But nothing so obvious is present in Titian's paintings, and it is impossible to trace a consistent thread of morality in his tangled paintings of desire and death. Are they painted tragedies, as has been recently proposed? Contemporaries particularly enjoyed

performances of works by classical tragedians such as Seneca, and knew about their dramatic principles from books such as Aristotle's *Poetics*. In Titian's *Venus and Adonis*, the puce-faced goddess of love struggles with her mortal lover in the effort to stop him going off to his death on the hunt. In the *Diana and Actaeon* and *Diana and Callisto*, the tables are turned, with the disproportionate cruelty of the goddess to 'innocent' mortals being stressed. But it is hard to see how the more open eroticism of the *Danaë*, the *Rape of Europa* or the *Perseus and Andromeda* fits this interpretation.

Given the loose way the paintings relate together, it may be that they did not have an over-arching iconographic theme or meaning, and this is surely one of the things that makes them so enjoyable today. It would mean that a work such as the *Diana and Actaeon* and its pendant could possess a dark tragic tone even if others in the cycle did not. In this work the more usual elements of classicism and eroticism in Renaissance mythological painting take their place alongside others that complicate or even contradict them. And if 'tragedy' is a useful term to describe these, then we need to be clear that this is understood in its classical sense, as operating beyond the control of the Christian redemptive scheme of moral cause and effect. Actaeon pays the price not for sins he has committed, but because of the intervention of cruel 'Fortuna' or fate. It is the sense that actions and consequences don't match, and that accident or chance dominate over order, that is so new in these paintings. It makes them truer to the spirit of pagan antiquity than any other mythological works of the Renaissance. But if they are, in this sense, authentically 'classical', it is also true that they look very unlike the static and pallid reality of the antique paintings uncovered in Pompeii and Herculaneum in the eighteenth century.

There is a sense of climax but also of ending in Titian's late *poesie*. With their persistent focus on the nude, these paintings provide a fitting climax to an important Renaissance theme. As

we have seen, the nude had become the central carrier of an artistic culture based, on the one hand, on the imitation of nature, and on the other on the classical works of antiquity. But despite this, the *poesie* are not wholly understandable in these terms. These works picture the common human facts of desire, love, and death in a fluid context of never-ending change. As such, Titian's imagery goes beyond the simple sensuality of Correggio's cycle. The *poesie* bring to a dramatic conclusion the exploration of immediate sensual life which we have already seen in other Renaissance works discussed in this book, but they also take this into new territory. It is no surprise to find that their emphasis on the fluid realities of emotional and physical life is at odds with other works of the mid- and later sixteenth century. In many of these the focus is, rather, on the eternal life of the soul and on the question of humankind's position in the eyes of God.

The turn toward spirituality in Mannerist art of the 1520s

Jacopo Pontormo's *Deposition* (plate 8), as it is sometimes called, is very unlike the mythologies discussed in this chapter, though it shares something of the intense emotionality of Titian's *Diana and Actaeon*. It is, of course, a religious work, but with its strange forms and colours and unusual composition it also very different from the other works we have been discussing. A logically impossible pattern of inter-related forms extends across the picture surface, demanding our engagement with them. There is no escape into an interesting landscape or natural setting, but also no central or settled point of visual focus. Our eyes must ceaselessly flow through the forms in a revolving motion around the void at the picture's centre. Laying aside the more usual concern with the accurate imitation of nature, Pontormo

presents a scene which has the force of an inward vision or dream, yet is emphatic about the tragic meaning of the episode. At the upper right, the Virgin swoons at the sight of her son's dead body, and it is the moment of their physical separation from one another that generates the throb of emotion at the centre of the composition.

If the figures are unified by the force of this emotion, seeming to flow into one another in a rippling centrifugal movement, Pontormo is also careful to punctuate this with affective details. In the lower foreground, pale rounded faces with mournful and haunted expressions (slightly open mouths and upturned eyebrows) peer out at us, while in the area of Christ's shoulders, hands, and face the sensation of touch comes to the fore. At least five hands (including those of the woman above who cradles his head) hold Christ up. Their action serves to present his dead body to the viewer, but also gives it an eerie semblance of life. The viewer's direct connection with the dead Christ is thus central to Pontormo's conception, as is clear from the haunted gaze of the leftmost figure, whose open-eyed stare forms a telling counterpart to the lowered lids just to his right. Commissioned for the family chapel of Ludovico di Gino Capponi in the little church of Santa Felicità in Florence around 1525, the painting is an *altarpiece*, and was thus intended to provide visual focus during the enactment of the Mass.

As such, Pontormo visualises Christ's body as Eucharistic, making it respond directly to the ritual performed before the painting at the altar: its proximity to the picture surface and its fleshy nakedness refer to the *transubstantiation*. It has been suggested that Christ's body is actually being raised upwards toward Heaven in the painting, perhaps toward the figure of God the Father who was shown in a now lost fresco in the dome of the chapel. The upward movement would mimic that of the priest as he raises the consecrated host at the Mass.

The angelic look of the youthful figures who carry Christ's body indicates again that Pontormo was at pains to focus his altarpiece very directly on the immediacy of the Eucharistic Mass and the emotional experience that went with it. He deliberately abstracted his scene from the more usual flow of history or narrative so as to concentrate on the core articles of the faith. Thus we do not see Christ being taken down from the cross or lowered into the tomb ('The Deposition' or 'The Entombment'). Pontormo's painting is perhaps closer to a '*Pietà*', the northern iconography (see box on p. 88) that Michelangelo had introduced into Italian art in an early work for St Peter's in Rome (1497–9). But Christ is not shown on his mother's lap, as is always the case in this kind of image.

It is hard to understand the spatial relationship between Christ and the Virgin in a naturalistic way: he seems to be both in front of and below her, but it is unclear how this can be, given that we do not see any signs of a raised structure (a seat or throne) on which she might sit. Indeed, she (like him) seems to defy gravity, and to float upwards toward Heaven. Pontormo's lack of concern with the usual realistic Renaissance principles has led many observers to suggest that he deliberately revived the Gothic style in the Capponi altarpiece. As early as 1550, the patriotic Giorgio Vasari roundly rebuked the painter for copying the 'German manner', though on that occasion Vasari had in mind Pontormo's ghostly frescos of the *Passion*, some of which were based directly on woodcut prints from Dürer's *Small Passion* cycle. It appears that Pontormo was very ready to look beyond his own artistic tradition, and even willing to sacrifice certain of its principles in the search to intensify the spiritual impact of his paintings. But not all of his expressive pictorial techniques involved turning away from the classical or Renaissance past.

Pontormo readily flattened or compressed pictorial space, while at the same time elongating or enlarging his figures. The

sense that the figures occupy a narrow zone of space that is tied to the frontal picture plane indicates that the artist has been looking at classical *relief sculpture*. Other features too show that Pontormo was acutely aware of antique art: for example, the curled hair of the two carrying 'angels' refers to the common type found in classical statues. Even the overall colouration of the painting is less unusual than it might seem at first. It is true that Pontormo departs from the kind of warm naturalistic harmonies and *chiaroscuro* of earlier Italian painting. He was at pains to separate what we see in his painting from everyday life, a necessary move if he was to successfully produce a transformative or visionary pictorial effect. Colour (like all other aspects of his painting) is used to generate a sense of sharp distinction from the real, but at the same time serves to express the intensely emotional 'vision' presented. The predominant tones are reds and blues, the traditional colours of the Virgin, though it may also be that the intense pinks and scarlets strategically spread through the draperies of the figure group refer to the spilling of Christ's blood, and thus serve as a further reference to the Eucharistic rite enacted before the painting.

The use of unexpected juxtapositions of colour as support to a striking formal conception is not unlike that of Michelangelo. The cleaning of the Sistine Chapel frescos (1980–94) has revealed that similarly 'unnatural' but expressive colour contrasts and effects were used to support Michelangelo's monumental forms. In particular, so-called 'shot colours' (tones woven together to give a constantly changing two-tone effect) were often used in the Sistine frescos, and are also apparent in the Capponi altarpiece (see, for example, the yellow/scarlet of the crouching figure's robe). There may be few precedents for Pontormo's habit of making shadowed surfaces so highly and opaquely coloured (see the intense pinks of the figure's robe at the lower right), but again these experiments follow Michelangelo's example in their bold departure from the facts of

nature to create expressive effects. The disturbingly coloured angelic carrier who crouches in the foreground of the painting is a memory of Michelangelo's *Libyan Sybil*, whose similarly complex form also balances precariously on the ball of her foot and her big toe (and who had inspired Correggio's *Io*).

Pontormo's close attention to Michelangelo's towering example puts him in line with other artists of his generation, such as Rosso Fiorentino (1494–1540), Giulio Romano, and Parmigianino. These artists are usually described as Mannerists, indicating their very keen sense of the debt owed to the famous masters of the 'High Renaissance' discussed in chapter 3. Their works are characterised not only by frequent references to the art of an older generation, but also by a taste for twisting forms, unnatural colours, and unexpected compositional arrangements. Pontormo's strange altarpiece is more understandable when it is seen in this context of early Mannerism, with its added emphasis on originality, on the need to have one's own 'maniera'. But this self-conscious individualism should not be mistaken for 'anti-classicism', as has sometimes been argued. Mannerist originality occurred as part of an on-going dialogue with art of ancient Greece and Rome. And despite the self-conscious artistry of many Mannerist works, their striking appearance was (in the field of sacred works at least) a result of the effort to deepen spiritual meaning.

The impact of the Catholic Counter-Reformation on Renaissance art

In Italy in the 1530s and 40s, the anguished soul-searching already apparent in works such as Pontormo's *Deposition* quickly gave way to a more concerted and aggressive response to the Protestant attack. This hardening response was exacerbated by the traumatic Sack of Rome in 1527 when Charles V's

semi-mutinous army (which included some German Lutherans) went on the rampage in the city, butchering anyone who got in their way, raping women, and despoiling churches and sacred shrines.

The Sack was certainly not premeditated or ideologically motivated, but was none the less a profoundly shocking event that changed the whole cultural climate in the 'Eternal City'. Many artists working in Rome fled. But by 1535 Michelangelo himself was at work in the city, the new pope, Paul III (1468–1549), having asked him to paint the west or altar wall of the Sistine Chapel. This was a chance to complete the decoration of the building Michelangelo had laboured on for four long years between 1508 and 1512, when he had frescoed the ceiling. It was simply too good an opportunity to miss.

But both the world and Michelangelo had changed in the intervening decades. His new patron was determined to push through a programme of zealous cultural and religious reform in his native city. Paul III eagerly embraced new evangelic religious orders such as the Jesuits (founded in 1540) and it was he who called the Council of Trent five years later (see box on p. 140). The Sistine Chapel was the building where the conclave of cardinals gathered to elect a new pope, and was thus of great symbolic significance to the papacy, as the existing imagery on walls and ceiling by an array of leading Italian artists testified. Pictured here was the whole providential history of the world from the Roman Catholic perspective, from the creation through to images of the Renaissance popes as God's chosen 'Vicars on Earth'.

The decision to paint a scene of the 'Last Judgement' on the west wall was, though, unusual, and again is best understood as a sign of the times. This dark theme, featuring the Second Coming of Christ, and the general resurrection of the dead, who are consigned to Heaven or Hell, was not typically chosen as a devotional focus on altar walls. It was to be a much less

comforting theme than that shown in the altarpiece it replaced, which featured the *Assumption of the Virgin* by Pietro Perugino (c. 1450–1523). In place of the soft and mediating feminine figure of the Virgin, Michelangelo was commanded to paint a terrifying image of Christ as a harsh figure of divine justice.

Michelangelo's fresco is dominated by the massive figure of Christ at the upper centre, whose giant form is back-lit by a narrow circle of yellow light, and further emphasised by the gathering of 'the saved' who encircle him, staring and gesturing in awe, like planets revolving around a sun (plate 12). The more exclusive focus on Christ himself in 'reformist' religious art of the sixteenth century was noted in chapter 5 (see plate 10). It is reinforced here by the contrastingly slight and cowering form of the Virgin. It is tempting to see this as a very deliberate re-orientation away from the Marian focus of Perugino's original painting, with its focus on the 'Madonna Mediatrix', the archetypal 'Mother' who mediates against God the Father's wrath in Heaven.

Some have seen this shift of emphasis toward Christ as reflecting Michelangelo's interest in the radical philo-Protestant ideas that circulated among the so-called 'Spirituali'. The leader of this group, the poet Vittoria Colonna (1490–1547), had become Michelangleo's confidant in the period of the fresco. If the Virgin is taken as a symbol of 'Ecclesia' (the Church), then it would appear that her shrinking and insignificant image speaks of Michelangelo's concern with a more direct approach to Christ himself; and perhaps even the idea of 'justification through faith alone', the key Lutheran tenet that had found support in the Colonna circle in the writings of figures such as Bernardino Ochino (1487–1564).

But the Virgin still has an important role to play in the *Last Judgement* fresco, and her glance down toward the saved to the left is carefully contrasted with Christ's toward the damned to the right, perhaps referencing the traditional idea of her as a

softening force in Heaven. And the inclusion of Protestant ideas in a high-profile work that concluded the providential history of the Roman Catholic Church depicted in the Chapel would have been wholly anachronistic. The decision to show the 'Last Judgement' in this place was, after all, a papal one: probably made by Paul III's predecessor, Clement VII (1478–1534), who was so traumatised by the horrors of the Sack of 1527 (when he was briefly imprisoned) that he vowed to have a scene of retributive divine justice painted on the altar wall. Michelangelo's concern with reform was probably more focused on the appearances of his own art than on covert heterodox statements.

In the fresco the damned are pulled down to Hell, on Christ's left (or sinister) side, while the saved are carried heaven-ward to arrive at his right. Christ's overall control over this twofold movement to Heaven and Hell is succinctly expressed in the commanding rhetoric of his gesture, with the upward movement of his right arm and contrasting downward one of his left. This orientation from the fresco outwards, from the position of God himself toward humankind, is also indicated by Christ's forward movement, as if he had just arrived through the ocular window which the new image covered up.

Setting aside the ambiguities of his earlier works such as the *Dying Slave* (figure 4), Michelangelo produced a work in which the theological message is made amply clear. Adam and St Peter at left and right are the largest figures other than Christ himself at the upper centre of the fresco, their massive bodies forming a mirror image of one another to indicate their key place within the redemptive drama: Adam as the representative of fallen mankind, Peter as the leading apostle, to whom Christ entrusted the keys to Heaven, and as the first bishop of Rome, a symbol of the Roman Catholic Church itself.

This visual juxtaposition contains a spiritual message: it is only through the ministry of the Church that we, the original

sinners, can achieve salvation in Heaven. Pictorial form operates like a visual sermon in Michelangelo's fresco, clarity of meaning replacing his earlier more open-ended or poetic mode. By no means all the saints gathered around Christ are identifiable, but the more prominent ones have clear identifying attributes, with reference to long-standing textual and visual traditions. Martyred saints have preference here: St Lawrence with his gridiron and St Bartholomew with his flayed skin are given a particular platform just below Christ.

It is sometimes said that Michelangelo included his self-portrait on Bartholomew's skin, perhaps as a reference to the tortures his own flesh caused him (so often the subject of his poetry). But again we should not under-estimate the didactic meaning of these two Christian martyrs (and others such as Blaise, Catherine, and Sebastian seen to the right), given the recent attacks of the Protestants on the veneration of non-biblical figures such as saints. Those featured here were martyred early in the history of the Church and had come to possess a kind of canonical authority. The horrible physical tortures they had to endure at the hands of heretics and doubters would also have had a powerful resonance with those who had suffered at the hands of the Lutheran soldiers during the Sack of Rome.

Scenes of Christian martyrdom were destined to become the stock-in-trade in works of the Counter-Reformation commissioned by new religious orders such as the Jesuits, and it may be that this kind of doctrinally charged imagery is anticipated in the saints featured in the *Last Judgement*. And there are other ways too in which Michelangelo's approach seems to express the changed religious climate in Rome. His extraordinarily free manipulation of space, for example, serves the fresco's underlying message. It has been suggested that the horizontal bands of figures continue the architectural articulation of the lateral walls of the Chapel. But the fluid pictorial space is generated almost

entirely by the figures themselves, an approach which reflects Michelangelo's practice as a sculptor.

Placed against the flat non-naturalistic azure of the firmament, the twisting and gesticulating figures create or disintegrate three-dimensional space almost at will. As the eye moves away up the altar wall, so the knots of writhing figures press further forward, seeming to draw nearer. The figures in the heavenly zone are, in fact, much larger than those in the earthly one below, and generally increase in size in accordance with their closeness to Christ. Figure scale is freed from the more objective co-ordinates of perspective space and now obeys the symbolic order instead: the larger the figure, the more important he or she is in the sacred schema.

The inflation of the size of the figures in the upper region of the fresco might make them more visible from the floor of the Chapel. But it also reflects the dominance of the spiritual heavenly domain over the earthly one below. And these formal manipulations indicate a reforming or 'archaising' return to earlier phases of religious art, in which the sacred figures are typically much larger than the secular ones placed in the world below them (for a northern example of this see Rogier van der Weyden's *Beaune altarpiece*, mentioned in chapter 5).

The bodies in the *Last Judgement* are characterised by a quality of exaggerated heaviness or bulkiness. In keeping with much of Michelangelo's work from the 1530s onwards, the fresco features human forms which are stripped back to their raw essentials, and have little of the sensual beauty of earlier works such as the *Dying Slave*. Michelangelo returns to earlier phases of Italian art in his quest to heighten spiritual content, reviving the simpler 'pious' approach of painters such as Giotto and Masaccio (plate 2). The easy alliance between beautiful art and religious feeling that had fuelled his earlier career was abandoned, as the artist grew away from the Neo-Platonic ideals of his youth. He wilfully avoids outward beauty, and is even prepared to make his

figures ugly in the reach toward inward spiritual meaning. His poetry from the period tells us that he had come to mistrust the world's transient show of physical beauty to such an extent that he (like the reformers in the north) doubted the value of visual art in the service of the divine ('I have made an idol out of art'). The whole enterprise of artistic creation in the service of religion was, in Michelangelo's late view, under the scrutiny of the all-seeing eye of God.

The nude and the end of the Renaissance

But this isn't the whole story with the *Last Judgement*. It would be too easy to present this monumental work as simply reflecting Michelangelo's embrace of Counter-Reformation orthodoxy. Despite the intellectual severity and stern visual rhetoric, Michelangelo's classicism is still everywhere apparent, linking his work to the Renaissance past. It is true that he used the nude to express the sacred subject of his fresco, rather than as a display of sensual beauty. The *Last Judgement* illustrates the future moment when mankind is rendered 'naked' by the all-seeing eye of God, and when all human virtues and vices are laid bare before the Creator. The inclusion of multiple nudes is to this extent wholly appropriate. Certain of Michelangelo's bodies are more impressive than others, particularly that of Adam, foremost among the saved. On the Judgement Day, so the theology goes, those who are saved will receive new bodies, and Adam's heroic form symbolises the spiritual regeneration of mankind more generally.

However, many nudes in the *Last Judgement* still remind us of classical sculptures and there are even some direct quotations from specific antique models. There are also numerous instances of the formal *difficoltà* for which Michelangelo had become famous, and these are taken to new extremes in many parts of

the fresco (see, for example, the extraordinary gravity-defying groups at the upper left and right who carry the instruments of Christ's torture). In this way Michelangelo's treatment of his nudes still reflects the relatively open, pluralistic culture in which he had been nurtured as an artist, with its overlapping interests in pagan antiquity and the physical realities of bodies within a Christian framework. There were many who saw the fresco as the crowning achievement of a brilliant career, and it soon became a focus point for younger generations of artists who flocked to Rome to learn from the Master. In the first Academies of artists that now began to appear in Italy its complex forms were feverishly studied, and in published accounts of the history of Renaissance art such as Vasari's *Lives of the Artists* of 1550 it was presented simply as the crowning work of the greatest artist who had ever lived.

Yet the wider majority in Italy and elsewhere probably did not share these positive views. The unveiling of the work in 1541 was greeted almost immediately by controversy and hostility. Even if the outraged response of the poet Pietro Aretino (1492–1556) in a letter of 1545 was hypocritical (he had recently published bawdy sonnets illustrated with pornographic images), his view that Michelangelo had seriously flouted decorum by painting so many nudes in a sacred work (figures 'more at home in some voluptuous bathhouse') was widely shared. His further accusation that Michelangelo's artistic licence was the result of his arrogant rating of 'art higher than faith' gave perfect voice to the new reformed mentality of the mid-sixteenth century.

In December 1563, when the Council of Trent finally issued its decree on religious images, the traditional place of such depictions in Christian worship as the 'bibles of the illiterate' was reconfirmed. But the official ruling also acknowledged that modern artists had gone too far, producing works in which the religious subject-matter was less important than a display of the artist's skill. The Council rounded, in particular, on those artists

who had used nudity in religious works, and by so doing had risked stimulating lascivious thoughts in the faithful. As far as the reformed Roman Catholic Church was concerned, the depiction of nudes recalling the 'false gods' of pagan antiquity – as they were now described – was no longer acceptable.

Though the new prescriptions were sometimes ignored, most late sixteenth-century artists went on to follow a kind of chastened and pallid style (sometimes described as 'Counter-Maniera' because of its reaction against the freedoms of Mannerism) which met the approval of the churchmen. Around 1600, Italian art quickly recovered its confidence and originality in the flamboyant style now known as the Baroque. But the sharp criticism of Michelangelo, commonly regarded as the very embodiment of the Renaissance tradition, none the less marked a turning point in the history of art.

Shortly after the old master's death in 1564 his follower Daniele da Volterra (1509–66) was commissioned by Pope Pius IV (1499–1565) to supply loincloths to cover the genitals and backsides of the main figures in the fresco. Daniele was from then onwards known as 'Il Braghettone' ('the breeches maker'): but this was not really a criticism, and the work of 'restoring' the *Last Judgement* was continued by others after his own death. Indeed, in these decades of intensifying religious purity there were repeated calls for the 'embarrassing' fresco simply to be whitewashed over. This, of course, never happened. But the experimental Renaissance tradition that Michelangelo represented was none the less at an end.

Conclusion: Renaissance art, medieval and modern

The controversy over Michelangelo's *Last Judgement* reveals something very important about Renaissance art and artists. But before returning to this point, we need to ask how far the discussion in this book has challenged the old nineteenth-century view of the period noted in the Introduction. Given what has been said, is it still possible to see the Renaissance (like Jacob Burckhardt) as characterised by individual freedom, secular values, and scientific interests? Do we find the art of the period so fascinating today because we recognise in it the birth of our own modern world?

In answering these key questions, we need to retrace our steps. Several of the key themes introduced in this book show that we should not make too clear a distinction between the 'Renaissance' and the medieval period that preceded it. It has been noted, for example, that 'sacred' and 'secular' in Renaissance art did not typically work against one another. Thus the new realism evident in the art of fifteenth-century Flanders and Florence was developed to heighten the power of the traditional Christian stories, and did not reflect a rejection of religious values. We have seen that sacred art continued to dominate throughout the Renaissance, despite the gradual emergence of

secular subjects such as mythologies. And although, in the hands of a Leonardo, art came very close to modern empirical science, sustained interest in this kind of idea is hard to find in Renaissance art.

All this reflects the continuing centrality of religion in the Renaissance centuries. As the sixteenth century progressed, this aspect intensified rather than declined, with many artists seeking to increase the spiritual or didactic meaning of their works in response to the upheavals of the Reformation and Counter-Reformation. On a stylistic level, it has become clear that the Renaissance style did not simply replace the Gothic: artists in the period constantly referred to older approaches, and clearly didn't see themselves as artistic iconoclasts, out to destroy the work of the past. Just as there was continuity of subject-matter and picture type, so too there was often continuity of artistic approach and technique.

These continuities between medieval and Renaissance art were seriously under-estimated in the nineteenth-century view of the period, which saw it as one in which a decisive split or break with the past occurred. The older view took little account of the impact of wider historical context on artistic developments. This 'non-artistic' influence has emerged as another key theme in this book. In particular we have seen just how far art patrons determined the appearance of Renaissance works. All of the examples discussed express, to some extent, the values of those who ordered and paid for them. The influence of patrons and of broader historical factors tied Renaissance art to its context to a much greater degree than was once realised. This recognition certainly limits the old idea that artists in the period were free agents who created works on the basis of their own individual whims or desires.

Contexts changed only slowly in the Renaissance centuries, so again we are dealing with continuities rather than a clean break from what went before. Even if we factor in the major

religious and cultural changes highlighted in chapters 5 and 6 (the Reformation and the new political power of national and international courts) the world did not alter so dramatically as was once thought. But does all this mean that Burckhardt was wholly wrong, and that it is no longer possible to think of the 'Renaissance' as a key period in art history? Does it now lack any truly defining characteristics? In order to answer these questions we need now to briefly summarise some of the themes we have noted in the book that *do* mark out Renaissance art as distinctive and progressive.

My account began with a portrait painted in an intensely realistic style using an artistic medium in a very new way. Examination of the *Arnolfini portrait* showed the Renaissance artist's willingness to develop new types of image and to experiment with artistic media (in this case oil paint), and the work also served as a good example of the move toward closer imitation of nature. Though we later saw that the traditions of northern and southern Europe differed from one another in their approach to imitation, it is none the less clear that most artists shared a commitment to making their work look as 'lifelike' as possible. Despite the local differences, and the frequent intermingling of Gothic forms, it is fair to say that this new measure of realism is a clear distinguishing trait of the Renaissance artwork.

The *Arnolfini portrait* also gave notice of a turn toward more 'realistic' subjects, set not in the sacred or historical past, but in the here and now. We have seen how Renaissance artists developed new 'empirical' kinds of imagery in unprecedented ways: not only portraits, but *genre images* and landscapes came to occupy a newly significant place in visual art, even if they did not come to dominate. And at the same time, Renaissance artists experimented with reproductive prints, and greatly developed the use of drawings and many other visual media. These technical experiments inevitably had an impact on the appearances of

Renaissance art, distinguishing it from the work of other periods.

In a number of the examples examined in this book we have seen that Renaissance art demanded new kinds of understanding: the works seem to anticipate a newly sophisticated art-loving viewer. On occasion the Renaissance artist even presented his work simply 'as itself': that is as a complex and elusive 'work of art' to be enjoyed for its own sake. This might seem an obvious point, but in the medieval period the works of the visual artist were more often understood as functional objects conforming to set patterns or types, to be used for specific purposes within wider social, devotional, or ritual contexts. In the Renaissance, the meaning of the work became less obvious or fixed: part of its pleasure lay in the puzzle it presented to the viewer. In examples such as Donatello's *David* or Leonardo's *Mona Lisa*, the concept of 'art' in our modern sense of the word was born.

Related to this was the new closeness of Renaissance visual works to other 'representational' arts, such as literature, philosophy, and (in particular) poetry. The association with these other highly respected disciplines is an aspect of the wider rise in the cultural value given to art and artists in the Renaissance, a theme first noticed in the discussion of the *Arnolfini portrait*, but which has recurred throughout the book. In great sixteenth-century figures such as Michelangelo and Titian the cultural prestige of the individual visual artist reached new heights, even if many others in the profession lived more humdrum existences as artisans in the workshop. The international fame and prestige of the leading figures indicate that the period had opened up new possibilities for artists. As we have seen, their social roles were increasingly various, such that they could appear as religious visionaries, natural scientists, eccentric geniuses, or sophisticated courtiers. The discussion has provided good evidence that our modern view of the identity of the artist as a complex, fluid, yet 'special' member of society took root in the Renaissance.

The rising status of the artist was also reflected in the typical appearance of Renaissance art. Several of the works discussed in this book have a quality of open-endedness, complexity, and sophistication that actively invites comparison with poetry. More widely, it is true that many of the illustrations possess a quality of uniqueness that reflects the Renaissance artist's newfound freedom to create original works. It would be easy to give a false impression here, given that the examples we have discussed are by leading practitioners at the cutting edge of art in their day. More run-of-the-mill productions of the time certainly do not always (or even typically) possess the quality of uniqueness noted here. Yet even if they are 'exceptional', the works we have focused on indicate a more general aspiration toward originality in the Renaissance. As we have seen, by the mid-sixteenth century the idea that each artist should have his own 'manner' or *maniera* had become central to the late Renaissance style known as Mannerism.

Mannerism was, however, also based on another leading characteristic of Renaissance art: the emulation of the art of classical antiquity. If northern artists initially remained somewhat resistant to this Italian obsession, by 1550 the classicising style was none the less established as a common artistic language across Europe. If this Renaissance obsession was more pronounced in Italy, and was based more on artistic form than subject-matter, it can none the less be considered one of the period's most important stylistic legacies, exerting a predominant influence over much European art up until the late nineteenth century.

Perhaps the key theme defining the essential characteristics of Renaissance art is the nude. In depicting the nude, artists brought together their twin interests in classical past and present reality. In classical art, of course, the nude was the predominant form, while the study of actual bodies allowed Renaissance artists to imitate nature. As an aspect of classicism, the nude took

time to emerge in northern Europe, but by the sixteenth century it was a common enough subject in both religious and secular art. Alongside the opportunities it provided for analysing the realities of anatomy, proportion, expression, and movement, the nude was easily integrated into Christian subjects, for example, to express ideas about the relationship between body and soul. In mythological art it became the central object of erotic contemplation.

What makes the nude the definitive Renaissance form is the sheer range of uses that it could be put to, or the multiple meanings it could generate: its essential quality of expressive plurality. The importance of the nude speaks of the underlying experimentalism of Renaissance culture. It is this that makes the moralistic censure of the nudes in Michelangelo's great *Last Judgement* fresco so significant and so disappointing. In the eyes of the reformers the meaning of the nude was singular: it was simply a provocation to lascivious thoughts. And this reductive classification brought to an end the kind of free visual combinations (of natural and supernatural, pagan and Christian) and the related sense of possibility that characterised Renaissance art.

So much gives a clue as to why Renaissance art remains so fascinating today. It is sometimes seen as the cold deposit of frosty 'Old Masters' lost in some obscure past: but anyone who takes care to look carefully will become aware of a living connection. This is not, though, the kind of identification proposed by Burckhardt. We do not recognise the Renaissance as wholly 'modern' and 'secular': as simply like ourselves. When looking at Renaissance art we are, rather, excited by a double sense: of both recognition and difference. The impact of the medieval world is everywhere apparent, but cannot define the period. Present, too, are the embryonic motifs of secular modernity: but they are only 'embryonic', not yet firmly fixed into the familiar post-Enlightenment pattern of normality. Renaissance

art is not quite medieval or modern, neither old nor new. Its essential qualities are those of mixture, fluidity, and transformation. Lying betwixt and between, in a state of becoming rather than of completeness, Renaissance art defines a moment of intense cultural openness that remains deeply alluring.

Glossary of terms

all'antica Italian phrase meaning 'like the antique' or 'in the manner of the ancients'. Often used to refer to Renaissance art that looks like that of classical Greece and Rome.

altarpiece (*see also* diptych, triptych, polyptych) Visual image (usually a painting, a sculpture, or a combination of the two) made to stand above an altar.

burin Sharp pointed tool used for making *engravings*.

chiaroscuro Italian word with the literal meaning 'light-dark'. Commonly used to describe effects of light and shade in a painting.

Cinquecento Italian word with the literal meaning 'five hundred'. Commonly used to describe the sixteenth century.

colore/colorito Italian words for 'colour' and 'colouring'. In the context of Renaissance art, usually used to describe the work of Venetian painters.

contrapposto Italian word with the literal meaning 'set against'. In the context of Renaissance art, used to refer to contrasts between relaxed and tensed limbs in representations of the human figure; such contrasts were much used in classical sculptures of ancient Greece and Rome.

craquelure Small cracks that appear on the painting surface when the *pigment* or varnish has become brittle.

devotional pictures Term often used to describe smaller-scale religious paintings made for private chapels, bedrooms,

or as portable items. Focus of private, often lay, religious devotion.

difficoltà Italian word for 'difficulty'. In the context of Renaissance art, used to describe a deliberate display of artistic skill in the representation of a human figure. Michelangelo and his followers were particularly famed for their figural complexity.

diptych A work of art, usually an *altarpiece*, with two hinged parts facing each other.

disegno Italian word for 'design' or 'drawing'. Key term in the Renaissance, used to describe not only drawings made in the preparation of a work of art, but also the outlining of forms and the overall intellectual conception of the work. Particularly associated with art of Florence and Rome.

drolleries Old (seventeenth-century) word for comic pictures found in the margins of medieval *manuscripts*. These were a possible source for the *genre images* that began to appear in the Renaissance.

engravings Images made by cutting lines into a metal (usually copper) plate or wooden block using a *burin*. The plate is then inked, pressed and wiped, with those parts that have been engraved forming the black lines on the image.

etching More sophisticated form of engraving that involves the use of an etching needle on a layer of acid-resistant wax or resin placed on top of the metal plate. The etcher 'draws' his design onto this soft layer, and the plate is then dipped in acid. Allows the artist to create subtle pictorial effects.

fantasia Italian word for 'fantasy'. In the Renaissance, particularly associated with the artist's power to create forms from his imagination at will, or to transform those he has seen into new ones.

finial Decorative architectural ornament, usually on top of a spire or gable. Much used in Gothic architecture, and on the frames of traditional *altarpieces*.

fresco Italian word for 'fresh'. Describes the medium used for painting directly onto walls in the Renaissance. Fresco painters typically worked onto wet plaster ('buon fresco'), though fresco can be used when the plaster is dry ('fresco secco'), but with less satisfactory or long-lasting results. The *pigments* are bound together using a water-based solution.

genre images/imagery From the French word 'genre', meaning 'kind' or 'type', this term describes artistic subject-matter that shows typical or 'everyday' scenes from contemporary life.

glazing Use of one transparent layer of paint over another, so that the original colour shows through. Many layers can be super-imposed on one another to create a rich effect of depth and luminosity. Much used by Renaissance oil painters.

grotesque Form of decorative, classical mural painting, first rediscovered in and around Rome and Naples at the end of the fifteenth century. It featured floral patterns, human and animal forms, masks etc. It was quickly revived by Renaissance artists and spread across much of Europe.

history painting Paintings that feature historical episodes or narratives. In the Renaissance, paintings with religious or mythological subjects were also considered to be 'histories' or 'istorie'.

impasto Thickly applied areas of paint which are opaque and often stand proud of the picture surface. Typically reveal the marks of the brush (or other instrument) used to apply them.

manuscripts Hand-made books, often 'illuminated' with paintings, that predominated in the period before the discovery of printing in the mid-fifteenth century.

monstrance Transparent container in which the consecrated Host is displayed for adoration in churches.

niche Wall recess, usually containing a statue.

paragone Italian word for 'comparison'. Refers to the Renaissance 'comparison' between the visual arts, usually focused on painting and sculpture. Leonardo particularly championed painting, while Michelangelo preferred sculpture.

pietà Italian word for 'pity'. A common subject in Renaissance art, though more favoured in northern Europe than Italy. It shows the Virgin with the dead body of Jesus on her lap.

pigment Substance used to provide colouring. When suspended in a 'medium' such as oil or *tempera*, paint is formed. In the Renaissance, pigments were typically formed out of ground minerals, plants, and animals.

polyptych Multiple-panelled work of art (typically an *altarpiece*).

printmaking Primarily used in the Renaissance context to describe *engravings*, *woodcuts* and *etchings*.

Quattrocento Italian word with the literal meaning 'four hundred'. Commonly used to describe the fifteenth century.

relief sculpture Sculpture in which figures project from a ground to which they are partially attached. The type of classical sculpture that survived in greatest quantity and that was most widely copied by Renaissance artists.

sacra conversazione Italian for 'holy conversation'. Refers to a much-favoured religious iconography (see box on p. 88) in the Italian Renaissance, featuring a selection of saints gathered around figures of the Virgin and Child.

sfumato From the Italian word for 'smoke' ('fumo'). Closely

associated with the paintings of Leonardo and his followers, the word refers to the softening of edges and surfaces of forms so that they appear to blend into one another.

silverpoint Tool used for drawing, especially in the early Renaissance. A pointed silver stylus, often used in combination with treated or roughened coloured paper.

simultaneous (or continuous) narrative Habit of illustrating more than one episode from a given story or narrative in a single visual field or image. Tended to be used less frequently as the Renaissance progressed.

sinopia/sinopie Italian word for reddish chalk *underdrawing* used in *fresco* paintings.

style label Term used to describe broad stylistic phases or periods in the history of art: for example 'Renaissance', 'Gothic', or 'Baroque'.

tempera Traditional binding agent or medium for *pigments*; formed out of egg-whites. Gradually superseded in the Renaissance by linseed or walnut oil.

tracery Form of decorative work originally found in medieval window openings, for example in Gothic architecture. Subsequently used in many other contexts, including on furniture and the frames of *altarpieces*.

transubstantiation Process by which the consecrated Host is literally transformed into the body and blood of Christ in the Catholic Mass.

triptych A work of art (typically an *altarpiece*) consisting of three parts or panels, usually hinged together.

underdrawing or underpainting Refers to the primary blocking out of lines, shapes, and tones on the picture surface prior to the painting itself. Materials used varied according to the

given medium, but could include 'terre verde' (green earth colour, *tempera*), chalk (*fresco*) and charcoal (oil painting).

vanishing point A point at which parallel lines converge in linear perspective. In Renaissance works there are typically between one and three vanishing points.

vellum Parchment or stretched animal skin, commonly used for drawing in artists' workshops. Gradually superseded by paper from the late fifteenth century onwards.

veronica Italian word literally meaning 'true image or likeness', referring to the representation of Christ's face that appeared on St Veronica's headscarf after she had offered it to him on his way to Crucifixion. Thousands of small 'veronica's' were produced in the medieval and Renaissance period, and were particularly associated with pilgrimage sites and pilgrims.

woodcut Simplest kind of reproductive print, made using a wooden block, ink, and a press. Those areas of the block that are cut away show as white in the print (in contrast to *engraving*).

x-radiography Photographic image produced on film or plate by radiation (x-rays). Useful to the study of Renaissance art because of its ability to reveal artists' first or earlier ideas in the form of hidden images concealed beneath the surfaces of paintings.

List of artists and works

Listed below are all the artists and works mentioned in this text. Dates and present locations of works are also included. The list is in alphabetical order according to the artists' names. Where the first name is commonly used this is followed (e.g. Leonardo da Vinci is listed under 'Leonardo' rather than 'da Vinci'). Where the name of the artist is unknown, then the work is listed under its title.

Apelles of Kos 4th century BC

Apollo Belvedere, Roman copy of a 4th-century BC Greek original, Rome, Vatican Museum

Alberti, Leon Battista (1404–72)

Antonello da Messina (c. 1430–79)

 San Cassiano altarpiece, 1475–6, Vienna, Kunsthistorisches Museum

Bellini, Gentile (c. 1429–1507)

Bellini, Giovanni (1431/6–1516)

 San Giobbe altarpiece, c. 1478–80, Venice, Gallerie dell'Accademia (plate 7)

 St Francis in the desert, c. 1480, New York, Frick Collection

 Pietà, 1467–70, Milan, Pinacoteca di Brera

Bellini, Jacopo (c. 1400–71)

 Sketchbooks, 1450–60, London, British Museum; Paris, Musée du Louvre

Bertoldo di Giovanni (c. 1420–91)

Bosch, Hieronymus (c. 1450–1516)

> *Garden of earthly delights*, 1500–5, Madrid, Museo del Prado
>
> *Hay-wain*, 1500–5, Madrid, Museo del Prado (plate 11)
>
> *Seven deadly sins*, c. 1475, Madrid, Museo del Prado

Botticelli, Sandro (1444/5–1510)

> *Birth of Venus*, c. 1485, Florence, Galleria degli Uffizi (plate 3)
>
> *Calumny of Apelles*, c. 1490, Florence, Galleria degli Uffizi
>
> *Primavera*, c. 1478, Florence, Galleria degli Uffizi

Bramante, Donato (1444–1514)

Bronzino, Agnolo (1503–72)

> *Eleonara de Toledo with her son*, c. 1545, Florence, Galleria degli Uffizi

Bruegel, Pieter (c. 1525–69)

> *Battle between Carnival and Lent*, 1559, Vienna, Kunsthistorisches Museum
>
> *Children's games*, 1560, Vienna, Kunsthistorisches Museum
>
> *Fall of Icarus*, c. 1555, Brussels, Musées Royaux des Beaux-Arts
>
> *Gloomy day*, 1565, Vienna, Kunsthistorisches Museum
>
> *Hunters in the snow*, 1565, Vienna, Kunsthistorisches Museum
>
> *Netherlandish proverbs*, 1559, Berlin, Gemäldegalerie
>
> *Peasant dance*, c. 1567, Vienna, Kunsthistorisches Museum
>
> *Peasant wedding*, c. 1567, Vienna, Kunsthistorisches Museum
>
> *Procession to Calvary*, 1564, Vienna, Kunsthistorisches Museum
>
> *Return of the herd*, 1565, Vienna Kunsthistorisches Museum (plate 4)

Brunelleschi, Filippo (1377–1446)

Campin, Robert ('Master of Flémalle', 1378/9–1444)

Capitoline Venus, 2nd century AD, Rome, Capitoline Museums

Correggio (Antonio Allegri, c. 1489–1534)

> *Danaë*, 1530–3, Rome, Galleria Borghese

Virgin and Child with Chancellor Nicolas Rolin, c. 1435, Paris, Musée du Louvre

Gentile da Fabriano (c. 1385–1427)

Adoration of the Magi, 1423, Florence, Galleria degli Uffizi

Ghiberti, Lorenzo (1378–1455)

Ghirlandaio, Domenico (1448/9–1494)

Giorgione (1478/80–1510)

Castelfranco altarpiece, c. 1505, Castelfranco, San Liberale

Sunset landscape, c. 1507–8, London, National Gallery

Tempest, c. 1508–9, Venice, Gallerie dell'Accademia (plate 9)

Giotto di Bondone (1267/75–1337)

Life of St Francis, Lives of St John the Baptist and John the Evangelist, early 1320s, Florence, Santa Croce

Goes, Hugo van der (d. 1482)

Portinari altarpiece, c. 1475, Florence, Galleria degli Uffizi (figure 2)

Holbein, Hans (1497/8–1543)

Anne of Cleves, c.1538–9, Paris, Musée du Louvre

Christina of Denmark, 1538, London, National Gallery

Gospel and Law, c. 1532, Edinburgh, National Gallery of Scotland

King Henry VIII, c. 1536, Madrid, Thyssen Collection (plate 6)

Thomas More, 1527, New York, Frick Collection

Laöcoon, 1st century AD, Rome, Vatican Museum

Leonardo da Vinci (1452–1519)

Adoration of the Magi, 1481–2, Florence, Galleria degli Uffizi

Cecilia Gallerani, c. 1490, Cracow, Czartoryski Museum

Last Supper, 1495–8, Milan, Santa Maria delle Grazie

Mona Lisa, 1503–16, Paris, Musée du Louvre (plate 5)

Virgin and Child with Sts Anne and John the Baptist, c. 1500, London, National Gallery

Virgin of the rocks, 1483–90, Paris, Musée du Louvre

Limburg, Herman, Jean, and Paul (c. 1390–1416)
Très Riches Heures of the Duc de Berry, 1412–16, Chantilly, Musée Condé
Lucas van Leyden (c. 1494–1533)
Beggars, 1520 (figure 9)
Mantegna, Andrea (1430/1–1506)
Pallas expelling the vices from the garden of virtue, 1499–1502, Paris, Musée du Louvre
Masaccio (1401–28)
Expulsion of Adam and Eve, 1425–8, Florence, Santa Maria del Carmine (plate 2)
St Peter raising a boy from the dead, 1425–8, Florence, Santa Maria del Carmine (plate 2)
Tribute money, 1425–8, Florence, Santa Maria del Carmine (plate 2)
Trinity, c. 1425–7, Florence, Santa Maria Novella
Masolino da Panicale (1383–after 1435)
St Peter preaching, 1425–8, Florence, Santa Maria del Carmine
Medici Venus, 1st century BC, Florence, Galleria degli Uffizi
Memling, Hans (1430/40–1494)
Michelangelo Buonarroti (1475–1564)
David, 1503–4, Florence, Gallerie dell'Accademia
Dawn, Day, Dusk, Night, 1526–34, Florence, San Lorenzo
Dying Slave, 1513–16, Paris, Musée du Louvre (figure 4)
Last Judgement, 1536–41, Rome, Vatican, Sistine Chapel
Libyan Sybil, c. 1511–12, Rome, Vatican, Sistine Chapel
Pietà, 1497–9, Rome, St Peter's
Rebellious Slave, 1513–16, Paris, Musée du Louvre
Sistine Chapel ceiling frescos, 1508–12, Rome, Vatican
Taddei Tondo, 1504–7, London, Royal Academy of Art
Michelozzo di Bartolomeo (1396–1472)
Monaco, Lorenzo (c. 1370/5–c. 1425/30)
Life of the Virgin, 1420–4, Florence, Santa Trinità

Parmigianino (1503–40)
Cupid, 1531–4, Vienna, Kunsthistorisches Museum
Patinir, Joachim (d. 1524)
Baptism of Christ, Penitence of St Jerome and Temptation of St Anthony, c. 1520, New York, Metropolitan Museum of Art
Perugino, Pietro (c. 1450–1523)
Pollaiuolo, Antonio (c. 1432–98) and Piero (c. 1441–c. 1496)
Pontormo, Jacopo (1494–1556)
Deposition, 1525–8, Florence, Santa Felicità (plate 8)
Passion frescos, 1523–6, Florence, Certosa del Galluzzo
Praxiteles (4th century BC)
Aphrodite of Cnidus, 4th century BC (lost)
Pucelle, Jehan (c. 1300–c. 1350)
Raphael (1483–1520)
Bridgewater Madonna, c. 1507–8, Edinburgh, National Gallery of Art (figure 5)
Colonna Madonna, c. 1507–8, Berlin, Gemäldegalerie
Drawing after Michelangelo's David, c. 1505–6, London, British Museum
Drawing after Michelangelo's David, c. 1505–6, Oxford, Ashmolean Museum
Drawing of Madonna and Child, c. 1507, London, British Museum (figure 6)
Drawing of a lady, c. 1506, Paris, Musée du Louvre
Tempi Madonna, c. 1508, Munich, Alte Pinakothek
Riemenschneider, Tilman (c. 1460–1531)
Holy Blood altar, 1499–1505, Rothenburg, St Jakob (figure 8)
Robbia, Luca della (1399–1482)
Rosso Fiorentino (1494–1540)
Santi, Giovanni (d. 1494)
Seisenegger, Jakob (1504/5–67)
Titian (c. 1490–1576)
Andrians, c. 1519–21, Madrid, Museo del Prado

Assumption of the Virgin, 1515–18, Venice, Santa Maria dei Frari

Bacchus and Ariadne, 1520–3, London, National Gallery

Danaë, c. 1551–3, Madrid, Museo del Prado

Diana and Actaeon, 1556–9, Edinburgh, National Gallery of Scotland (figure 11)

Diana and Callisto, 1556–9, Edinburgh, National Gallery of Scotland

Federico Gonzaga, 1529, Madrid, Museo del Prado

Rape of Europa, 1559–62, Boston, Museum of Fine Arts

St Peter Martyr altarpiece, 1528–30 (lost)

Venus and Adonis, c. 1553–4, Madrid, Museo del Prado

Worship of Venus, 1518–19, Madrid, Museo del Prado

Verrocchio, Andrea del (1435–88)

David, c. 1475, Florence, Museo Nazionale di Bargello

Weyden, Rogier van der (1399/1400–1464)

Beaune altarpiece, 1445–8, Beaune, Hôtel Dieu

St Luke painting the Virgin, 1435–40, Boston, Museum of Fine Arts (figure 1)

Further reading

Introduction

Burckhardt, Jacob, *Civilization of the Renaissance in Italy* (1860) (London: Penguin, 2004)

Vasari, Giorgio, *Lives of the Artists* (London: Penguin, 1970)

Chapter 1

Campbell, Lorne, *Van der Weyden* (London: Chaucer Press, 2004)

Harbison, Craig, *Jan van Eyck: The Play of Realism* (London: Reaktion Books, 1995)

Hall, Edwin, *The Arnolfini Betrothal: Medieval Marriage and the Enigma of van Eyck's Double Portrait* (California: University of California Press, 1997)

Kemperdinck, Stephen, *Rogier van der Weyden: 1399/1400–1464* (New York: Ullman, 2008)

Koster, Margaret L., *Hugo van der Goes and the Procedures of Art and Salvation* (Amsterdam: Harvey Miller, 2008)

Chapter 2

Bennett, Bonnie A. and David Wilkins, *Donatello* (London: Phaidon, 1984)

Cole Ahl, Diana, ed., *The Cambridge Companion to Masaccio* (Cambridge: Cambridge University Press, 2002)

Dempsey, Charles, *The Portrayal of Love: Botticelli's 'Primavera' and the Humanist Culture at the time of Lorenzo the Magnificent* (Princeton: Princeton University Press, 1997)

Johannides, Paul, *Masaccio and Masolino: A Complete Catalogue* (London: Phaidon, 1993)

Lightbown, Ronald W., *Sandro Botticelli* (Berkeley, California: University of California, 1978)

Pope-Hennessy, John, *Donatello Sculptor* (New York: Abbeville Press, 1993)

Chapter 3

Goldscheider, Ludwig, *Michelangelo: Paintings, Sculpture, Architecture* (London: Phaidon, 1996)

Hibbard, Howard, *Michelangelo* (London: Allen Lane, 1975)

Hughes, Anthony, *Michelangelo* (London: Phaidon, 1998)

Kemp, Martin, *The Marvellous Works of Nature and Man* (Oxford: Oxford University Press, 2007)

Leonardo da Vinci, *Notebooks*, ed. Irma A. Richter, Martin Kemp, Thereza Wells (Oxford: Oxford University Press, 2008)

Sassoon, Donald, *Mona Lisa: The History of the World's Most Famous Painting* (Glasgow: Harper Collins, 2002)

Talvacchia, Bette, *Raphael* (London: Phaidon, 2007)

Chapter 4

Anderson, Jaynie, *Giorgione: The Painter of Poetic Brevity* (Paris: Flammarion, 1997)

Batschmann, Oskar, *Giovanni Bellini* (London: Reaktion Books, 2008)

Baxandall, Michael, *The Limewood Sculptors of Renaissance Germany* (Yale: Yale University Press, 1982)

Humfrey, Peter, ed., *The Cambridge Companion to Giovanni Bellini* (Cambridge: Cambridge University Press, 2008)

Panofsky, Erwin, *The Life and Art of Albrecht Dürer* (Princeton: Princeton University Press, 2005)

Settis, Salvatore, *Giorgione's Tempest: Interpreting the Hidden Subject* (Chicago: University of Chicago, 2004)

Strauss, Walter L., *The Complete Engravings, Etchings and Drypoints of Albrecht Dürer* (New York: Dover Publications, 2000)

Chapter 5

Brinkmann, Bodo, ed., *Cranach*, exhibition catalogue (London: Royal Academy of Arts, 2008)

Buck, Stephanie and Jochen Sander, *Hans Holbein the Younger: Painter at the Court of Henry VIII* (London: Thames and Hudson, 2003)

Dixon, Laurinda, *Hieronymus Bosch* (London: Phaidon, 2003)

Gibson, Walter S., *Pieter Bruegel and the Art of Laughter* (Berkeley, California: University of California, 2006)

Jacobowitz, Ellen S. and S. Stepanek, eds., *The Prints of Lucas van Leyden and his Contemporaries* (Princeton: Princeton University Press, 1983)

Seipel, Wilfried, *Pieter Bruegel the Elder: At the Kunsthistorisches Museum in Vienna* (Milan: Skira Editore, 1998)

Chapter 6

Barnes, Bernardine, *Michelangelo's 'Last Judgment': The Renaissance Response* (Berkeley, California: University of California Press, 1998

Ekserdjian, David, *Correggio* (Yale: Yale University Press, 1997)

Hall, Marcia B., ed., *Michelangelo's 'Last Judgment'* (Cambridge: Cambridge University Press, 2004)

Humfrey, Peter, *Titian* (London: Phaidon, 2007)

Nigro, Salvatore S., *Pontormo: Paintings and frescoes* (New York: Harry N. Abrams, 2004)

Puttfarken, Thomas, *Titian and Tragic Painting: Aristotle's Poetics and the Rise of the Modern Artist* (Yale: Yale University Press, 2005)

Conclusion

Baxandall, Michael, *Art and Experience in Fifteenth Century Italy: A*

Primer in the Social History of Pictorial Style (Oxford: Oxford University Press, 1988)

Hollingsworth, Mary *Patronage in Renaissance Italy from 1400 to the Early Sixteenth Century* (Baltimore: Johns Hopkins University Press, 1995)

—— *Patronage in Sixteenth Century Italy* (London: John Murray, 1996)

O'Malley, Michelle and Evelyn Welch, eds., *The Material Renaissance* (Manchester: Manchester University Press, 2007)

Tignali, Paola, *Women in Italian Renaissance Art* (Manchester: Manchester University Press, 1997)

Bibliography

Ames-Lewis, Frances, *The Intellectual Life of the Early Renaissance Artist* (Yale: Yale University Press, 2002)

—— *Drawing in Early Renaissance Italy* (Yale: Yale University Press, 2000)

—— *The Draughtsman Raphael* (Yale: Yale University Press, 1986)

Alberti, Leon Battista, *On Painting* (1435), ed. M. Kemp (London: Penguin, 2005)

Avery, Charles, *Florentine Renaissance Sculpture* (London: John Murray, 1990)

Aymar-Wollheim, Marta and Flora Dennis, *At Home in Renaissance Italy: Art and Life in the Italian House 1400–1600* (London: V and A Publications, 2006)

Blunt, Anthony, *Artistic Theory in Italy 1450–1600* (Oxford: Oxford University Press, 1963)

Brown, Alison, *The Renaissance* (London: Longman, 2nd edition, 1999)

Brown, Patricia Fortuni, *The Renaissance in Venice* (London: Weidenfeld and Nicolson, 1997)

Bull, Malcolm, *The Mirror of the Gods: Classical Mythology in Renaissance Art* (London: Penguin, 2006)

Burke, Peter, *The Italian Renaissance: Culture and Society in Italy* (Cambridge: Polity Press, 2nd edition, 1999)

Campbell, Lorne, *Renaissance Faces: Van Eyck to Titian* (Yale: Yale University Press, 2008)

—— *Renaissance Portraits* (Yale: Yale University Press, 1990)

Castiglione, Baldassare, *The Book of the Courtier* (1527) (London: Penguin, 2004)

Chipps Smith, Jeffery, *The Northern Renaissance* (London: Phaidon, 2004)

Clark, Kenneth, *Landscape into Art* (London: John Murray, 3rd revised edition, 1997)

—— *Leonardo da Vinci* (London: Penguin, revised edition, 1993)

Cole, Bruce, *The Renaissance Artist at Work: From Pisano to Titian* (London: John Murray, 1983)

Cuttler, Charles D., *Northern Painting from Pucelle to Bruegel/Fourteenth, Fifteenth and Sixteenth Centuries* (New York: Holt, 1968)

Dunkerton, Jill, Susan Foister, Dillion Gordon, Nicholas Penny, *Giotto to Dürer: Early Renaissance Painting in the National Gallery* (Yale: Yale University Press, 1991)

Foister, Susan, *Holbein in England* (London: Tate Publishing, 2006)

Friedlaender, Walter, *Mannerism and Anti-Mannerism in Italian Painting* (New York: Columbia University Press, 1990)

Friedlander, Max J., *Early Netherlandish Painting from van Eyck to Bruegel* (London: Phaidon, 1956)

Goldthwaite, Richard A., *Wealth and the Demand for Art in Italy 1300–1600* (Baltimore: Johns Hopkins University Press, 1993)

Gombrich, E. H., *Gombrich on the Renaissance Vols 1–4* (London: Phaidon, 1979–94)

Hale, J. R., *The Civilization of Europe in the Renaissance* (Glasgow: Harper Collins, 2005)

Hall, James, *Dictionary of Subjects and Symbols in Art* (Boulder: Westview Press, 2nd revised edition, 2008)

Hall, James, *Michelangelo and the Reinvention of the Human Body* (London: Chatto and Windus, 2005)

Hall, Marcia B., *After Raphael: Painting in Central Italy in the Sixteenth Century* (Cambridge: Cambridge University Press, 1998)

Harbison, Craig, *The Mirror of the Artist: The Art of the Northern Renaissance* (London: Prentice-Hall, 1996)

Hartt, Frederick, *History of Italian Renaissance Art: Painting, Sculpture, Architecture* (London: Prentice Hall, 6th edition, 2006)

Hauser, Arnold, *Social History of Art: Renaissance, Mannerism and Baroque, Volume 2* (Oxford: Routledge, 1990)

Hersey, George L., *High Renaissance Art in St Peter's and the Vatican: An Interpretive Guide* (Chicago: Chicago University Press, 1993)

Heydenreich, Gunnar, *Lucas Cranach the Elder: Painting Materials, Techniques and Workshop Practice* (Chicago: Chicago University Press, 2007)

Hibbert, Christopher, *The Rise and Fall of the House of Medici* (London: Penguin, 2001)

Humfrey, Peter, *The Altarpiece in Renaissance Venice* (Yale: Yale University Press, 1993)

—— *Painting in Renaissance Venice* (Yale: Yale University Press, 1996)

Janson, Horst W., *The Sculpture of Donatello* (Princeton: Princeton University Press, 1957)

Johnson, Geraldine, *Renaissance Art: A Very Short Introduction* (Oxford: Oxford University Press, 2005)

Jones, Roger and Nicholas Penny, *Raphael* (Yale: Yale University Press, 1983)

Kashnitz, Rainer and Achim Bunz, *Carved Altarpieces: Masterpieces of the Late Gothic* (London: Thames and Hudson, 2006)

Kavaler, Ethan Matt, *Pieter Bruegel: Parables of Order and Enterprise* (Cambridge: Cambridge University Press, 1999)

Kemperdinck, Stephen and Jochen Sander, *The Master of Flemalle and Rogier van der Weyden: The Birth of Modern Painting* (Frankfurt: Hatje Cantz, 2009)

Kempis, Thomas à, *Imitation of Christ* (London: Penguin, 2005)

Koerner, Josef Leo, *The Reformation of the Image* (Chicago: University of Chicago Press, 2003)

Landau, David and Peter Parshall, *The Renaissance Print: 1470–1550* (Yale: Yale University Press, 1994)

Lane, Barbara L., *Altar and the Altarpiece: Sacramental Themes in Early Netherlandish Painting* (London: Grafton, 1984)

Laurenza, Domenico, *Leonardo's Machines: Da Vinci's Inventions Revealed* (London: David and Charles, 2006)

Levey, Michael, *Early Renaissance* (London: Penguin, 1991)

—— *High Renaissance* (London: Penguin, 1975)

Michelangelo Buonarroti, *Life, Letters and Poetry* (Oxford: Oxford University Press, 1987)

Murray, Linda, *The High Renaissance and Mannerism: Italy, the North and Spain 1500–1600* (London: Thames and Hudson, 1978)

Murray, Peter and Linda, *The Art of the Renaissance* (London: Thames and Hudson, 1963)

Nagel, Alexander, *Michelangelo and the Reform of Art* (Cambridge: Cambridge University Press, 2000)

Nash, Susie, *Northern Renaissance Art* (Oxford: Oxford University Press, 2008)

Nichols, Tom, *The Art of Poverty: Irony and Ideal in Sixteenth Century Beggar Imagery* (Manchester: Manchester University Press, 2007)

Nuttall, P., *From Flanders to Florence: The Impact of Netherlandish Painting 1400–1500* (Yale: Yale University Press, 2004)

Olson, Roberta J., *Italian Renaissance Sculpture* (London: Thames and Hudson, 1992)

O'Malley, Michelle, *The Business of Art: Contracts and the Commissioning Process in Renaissance Italy* (Yale: Yale University Press, 2005)

Panofsky, Erwin, *Renaissance and Renascences in Western Art* (Boulder: Westview Press, 1972)

—— *Early Netherlandish Painting* (Glasgow: Harper Collins, 1971)

Paoletti, John T. and Radke, Gary M., *Art in Renaissance Italy* (London: Laurence King, 2005)

Parks, Tim, *Medici Money: Banking, Metaphysics and Art in Fifteenth Century Florence* (London: Profile Business, 2006)

Partridge, Loren, *The Renaissance in Rome* (London: Weidenfeld and Nicolson, 1996)

Pater, Walter, *The Renaissance: Studies in Art and Poetry*, ed. Adam Philips (Oxford: Oxford University Press, new ed., 1998)

Richardson, C. M., *Locating Renaissance Art: Renaissance Art Reconsidered 2* (Yale: Yale University Press, 2007)

Richardson, C. M., K. W. Woods, M. W. Franklin, eds., *Renaissance Art Reconsidered: An Anthology of Primary Sources* (Oxford: Wiley-Blackwell, 2006)

Seidel, Laura, *Jan van Eyck's Arnolfini Portrait: Stories of an Icon* (Cambridge: Cambridge University Press, 1993)

Sellink, Manfred and Till-Holger Borchert, *Bruegel: The Complete Paintings, Drawings and Prints* (Ghent: Ludion, 2007)

Shearman, John, *Only Connect: Art and the Spectator in the Italian Renaissance* (Princeton: Princeton University Press, 1992)

—— *Mannerism* (London: Penguin, 1970)

Silver, Larry, *Hieronymus Bosch* (New York: Abbeville, 2006)

Snyder, James, *Northern Renaissance Art: Painting, Sculpture, the Graphic Arts from 1350 to 1575* (London: Prentice Hall, 2004, 2nd edition)

Turner, Jane, ed., *Encyclopedia of Italian Renaissance and Mannerist Art*, 2 vols. (Basingstoke and Oxford: MacMillan, 2000)

Vermeylen, Filip, *Painting for the Market: Commercialisation of Art in Antwerp's Golden Age* (Turnhout: Brepols, 2004)

Welch, Evelyn, *Art in Renaissance Italy 1350–1500* (Oxford: Oxford University Press, 1997)

Wilson, Derek, *Hans Holbein: Portrait of an Unknown Man* (London: Pimlico, 2006)

Wind, Edgar, *Pagan Mysteries of the Renaissance* (Oxford: Oxford University Press, 1980)

Woods, Kim W., *Viewing Renaissance Art: Renaissance Art Reconsidered 3* (Yale: Yale University Press, 2007)

—— *Making Renaissance Art: Renaissance Art Reconsidered 1* (Yale: Yale University Press, 2007)

Index

A Beginner's Guide to Christianity

Renowned theologian and bestselling author Keith Ward provides an original and authoritative introduction for those seeking a deeper understanding of this complex faith.

978-1-85168-539-4
£9.99/14.95

"Well ordered and clearly written. Will quickly become a standard textbook." *Theology*

"An articulate presentation of diverse approaches to Christianity's central concerns ... highly recommended." *Library Journal*

KEITH WARD is Professor of Divinity at Gresham College, London and Regius Professor of Divinity Emeritus, at the University of Oxford. A Fellow of the British Academy and an ordained priest in the Church of England, he has authored many books on the topics of Christianity, faith, and science including the best-selling *God: A Guide for the Perplexed* and *The Case for Religion*, both published by Oneworld.

Browse further titles at
www.oneworld-publications.com

A Beginner's Guide to Medieval Philosophy

In this fast-paced, enlightening guide, Sharon M. Kaye takes us on a whistle-stop tour of medieval philosophy, revealing the debt it owes to Aristotle and Plato, and showing how medieval thought is still inspiring philosophers and thinkers today.

978-1-85168-578-3
£9.99/ $14.95

"Beautifully written and wonderfully accessible. Discussing all the major thinkers and topics of the period, Kaye's volume does exactly what it should." **William Irwin** – Professor of Philosophy, King's College Pennsylvania and Editor of *The Blackwell Philosophy and Pop Culture Series*

"Simultaneously entices students into and prepares them for the riches of the abundant literature that lies ready for their exploration." **Martin Tweedale** – Professor Emeritus of Medieval Philosophy, University of Alberta

SHARON M. KAYE is Associate Professor of Philosophy at John Carroll University. She is the author of *On Ockham* and *On Augustine*.

Browse further titles at
www.oneworld-publications.com

A Beginner's Guide to Philosophy of Religion

Assuming no prior knowledge of philosophy from the reader, Taliaferro provides a clear exploration of the discipline, introducing a wide range of philosophers and covering the topics of morality and religion, evil, the afterlife, prayer, and miracles.

9781851686506
£9.99/ $14.95

"Brimming with arguments, the material is cutting edge, and the selection of topics is superb."
J.P. Moreland – Professor of Philosophy, St Olaf College, Minnesota

"Covers all the most important issues in a way that is always fair-minded, and manages to be accessible without over-simplifying" **John Cottingham** – President of the British Society for the Philosophy of Religion and Professor Emeritus of Philosophy, Reading University

CHARLES TALIAFERRO is Professor of Philosophy at St. Olaf College, Minnesota, USA. He is the author or editor of numerous books on the philosophy of religion including as co-editor of *The Blackwell Companion to Philosophy of Religion.*

Browse further titles at
www.oneworld-publications.com